MONET

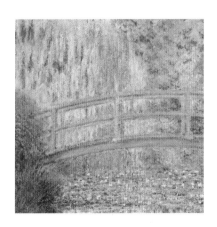

Publisher and Creative Director: Nick Wells
Picture Research: Melinda Révész and Chelsea Edwards
Project Editors: Polly Willis and Chelsea Edwards
Designer: The Urban Ant Ltd
Production: Chris Herbert and Digby Smith
Copy-editor: Anna Groves
Proofreader: Helen Tovey
Indexer: Penny Brown

Special thanks to: Laura Bulbeck and Cat Taylor

FLAME TREE PUBLISHING
Crabtree Hall, Crabtree Lane
Fulham, London, SW6 6TY
United Kingdom

www.flametreepublishing.com

First published 2011

11 13 15 14 12

1 3 5 7 9 10 8 6 4 2

Flame Tree is part of The Foundry Creative Media Company Limited

A CIP record for this book is available from the British Library.

ISBN: 978 1 84786 983 8

Every effort has been made to contact copyright holders. We apologize in advance for any omissions
and would be pleased to insert the appropriate acknowledgement in subsequent editions of this publication.

While every endeavour has been made to ensure the accuracy of the reproductions of the images in this book,
we would be grateful to receive any comments or suggestions for inclusion in future reprints.

Printed in China

Contents

Claude Monet, *Still Life with Bottles*; *Women in the Garden*; *Impression: Sunrise, Le Havre*

Claude Monet, *The Beach at Trouville*; *Promenade near Argenteuil*; *The Hotel des Roches Noires at Trouville*

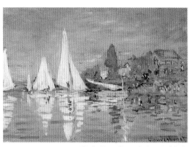

Claude Monet, *Regatta at Argenteuil; Path through the Poppies, Ile Saint-Martin, Vétheuil; Monte Carlo: view of Roquebrune*

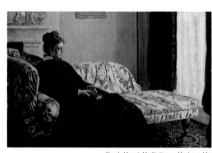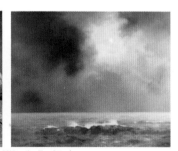

Claude Monet, *Meditation, or Madame Monet on the Sofa; La Japonaise*; Gerhard Richter, *Sea Piece (Wave)*

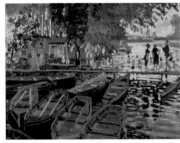

Claude Monet, *Camille Monet in a Red Cape*; *Bathers at La Grenouillère*; *The Reader* or *Springtime*

How To Use This Book

The reader is encouraged to use this book in a variety of ways, each of which caters for a range of interests, knowledge and uses.

- The book is organized into five sections: **Life**, **Society**, **Places**, **Influences** and **Styles & Techniques**.
- **Life** provides a snapshot of how Monet's work developed during the course of his career, and discusses how different people and events in his life affected his work.
- **Society** shows how Monet's work reflected the times in which he lived, and how events in the wider world of the time were a source of inspiration to him.
- **Places** looks at the work Monet created in the different places he lived and travelled, and how these places affected his painting.
- **Influences** reveals who and what influenced Monet, and touches on his inspiration to future generations of artists.
- **Styles & Techniques** delves into the different techniques Monet used to produce his pieces, and the varying styles he experimented with throughout his career.

Self-portrait with a Beret, 1886

1. Title of work (NB: all works are by Monet unless another artist's name is given at the foot of the page

2. Date of work (if known)

9. Picture credit

3. Information about the work and the context within which it was created

8. Place in which the work was created (if known)

7. Medium in which the work was created (if known)

6. Series, period or movement to which the work belongs (if known)

5. Similar work to the one pictured

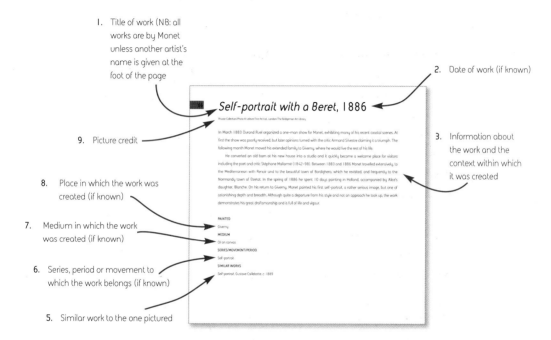

Self-portrait with a Beret, 1886

Private Collection/Photo © Lefevre Fine Art Ltd, London/The Bridgeman Art Library

In March 1883 Durand Ruel organized a one-man show for Monet, exhibiting many of his recent coastal scenes. At first the show was poorly received, but later opinions turned with the critic Armand Silvestre claiming it a triumph. The following month Monet moved his extended family to Giverny, where he would live the rest of his life.

He converted an old barn at his new house into a studio and it quickly become a welcome place for visitors including the poet and critic Stéphane Mallarmé (1842–98). Between 1883 and 1886 Monet travelled extensively, to the Mediterranean with Renoir and to the beautiful town of Bordighera, which he revisited, and frequently to the Normandy town of Etretat. In the spring of 1886 he spent 10 days painting in Holland, accompanied by Alice's daughter, Blanche. On his return to Giverny, Monet painted his first self-portrait, a rather serious image, but one of astonishing depth and breadth. Although quite a departure from his style and not an approach he took up, the work demonstrates his great draftsmanship and is full of life and vigour.

PAINTED
Giverny
MEDIUM
Oil on canvas
SERIES/MOVEMENT/PERIOD
Self-portrait
SIMILAR WORKS
Self-portrait, Gustave Caillebotte, c.1889

Foreword

Recognized as the 'Father of Impressionism', Claude-Oscar Monet (1840–1926) instigated one of the most important artistic movements in history, and his groundbreaking work continues to inspire the development of artists and artistic styles today.

The 2010 exhibition at the Grand Palais museum in Paris, which displayed nearly 200 of the great artist's works, attracted huge crowds willing to queue for hours to get a glimpse of Monet's genius. It was regarded as the most important Monet exhibition in over 30 years, and emphasized the artist's timeless appeal to contemporary audiences. Marking the significance of the occasion, President Nicolas Sarkozy contributed a quote to the catalogue, praising the exhibition as an 'unmistakable emblem of the international influence of French culture'.

Fellow Impressionists, such as Pierre-Auguste Renoir, Vincent Van Gogh and Paul Gauguin, clearly also had a substantial impact on the popularity of this artistic movement. However it was, and still is, Monet's ability to capture the nuances of nature in the materiality of paint – the physical substance with which he worked – that sets him apart from his contemporaries.

Monet did this by translating the expressive variations of nature into paint, focusing on the subjectivity in painting rather than adhering to traditionally accepted, figurative ideals. In other words, he painted what he saw in a moment including the effects of the weather and the changing position of the sun. This method of painting paved the way for abstract modern artists in the twentieth century who, like Monet, challenged the notion of what it means to be 'modern'.

Monet's view of the world captured the essence of creative expression through his palette of gentle, pastel colours and suggestive brushstrokes. Like any radical departure from traditional art making, the beginnings of Impressionism drew mixed responses from audiences and critics alike.

Monet's earliest creative output began with caricatures depicting the residents of Le Havre during the 1850s. It was here that he exhibited his first oil painting, *View at Rouelles* (1858). Almost 20 years later, he exhibited the painting that sealed his reputation. Unveiled to the public for the first time at what has come to be known as the first independent Impressionist Exhibition in 1874, *Impression: Sunrise* (1872) was the painting from which the movement took its name. Overall, the exhibition was not a success. The public did not take to the new style, complaining of 'sketchy lines' and 'blurred appearances'. Critics compared the execution of Monet's *Impression: Sunrise* in particular to the 'musings of an infant' and

'unfinished wallpaper'. But despite these initial reactions, *Impression: Sunrise* found a buyer marking the beginning of Monet's career as a professional artist.

While Monet was hard at work producing approximately 300 pictures in the space of five years, his wife's health was declining and his debts were piling up. Perhaps as a means of escape from his own troubles, combined with the need to sell paintings to pay the bills, his images at this time not only depicted rural idylls designed to appeal to the bourgeois and tourists, but also were produced at an almost industrial pace.

Whatever the reasons, this period of development, including much exposure to landscape painting and the repetition of subject matter, led to the execution of his early 'series' paintings, which he produced in Giverny, north-west of Paris, where he lived from 1883.

The notion of painting the same scene during different seasons of the year, or different times during the same day, capturing the changing weather and sunlight, was a technique favoured by the Impressionists. Monet's use of this technique is typified in his multiple renditions of haystacks, poplars, *Houses of Parliament, London* (1904–05), *Rouen Cathedral* (1892–93) and his most famous subject, water lilies. Monet's seemingly obsessive series of water lily paintings, most notably *The Waterlily Pond with the Japanese Bridge* (1899), was inspired by the garden at his house at Giverny. His repetition of the subject culminated into a significant commission for the Orangerie des Tuileries museum in Paris.

Monet's productivity never waned; he painted continuously throughout his lifetime despite being diagnosed with cataracts in his seventies. His output is almost superhuman; during his life he produced somewhere in the region of 2,000 paintings. Today, with countless reproductions available, Monet's works have become so familiar that it is hard to fully comprehend their initial impact.

This book encapsulates the evolution of Monet's oeuvre, highlighting his development of the subtle and beautiful brushstrokes that captured fleeting moments in time. These glimpses of light and shadow have come to embody the artistic movement of Impressionism and demonstrate that Monet's paintings will forever hold the power to move, inspire and enthral.

Stephanie Cotela Tanner, *2010*

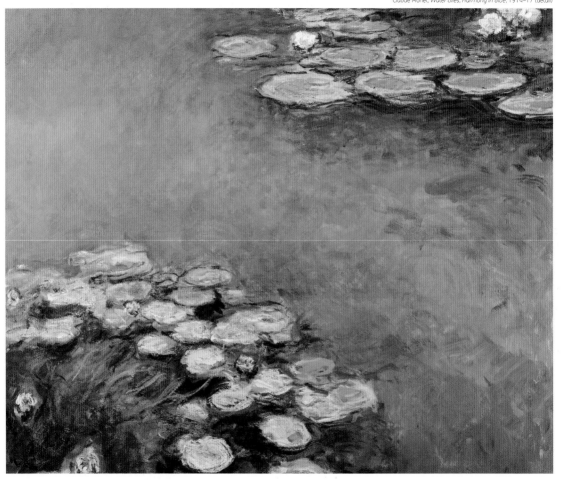

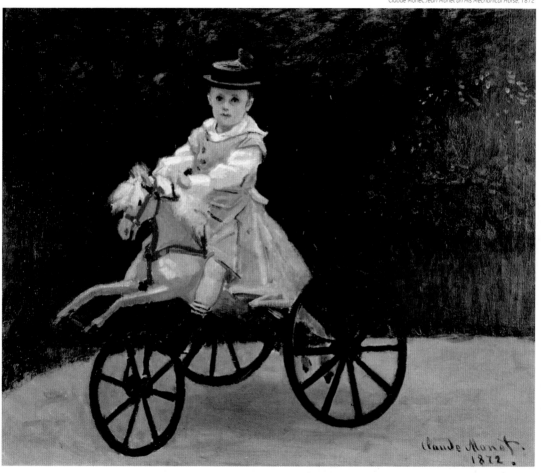

Claude Monet, *Jean Monet on His Mechanical Horse*, 1872

Bazille (1841–70) in his early days in Paris; all of them young, avant-garde artists. These artists supported each other, painted alongside each other, exchanged ideas and techniques and formed long-lasting friendships. These bonds and shared experiences – the monthly dinners in Paris in later years and meetings in such places as Café Guerbois, a Mecca for radical artists and writers of the day – were fundamental in shaping all of their careers. Evidence from Monet's numerous surviving letters indicate he was a man of many friends from such diverse quarters as the radicals and critics Octave Mirabeau (1848–1917) and Gustave Geffroy (1855–1926), to the writer Emile Zola (1840–1902), the poet Stéphene Mallarmé (1842–98) and the politician Clemenceau. He was a close friend of James Abbott McNeill Whistler (1834–1903) and in later years of John Singer Sargent (1856–1925). By the end of

his life, the little village of Giverny where he lived had attracted large numbers of young American artists, and it would be in America that his work would have particular influence on the development of modern art, seen through the work of the Abstract Expressionists.

An outstanding aspect of Monet's work is its sheer beauty. He painted lovely things, and in the first stages of his career often painted the wealthy, fashionable middle classes at leisure. These paintings of boating and promenading should have appealed to the very people they depicted, but it was the manner in which he painted that initially offended both academic art circles and the public. Monet treated all aspects of his scenes the same way, with the same freely expressed, textured brushwork, making no differentiation between a human figure and a field of poppies. While he might have chosen to paint the middle classes and the beautiful countryside, he did so to express a moment in time: a flash of sunlight on water, the dapple of light falling across a white dress or the

colours of reflection in deep water. His human figures were no more important in a landscape than a bank of trees, and in time they became barely discernible from the tall grasses of a meadow or monumentally dwarfed by the cliffs of a shoreline. For Monet, truth was not achieved through detail but in the overall harmony of nature.

His paintings were always creations of his own world, a world that was safe and often removed from reality: the grime of industrial

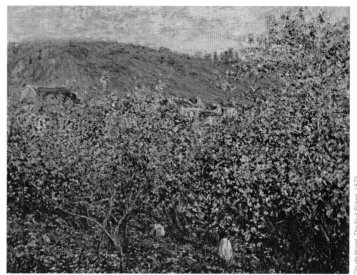

growth in towns such Argenteuil appears as faint puffs of smoke on a horizon; the smog of London becomes an ethereal, coloured atmosphere. References to the atrocities of war, the deaths of his friends, both wives, his son and stepdaughter are absent in any obvious form from his work, emphasizing the detachment in his paintings. The sincerity and singlemindedness of his objectives are tremendous. The most extraordinary in these terms are his final works, his giant series of water lily paintings that are deeply introspective and reflective on both visual and cerebral levels. There is no horizon in these works: sky becomes water and water sky in an endless inversion of truth and reality. Painted at the end of his life following various bereavements and with an increasing sense of mortality, these great monuments of twentieth-century art are infinitely contemplative.

Monet and his contemporaries shook the academic art world to its foundations during the latter part of the nineteenth century. They opened the door for progressive, modern art. Although Monet's impact had waned in France by the time of his death, he was rightly established as a leading artist, if not *the* landscape artist of the twentieth century. His work remained particularly popular in America and Europe, and within several decades of his death his genius was globally appreciated and his poetic vision recognized. Monet was not just a painter of pretty pictures.

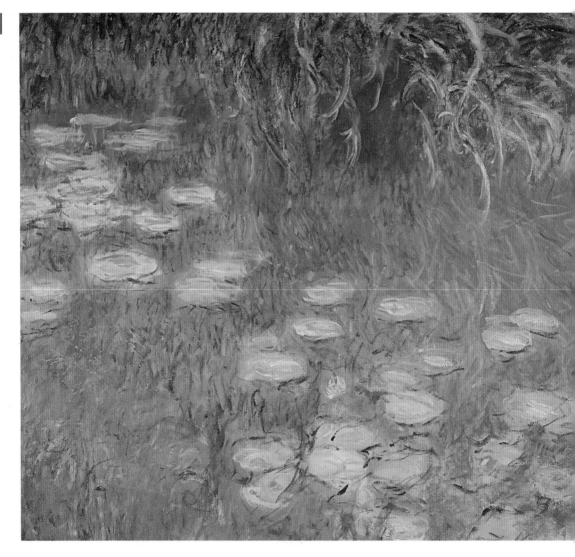

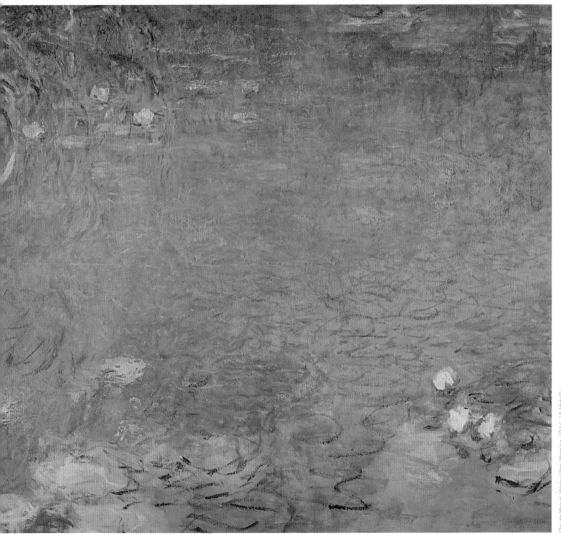

Claude Monet, *Water Lilies: Morning*, 1914–18 (detail)

THE W

GREATE

Monet

Life

View at Rouelles, 1858

Claude Monet spent his childhood growing up in Le Havre, Normandy, where he was, by his own account, an 'unruly' child, who nevertheless exhibited an early talent for drawing. His mother died in 1857 and the young Monet went to live with his aunt, Marie-Jeanne, herself an artist and the friend of painter Amand Gautier (1825–94), both of whom encouraged Monet in his artistic pursuits.

The following year the young artist was persuaded by Eugène Boudin (1824–98) to travel with him to Rouelles, north-east of Le Havre, for a painting excursion. Here, under the influence of Boudin, Monet produced his first-known painting, *View at Rouelles*, later exhibited at the Le Havre municipal exhibition in August and September 1858. Monet described the experience of painting *en plein air* as, 'it was like the rending of a veil; I understood, I grasped what painting could be'.

It is an extraordinarily accomplished work for the artist, who had only just started using oil paints, and already reveals his interest in the depiction of light and his skills as a colourist.

PAINTED

Rouelles

MEDIUM

Oil on canvas

SERIES/PERIOD/MOVEMENT

Early

SIMILAR WORKS

Pear Tree on the Banks of the Pond, Eugène Boudin, c. 1853–56

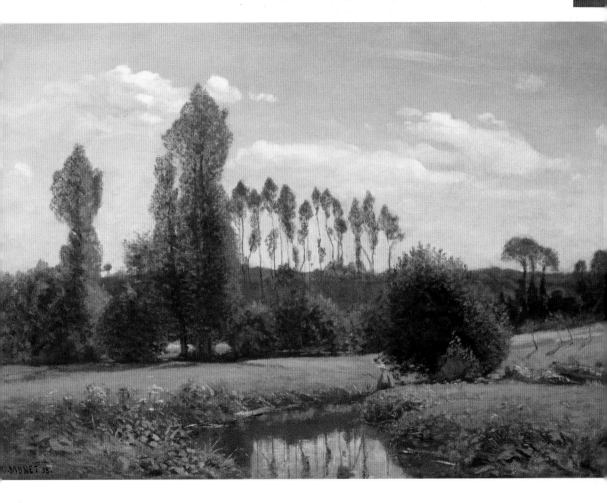

Still Life with Bottles, 1859

In 1859 Monet announced to his father that he wished to become a painter and move to Paris to further his skills. Père Monet applied for a municipal scholarship on his son's behalf to aid his study, but was unsuccessful and the young Monet had to fund himself. This he did by the sale of his clever caricature drawings, amassing a not inconsiderable sum of around 2,000 francs. Monet had begun producing the caricatures while still at school, at times to the consternation of his teachers, and had furthered his drawing skills through lessons with Jean-Francois Ochard, a former pupil of Jacques-Louis David (1748–1825).

Monet left Le Havre in the spring to visit the Paris Salon, which opened on 15 April, and saw the work of Charles Francois Daubigny (1817–78), Camille Corot (1796–1875), Eugène Delacroix (1798–1863) and Constant Troyon (1810–65). He later produced the amateurish *Still Life with Bottles*, with its hesitant perspective and unresolved composition, but also a fluent use of tonal contrasts and reflective light.

PAINTED

Paris

MEDIUM

Oil on canvas

SERIES/PERIOD/MOVEMENT

Still life

SIMILAR WORKS

The Salmon, Edouard Manet, 1868–69

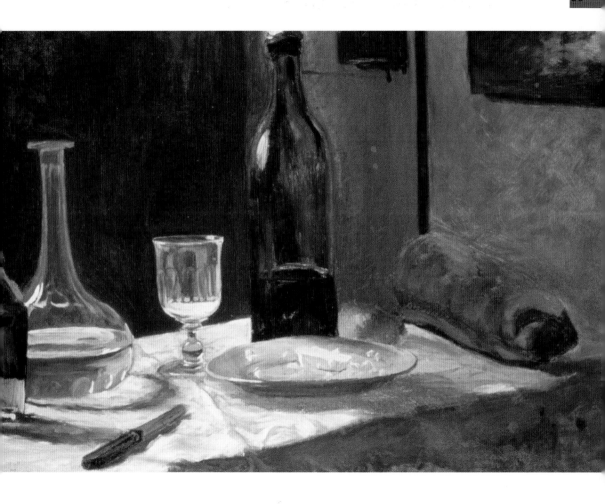

Petit Pantheon Theatral, 1860

In 1860 Monet enrolled at the Académie Suisse, a free academy that provided facilities and tuition in life drawing, rather than any formal instruction. Here he met Camille Pissarro (1830–1903) who advised him to study Corot. Monet, however, favoured the work of the landscape artist Daubigny and sought out the advice of Troyon. At this time Paris was a Mecca of artistic talent and Monet, the provincial boy from Le Havre, would have been thrust into a whirlwind of new ideas and influences. The city was in the grip of a mass modernization programme: new buildings were going up, the population was increasing and commerce and industry were booming. This was the setting for the new bourgeoisie, the sparkling wealthy. Over the coming years, this was the subject of many of Monet's paintings.

Monet greatly admired the drawings of Honoré Daumier (1808–79), and his early caricatures such as *Petit Pantheon Theatral* (1860) show Daumier's influence. His clean lines and witty depictions captured the very essence of his unwitting subjects. His skill was in part aided by his endless practising as a schoolboy, using his teachers as models.

PAINTED

Paris

MEDIUM

Pencil on paper

SERIES/MOVEMENT/PERIOD

Caricatures

SIMILAR WORKS

Behold our Nuptial Chamber, Honoré Daumier, 1853

Landscapists at Work, Honoré Daumier, 1862

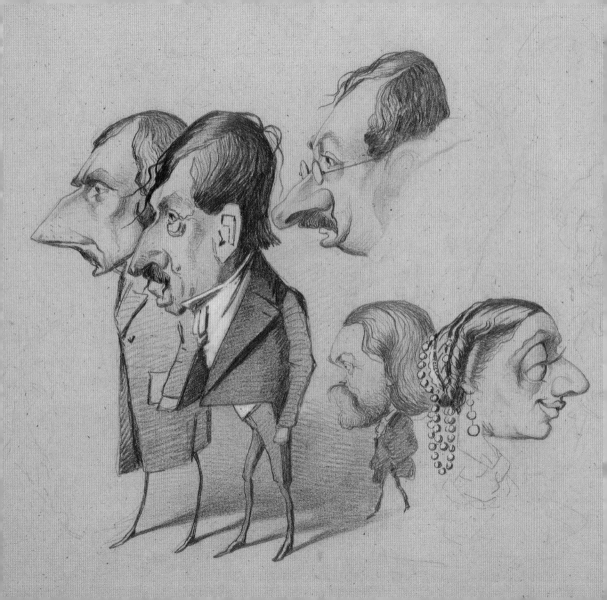

Rue de la Bavolle, Honfleur, 1864

Monet financed his studies at the Académie Suisse through the sale of his caricatures, and during this period met and became friendly with Pissarro, Paul Cézanne (1839–1906) and Gustave Courbet (1819–77), amongst others. In 1861 Monet was conscripted to serve in the French army and was sent to Algeria. His service was short lived, and by the following year he had returned to Paris suffering from typhoid. Algeria, however, had had a profound effect on the young man, who was deeply moved by the brilliant sunlight and colours, and the exotic vegetation.

On the recommendation of the artist Auguste Toulmouche (1829–90) Monet enrolled in Charles Gleyre's Studio in the autumn of 1862, where he met Pierre Auguste Renoir (1841–1919), Alfred Sisley (1839–99) and Frédéric Bazille (1841–70).

In 1864 Monet travelled to Honfleur, urging his friend Bazille to join him. Later the two spent some time painting the charming scenery around the estuary town, including Monet's striking *Rue de la Bavolle*, and travelled the short distance across the Seine to paint at Rouen and Sainte-Adresse.

PAINTED

Honfleur

MEDIUM

Oil on canvas

SERIES/PERIOD/MOVEMENT

Early

SIMILAR WORKS

The Crystal Palace, London, Camille Pissarro, 1871

Wooded Path, 1865

During 1864–65 Monet spent much of his time painting *en plein air* on the beautiful Normandy coastline and in the stunning forest of Fontainebleau. He first visited the little town of Chailly-en-Bière on the outer edge of Fontainbleau in 1863 with Bazille. Back in Paris soon after, Monet learned of Gleyre's illness and, with the prospect of the studio closing, Monet and his three friends Bazille, Sisley and Renoir quit.

In the autumn of 1864 Monet visited his family in Le Havre and by accounts had a serious argument with his father. Bazille paid Monet's return ticket to Paris and invited him to join his studio. The following year Monet submitted two large marine paintings to the Salon, his first public success. They earned him a mention by the critic Paul Mantz in the highly regarded *Gazette des Beaux-Arts*.

In the spring of that year Monet returned to Chailly, where he painted a large number of landscapes that reveal him experimenting with composition, the use of heavy verticals and oblique angles, and the evocation of the strong, dappled forest light.

PAINTED

Chailly

MEDIUM

Oil on canvas

SERIES/PERIOD/MOVEMENT

Early

SIMILAR WORKS

The Road to Rouen, Paul Gauguin, 1885

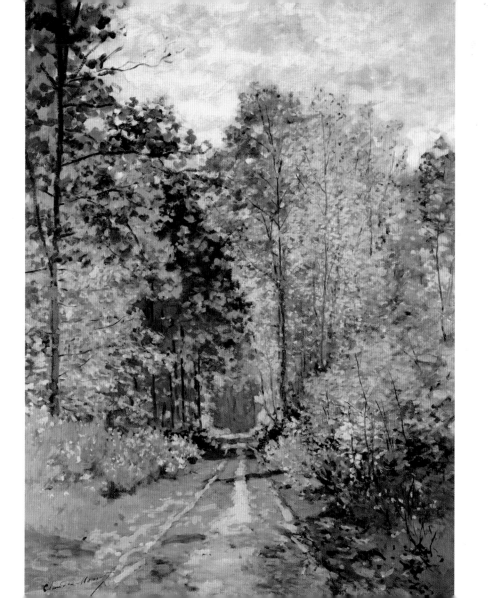

The Picnic, 1865–66

Edouard Manet's (1832–83) painting *The Picnic* was exhibited at the Salon des Refuses in 1863 and caused outrage with its scandalous subject of a naked woman lunching with two clothed men. Two years later Monet decided to paint his own version.

Monet's motive in such direct reference is questionable and, while he undoubtedly conceived the painting in part as an homage to Manet, it was also a clear attempt to distance himself from the older artist (Monet's name had been mistaken for Manet's at the Salon of 1865, causing great affront to the latter). The canvas for this ambitious work measured approximately 4.5 m high x 5.8 m wide (15 ft x 19 ft), for which Monet made numerous *plein air* sketches using his young lover Camille Doncieux and Bazille as models, returning to the Paris studio to paint.

The painting was not finished in time for the 1866 Salon and remained unfinished. Some 10 years later much of the canvas was so badly damaged that it was cut up and destroyed, and now only two large portions of the work remain, along with a few sketches and oil studies.

PAINTED

Forest of Fontainbleau

MEDIUM

Oil on canvas

SERIES/PERIOD/MOVEMENT

Impressionist

SIMILAR WORKS

Le Dejeuner sur L'Herbe, Paul Cézanne, 1869–70

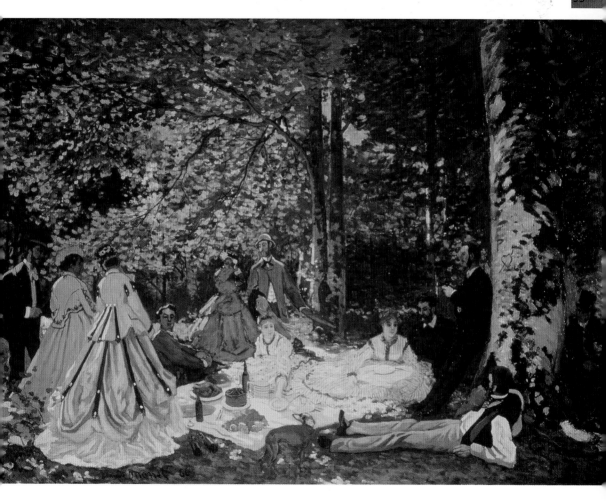

Camille or *The Woman in the Green Dress*, 1866

Courbet had been an influence on Monet, and the older artist had visited him at his Paris studio while he was painting *The Picnic*. On seeing that the giant work would never be completed in time for the 1866 Salon, Courbet urged Monet to paint something 'quickly and well, in a single go,' so he would have something to submit.

Accordingly Monet painted *Camille*, a dazzling figurative painting of his lover Camille Doncieux, who would become the first Mrs Monet. The work was allegedly done in a mere four days and was well received by the critics, being described as, 'the Parisian queen, the triumphant woman' in the magazine *L'Artiste*. It represents the epitome of a fashionable, avant-garde woman.

Most striking was Monet's combination of traditional approach and modern subject in the painting. His treatment of the fabrics – the silk with its hint of stiffness and gleaming colours and the warm, organic fur – recalled the portraiture of Old Masters, amplified by the dark tonal treatment. Yet Camille herself is contemporary and convincingly real, an icon of modern womanhood.

PAINTED

Paris

MEDIUM

Oil on canvas

SERIES/PERIOD/MOVEMENT

Figurative

SIMILAR WORKS

The Sisley Family, Pierre-Auguste Renoir, 1868

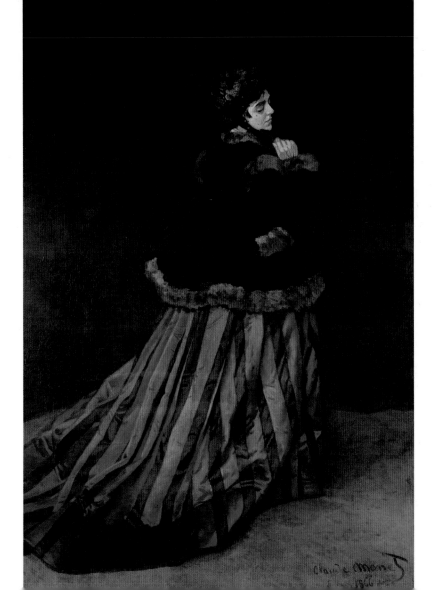

Women in the Garden, 1866–67

Monet had two works accepted at the 1866 Salon, his highly praised *Camille* and a landscape, *The Road to Chailly*. It was a great boost to the artist, both personally and also financially. This sudden change in his financial fortunes, although it would be very short lived, inspired Monet to begin another full-scale landscape painting with figures.

He moved to Sèvres, south-west of Paris, where he dug a trench in his garden into which he lowered his new, huge canvas to allow him to paint the upper portions. The painting was *Women in the Garden*, started in Sèvres and then taken to Honfleur, where Monet spent the summer and part of the winter. All the female figures were modelled on Camille, and again Monet wished to recreate the essence of modern life for the bourgeoisie. His depiction of the figures' fashionable clothing expresses an enthusiasm for the modern styles, and he also experimented with the effects of dappled light through leaves. The painting was rejected by the Salon, but his good friend Bazille stepped in and bought it for 2,500 francs to help his fluctuating finances.

PAINTED

Ville d'Avray, outside Paris

MEDIUM

Oil on canvas

SERIES/MOVEMENT/PERIOD

Impressionist

SIMILAR WORKS

Family Reunion, Frédéric Bazille, 1867

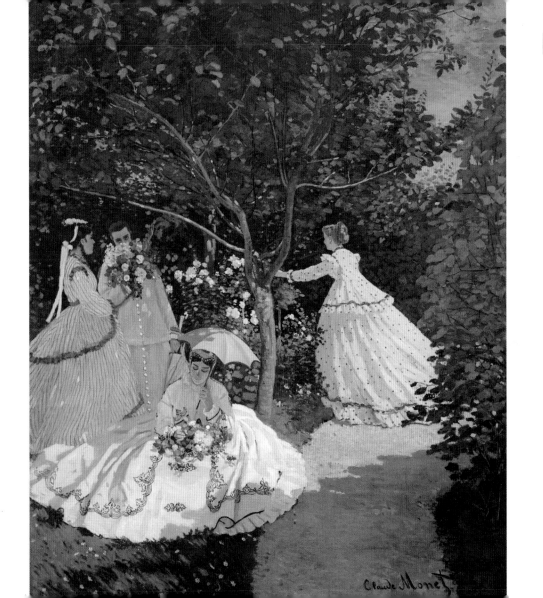

Claude Monet

Jeanne-Marguerite Lecadre in the Garden, 1867

Monet's strained relationship with his family was again tested in 1867, when at the start of the year the artist told them his lover, Camille, was pregnant. His father cut off his allowance, but his aunt offered him a place to stay at her house in Sainte-Adresse if he agreed to leave Camille. Monet decided to pretend to do this, installing Camille with her parents in Paris while he moved to Sainte-Adresse and continued to paint.

He produced a number of brilliantly sunny and light-filled paintings during this period and several of the beautiful garden at his aunt's house, the Le Coteaux Estate. In the painting *Jeanne-Marguerite Lecadre in the Garden* Monet combined beauty with melancholy as the lonely but fashionably dressed figure surveys the garden. It is an exercise in colour and contrast, and foretells the artist's great devotion to his garden later in life. Although painted *en plein air*, the highly finished feel to the work suggests he finished it in the studio. Like his earlier landscapes with figures, here again the figure is slightly uneasy in its setting and not entirely convincing.

PAINTED

Sainte-Adresse

MEDIUM

Oil on canvas

SERIES/PERIOD/MOVEMENT

Impressionist

SIMILAR WORKS

Eugene Manet and His Daughter in the Garden at Bougival, Berthe Morisot, 1881

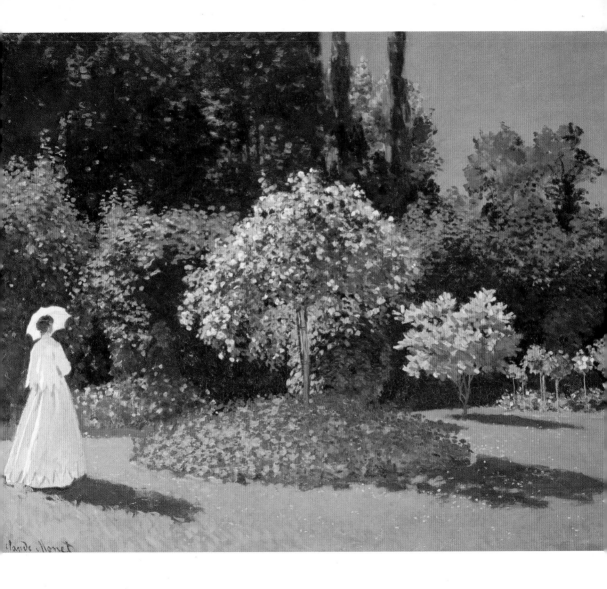

Claude Monet

The Jetty of Le Havre, 1868

In one of his many letters to Bazille, Monet wrote in 1868 that he was desperately worried about his pregnant lover Camille. The stress was such that Monet temporarily lost his sight a fortnight before the birth, and later in the year contemplated throwing himself into the river Seine.

Bazille sent the artist money to travel to Paris for the birth of his son, Jean, although Monet returned to Sainte-Adresse afterwards. It was in Sainte-Adresse that Monet painted his two Salon entries, *Ships leaving the Jetties of Le Havre* and *The Jetty at Le Havre*. The former was accepted but the latter rejected, criticized for the crudeness of the brushstrokes. In the words of the caricaturist Bertall, 'Here at last is some truly naïve and sincere art. M. Monet was four and a half when he did this painting ...'.

The spontaneity and apparent rapidity of the brushstrokes were at odds with the months of laborious and painstaking efforts it took for the artist to produce. However, there is a tangible communion between man and nature as the ferocious waves whip across the huddled figures.

PAINTED

Sainte-Adresse

MEDIUM

Oil on canvas

SERIES/PERIOD/MOVEMENT

Salon piece, rejected

SIMILAR WORKS

The Jetty at Honfleur, Johan Barthold Jongkind, 1865

The Red Cape (Madame Monet), *c.* 1870

In March 1870 the Salon rejected Monet's *Luncheon*, 1868–70, a disappointment made all the more bitter by the acceptance of virtually every other artists' offering. His good friend Daubigny resigned from the jury in protest.

Monet and Camille Doncieux were married in June that year, to the disapproval of Monet's family. Napoleon III (1808–73) declared war on Prussia in July, but Monet continued to paint Parisians at leisure. Throughout his life Monet ignored the stresses of the real world and chose to continue his paintings of light and beauty. Monet's great friend and patron Bazille was killed during the French retreat and in October Monet and his family fled to London, closely followed by Pissarro.

The Red Cape is an intimate painting of Monet's new wife, Camille. It is believed that the painting was not exhibited to the public during his lifetime. She is caught in the fleeting instant as she turns towards the window, her red cape startling against the snowy background. The spatial composition with the subject behind the strong grid of the window is extraordinarily modern in concept and unusual within Monet's oeuvre.

PAINTED

Paris

MEDIUM

Oil on canvas

SERIES/MOVEMENT/PERIOD

Impressionist portrait

SIMILAR WORKS

View of a Pork Butcher's Shop, Vincent Van Gogh, 1888

Fanny Clous on the Balcony, Edouard Manet, 1868

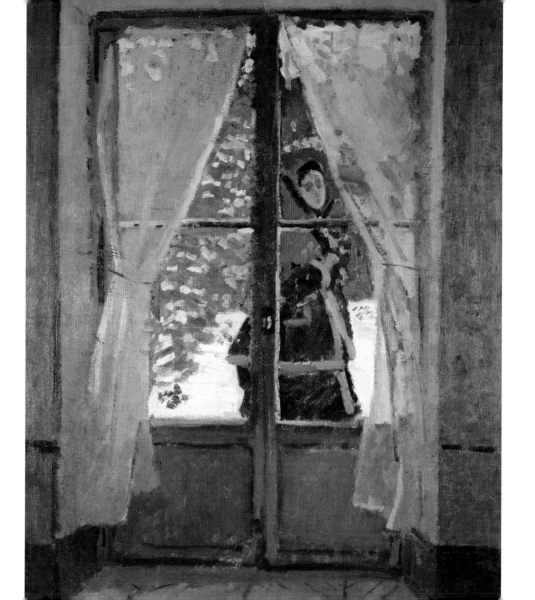

The Thames at London, 1871

London was increasingly becoming a shelter for French artists, fleeing from the turmoil at home. There Monet was introduced to the dealer Paul Durand Ruel (1831–1922), who would become one of his greatest supporters. Durand Ruel was a great advocate of the Impressionists and tirelessly defended their artistic endeavours against mainstream opinion. While in London Monet visited the city's museums, and the collection of Joseph Mallord William Turner's (1775–1851) paintings at the National Gallery and the works of John Constable (1776–1837) had a profound effect.

The nuance of his painting at this time is different and his pictures are edged with sobriety and a detached quality, suggesting the artist was not entirely at home in his new surroundings. His treatment of light, the reflection of light on water and the evocation of the damp, watery atmosphere of the Thames echo Turner's earlier vision. In *The Thames at London* Monet focuses the eye on the dark structures in the foreground, with their strong oblique composition contrasting with the soft handling of the background of mists, cloud and sky.

PAINTED

London

MEDIUM

Oil on canvas

SERIES/MOVEMENT/PERIOD

Impressionist landscape

SIMILAR WORKS

Entrance to the Port of Honfleur, Johan Barthold Jongkind, 1864

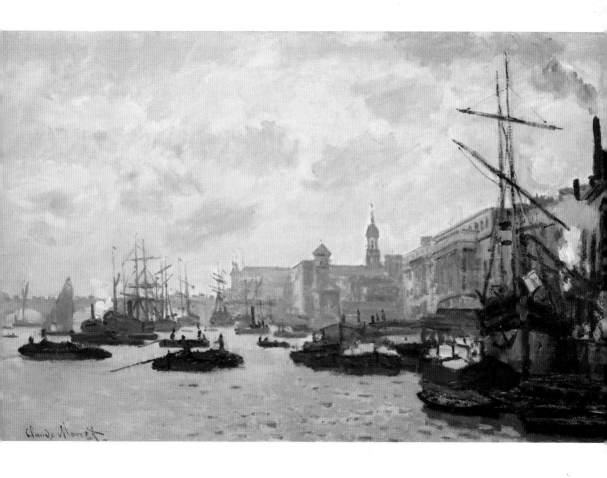

Impression: Sunrise, Le Havre, 1872

By November 1871 the war was over and Monet moved his family to Argenteuil, where he found the peace to continue developing his painting. The post-war years saw a hostile reaction to the work of Monet and his contemporaries, fuelled by the disparity between their depiction of the high life of the bourgeoisie and the recent horrors of the civil war.

The Salon of 1873 again rejected Monet, Pissarro, Sisley, Edgar Degas (1834–1917) and Renoir. At Monet's suggestion the group, with Berthe Morisot (1841–95), formed the Limited Company of Painters, Sculptors and Engravers and in 1874 staged their own exhibition. Monet's *Impression: Sunrise* was one of the exhibits to be ridiculed by the critics. The translucent, ethereal light of a misty sunrise and the ghostly structures looming in the haze bore the brunt of their derision. Louis Leroy, critic for the magazine *Charivari*, picked on the 'Impression' and the word was swiftly adopted to describe the new style of painting. The derisory nature of the term was corrected through the skilful diplomacy of Jules Castagnary, who put the record straight some days later in *Le Siècle*.

PAINTED

Le Havre

MEDIUM

Oil on canvas

SERIES/MOVEMENT/PERIOD

Impressionist

SIMILAR WORKS

Nocturne in Black and Gold: Entrance to Southampton Waters, James Whistler, *c.* 1870–80

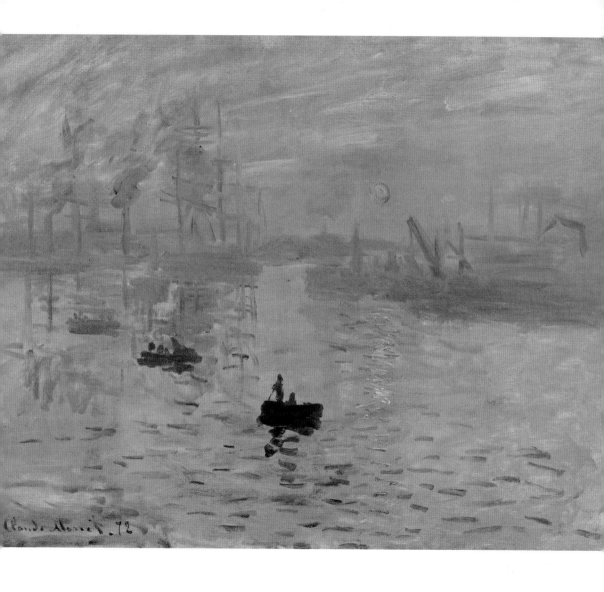

Jean Monet on His Mechanical Horse, 1872

Monet and his family moved to a small rented house on the outskirts of the rapidly growing town of Argenteuil, which sat on a small hill with vineyards stretching away down to the river Seine. It was a popular tourist destination and would become a favourite spot for many of the Impressionist painters. The river and its reflection of light was a particular draw for Monet, as was the little garden at the family home.

He painted the garden and his family, Camille and young Jean, and soon after moving into the house threw a housewarming party. His friend Sisley stayed for some time and they would paint together. It was a time of relative stability, financially and personally for Monet, for whom family was a key anchor. This painting of his growing son Jean has an echo of Manet's influence. It is a rather melancholy image with the little boy appearing very isolated, emphasized by the pale background of the path on which he sits. Monet has struggled here to sit his figure comfortably into its landscape background, a problem seen in several of his early paintings.

PAINTED

Argenteuil

MEDIUM

Oil on canvas

SERIES/MOVEMENT/PERIOD

Figurative

SIMILAR WORKS

A Woman and Child in the Driving Seat, Mary Cassatt, 1881

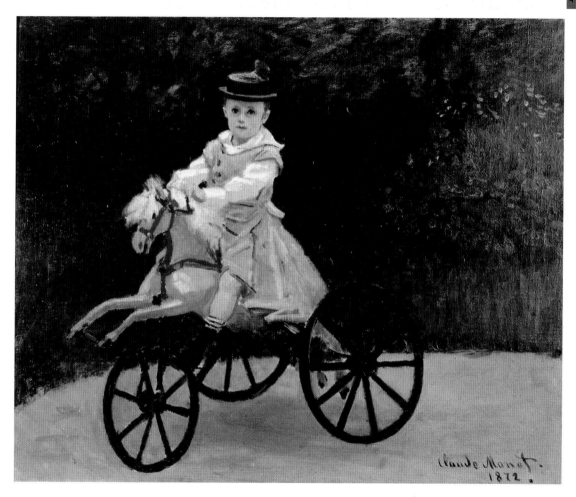

The Luncheon: Monet's garden at Argenteuil, c. 1873

For the first time Monet was reasonably financially well off, and his account books indicate that in 1873 his profits more than doubled those from the year before. He had been left a little money after the death of his father in 1871, and his picture sales had improved greatly. With the end of the Civil War there was an economic boom that spilled over into the arts and for a time trade was good. The art dealer Durand Ruel, whom Monet had met during his time in London, was regularly buying paintings from him and the prices of his paintings had gone up.

Monet's house in Argenteuil was, judging by his paintings, a place of some substance, and records reveal that the artist was employing two servants and a gardener until the middle of the decade. Camille and Jean too are fashionably dressed in Monet's paintings of the time, and the accoutrements of family dining as seen in *The Luncheon* with its silver teapot and blue-patterned Chinese cups indicate the artist's turn of good fortune.

PAINTED

Argenteuil

MEDIUM

Oil on canvas

SERIES/MOVEMENT/PERIOD

Figurative

SIMILAR WORKS

Eugene Manet and his Daughter in the Garden at Bougival, Berthe Morisot, 1881

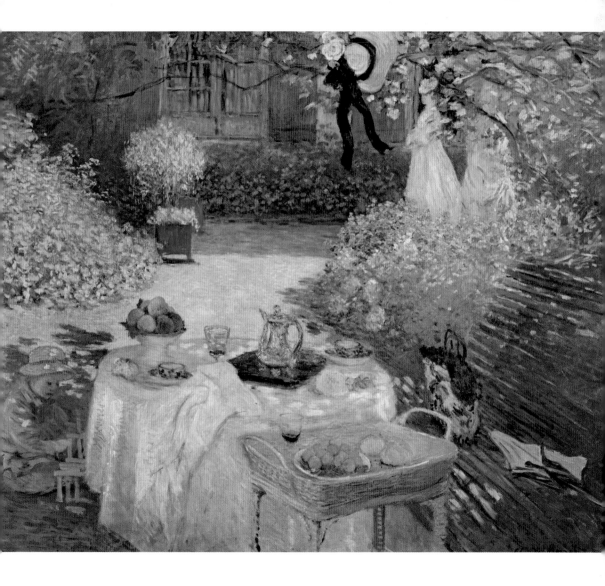

The Studio Boat, 1876 (detail)

Between leaving London and moving to Argenteuil in 1871, Monet travelled to Holland for a brief spell on the recommendation of Daubigny, who had extolled the virtues of this land of light and water.

On returning to France, Monet again followed Daubigny's example and looked for a riverboat to convert into a floating studio (Daubigny had for some time worked from a small flat-bottomed boat, in which he would float up the Seine and Marne). During Monet's search around Argenteuil for such a craft he met Gustave Caillebotte (1848–94), a wealthy young boat buff. Together they found his floating studio, which then became the subject of a group of four paintings. The four images suggest a slow progression upriver through the tranquillity of a luxuriant landscape. Monet's painting of 1876 captures the boat in a soft light, the seated figure bowed in thought and concentration. Manet, on visiting Monet in his new studio, also painted the unusual vessel, and Caillebotte, inspired by his artist friend, took up painting himself, producing paintings both from and of Monet's floating studio.

PAINTED

Argenteuil

MEDIUM

Oil on canvas

SERIES/MOVEMENT/PERIOD

Impressionist

SIMILAR WORKS

Claude and Camille Monet in the studio boat, Edouard Manet, 1874

Le Seine au Bas-Meudon, Pierre Prins, 1869

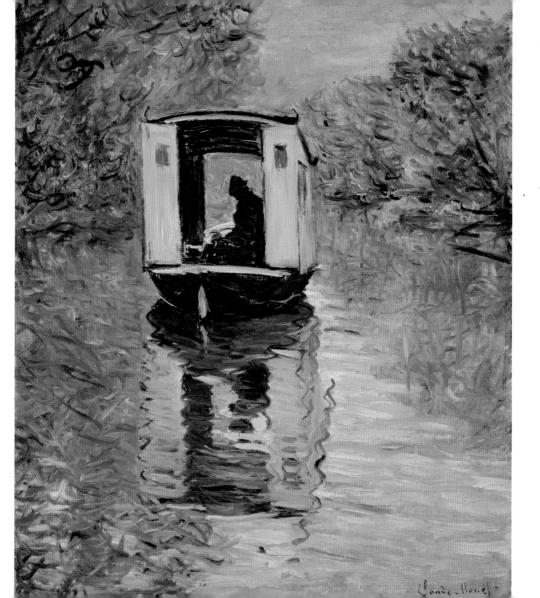

Claude Monet

The Gare Saint-Lazare, 1877 (detail)

The first Impressionist Exhibition was held in 1874 and organized by Monet and his friends, who had formed the *Société Anonyme des Artistes*. The exhibition was a disaster and the company of painters was dissolved later that year.

The second Impressionist Exhibition in 1876 was greeted with even more hostility. In September of that year Monet travelled to the home of Ernest and Alice Hoschedé to paint four decorative panels. Alice would later become his lover, then his wife.

In early 1877 Monet started work on a series of paintings of the Gare Saint-Lazare, turning again to the subject of modern life. Monet was fascinated by the steam engines; the people in his series of paintings recede into incidentals against the bigger might of the train. Monet's Gare Saint-Lazare series shows him evolving his treatment of steam and its effects on the atmosphere. His engines dominate the paintings, their solidity in direct contrast to the vapour of their steam. The paintings were included in the third Impressionist Exhibition of April 1877 but again were widely criticized.

PAINTED

Argenteuil

MEDIUM

Oil on canvas

SERIES/MOVEMENT/PERIOD

Gare St Lazare

SIMILAR WORKS

Rain, Steam and Speed, J. M. W. Turner, 1843

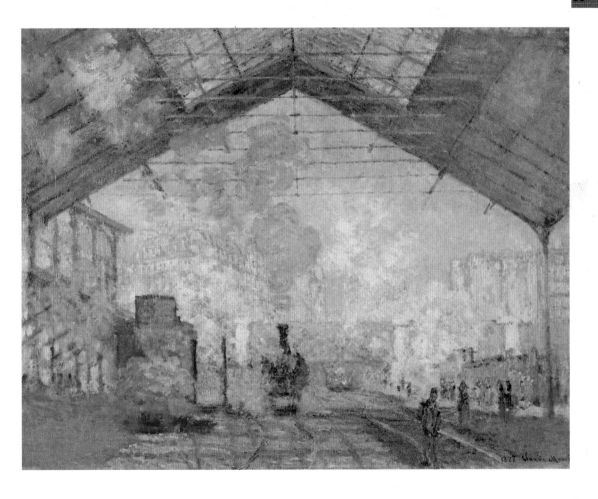

Small Branch of the Seine, 1878

Private Collection/Photo © Lefevre Fine Art Ltd., London/The Bridgeman Art Library

Monet's commercial success was short lived and by 1874 the dealer Durand Ruel was in financial difficulties, which in turn affected Monet. But a stroke of luck saw the artist introduced to Ernest and Alice Hoschedé who became important patrons, until they too fell on hard times. Heavily in debt and worried that his possessions would be repossessed, the artist wrote to his friends begging for aid, before having to leave his beloved house in Argenteuil in January 1878. By now Camille, who was ill, had had a second child, Michel.

Monet briefly stayed in Paris before moving to Vétheuil where the Monet family and the Hoschedés, who had become bankrupt, set up home together. Monet wrote later that year that he had '... pitched my tent by the Seine at Vétheuil in an enchanting area'. The energy and light in this painting along the Seine belies the artist's troubled life at this time. He has used rapid, small brushstrokes worked across the canvas to create great immediacy and a sense of shifting atmosphere.

PAINTED

Along the Seine

MEDIUM

Oil on canvas

SERIES/MOVEMENT/PERIOD

Landscape, Impressionist

SIMILAR WORKS

The Oxen at L'Hermitage, Pontoise, Camille Pissarro, 1877

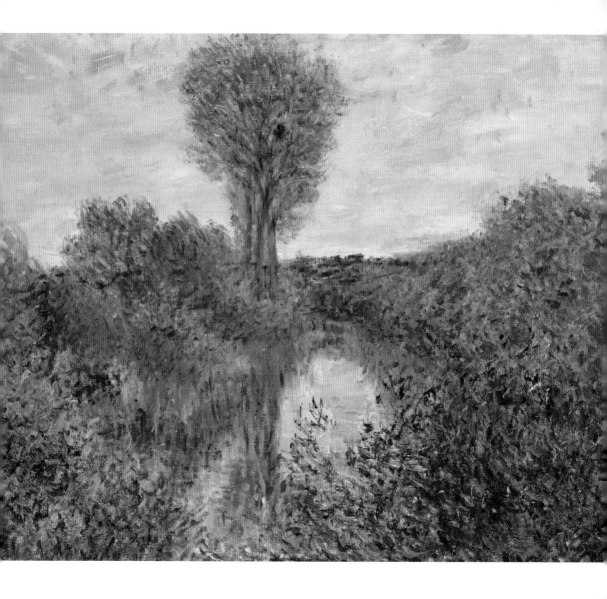

Camille Monet on her Deathbed, 1879

The year 1879 was a traumatic one for Monet that saw financial difficulties, the 'crisis of Impressionism' and the death of his adored wife Camille. Camille had given birth to their second child Michel in March 1878. She had become increasingly ill throughout the pregnancy, and following the birth her condition deteriorated. By this time Alice Hoschedé, her six children and her husband were living with the Monets. Ernest Hoschedé was spending more time in Paris, and Alice and Monet were thrown together in their care of the faltering Camille.

Camille, Monet's model and companion for 13 years, died leaving the artist with his young family on 5 September 1879. The artist painted her at her deathbed, recording her features with exquisitely delicate colours as they recede into the sheets around her. He wrote, 'I found myself at daybreak at the bedside of a dead woman who had been and always will be dear to me – I caught myself observing the shades and nuances of colour Death brought to her countenance. Blues, yellows, greys, I don't know what. That is the state I was in.'

PAINTED

Vétheuil

MEDIUM

Oil on canvas

SERIES/MOVEMENT/PERIOD

Figurative, Impressionist

SIMILAR WORKS

The Dying Nun, Gwen John, early twentieth century

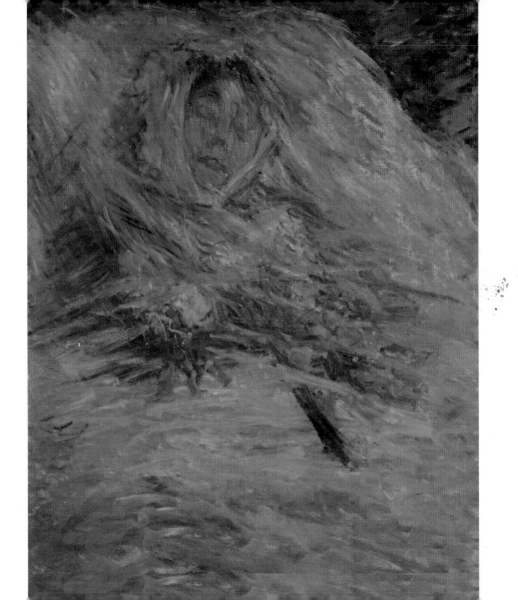

The Artist's Garden at Vétheuil, 1880

With very few exceptions, Monet did not paint his family in a landscape or garden setting between 1878 and 1880. The winter of Camille's death in 1879 was icy cold and saw the Seine freeze over. Monet took his canvas and painted scenes of the frosty countryside using short, rapid brushstrokes and frigid tones to create works saturated with a sense of isolation.

Spring came early in 1880 and as it moved into summer Monet again began to paint his brilliantly coloured garden and meadow scenes, and began to include his children as well as the figure of Alice Hoschedé. These paintings are sun-filled and strikingly coloured, composed of tiny, fragmented brushstrokes of pure, jewel-like tones of vibrant yellow, iridescent blue and blood red. His figures have regained their relationship to the landscape around them to such extent they appear an organic extension of the scene around them. The painting of his garden at Vétheuil with the youngest children and Alice in the background is particularly delicately constructed with a fineness and lightness that had been missing from his work of the preceding winter.

PAINTED

Vétheuil

MEDIUM

Oil on canvas

SERIES/MOVEMENT/PERIOD

Impressionist

SIMILAR WORKS

Pere Melon Sawing Wood, Pontoise, Camille Pissarro, 1879

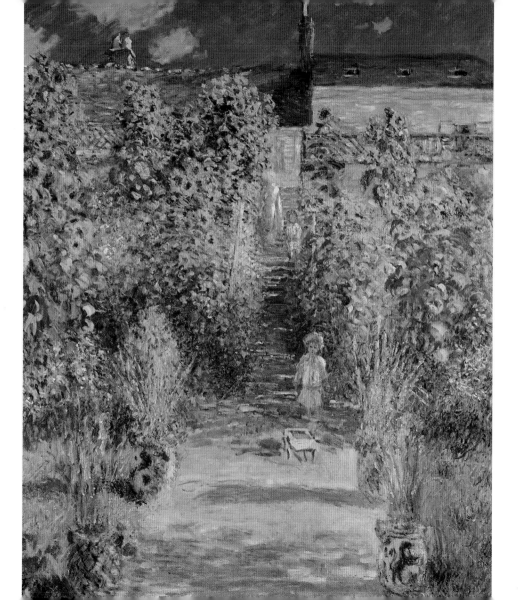

Vase of Flowers, c. 1881–82 (detail)

Shortly after Camille's death and sporadically over the next two years Monet began to paint still-life compositions. Also during this period he was spending more time painting indoors in his studio, and was typically finishing his landscapes indoors. Monet's still-life paintings, which reflect the artist's great affinity with colour, were largely of fruit and flowers and particularly beautiful. They were also small works, which had a greater chance of selling, and yet again money was at the forefront of Monet's concerns, although by 1882 his accounts show that he was again making money.

In 1880 Monet again submitted to the Salon, this time with two paintings, *Sunset on the Seine at Lavacourt* and *Break Up of the Ice near Vétheuil*. The sunset painting was the only one accepted and then, in a slight to the artist's ego, was exhibited high up and in an inferior location. The following year the artist moved to Poissy, which he wrote left him feeling uninspired. Despite this 1882 was a productive and profitable year for the artist, who painted a number of coastal scenes along the Normandy coast.

PAINTED

Poissy

MEDIUM

Oil on canvas

SERIES/MOVEMENT/PERIOD

Impressionist

SIMILAR WORKS

Still Life with Anemones, Pierre Auguste Renoir

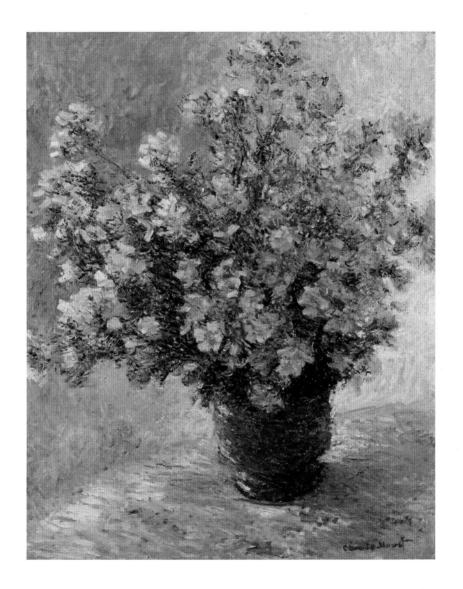

Road at La Cavée, Pourville, 1882

When Monet moved to Poissy, Alice Hoschedé and her six children moved with him, while her husband continued to live a bachelor life in Paris. Their move together to Poissy placed their relationship on an altogether different level, one that caused consternation amongst the locals.

Uninspired by the small industrial town, Monet left Alice there and embarked on a series of painting trips along the Normandy coastline, spending much of his time in Pourville, where he painted a large number of canvases, including *Road at La Cavée* with its wonderfully ominous, brooding sky. The same year he reluctantly took part in the seventh Impressionist Exhibition, submitting 35 canvases. The exhibition was received with cautious positivity and Monet's seascapes in particular were singled out for praise.

Despite his productivity at Pourville, the artist suffered bouts of deep anxiety, particularly in the winter of 1882 when he wrote to Durand Ruel, 'Doubt has overtaken me, I think I'm lost and can do nothing more.' The following spring he wrote again, 'I am going to travel around until I find a house and a landscape that suits me.'

PAINTED

Pourville

MEDIUM

Oil on canvas

SERIES/MOVEMENT/PERIOD

Impressionist

SIMILAR WORKS

Woman with Parasol, Pierre Auguste Renoir, 1875

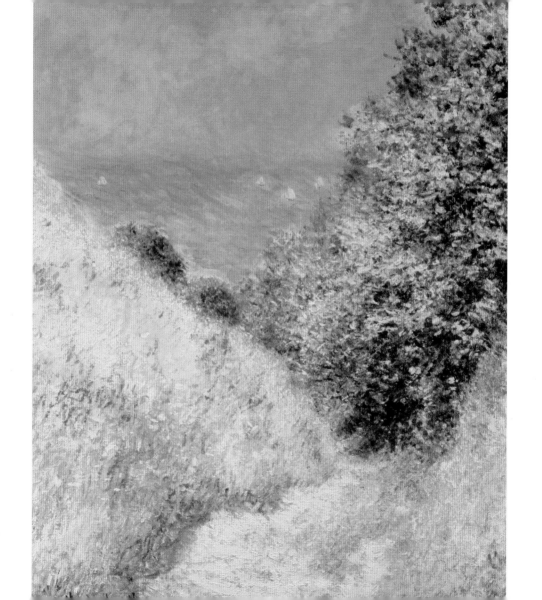

Self-portrait with a Beret, 1886

Private Collection/Photo © Lefevre Fine Art Ltd., London/The Bridgeman Art Library

In March 1883 Durand Ruel organized a one-man show for Monet, exhibiting many of his recent coastal scenes. At first the show was poorly received, but later opinions turned with the critic Armand Silvestre claiming it a triumph. The following month Monet moved his extended family to Giverny, where he would live the rest of his life.

He converted an old barn at his new house into a studio and it quickly became a welcome place for visitors including the poet and critic Stéphane Mallarmé (1842–98). Between 1883 and 1886 Monet travelled extensively, to the Mediterranean with Renoir and to the beautiful town of Bordighera, which he revisited, and frequently to the Normandy town of Etretat. In the spring of 1886 he spent 10 days painting in Holland, accompanied by Alice's daughter, Blanche. On his return to Giverny, Monet painted his first self-portrait, a rather serious image, but one of astonishing depth and breadth. Although quite a departure from his style and not an approach he took up, the work demonstrates his great draftsmanship and is full of life and vigour.

PAINTED

Giverny

MEDIUM

Oil on canvas

SERIES/MOVEMENT/PERIOD

Self-portrait

SIMILAR WORKS

Self-portrait, Gustave Caillebotte, *c.* 1889

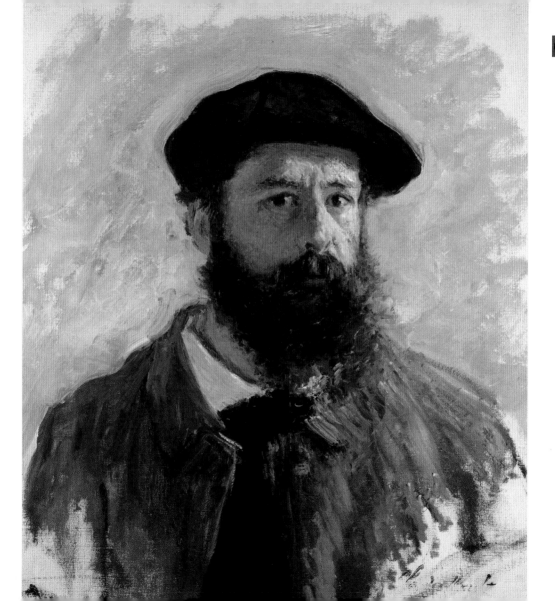

Haystack at Giverny, 1886

The decade between Monet's Gare St Lazare series and his *Haystack at Giverny* painting was one of upheaval, bereavement, financial struggle and the establishment of political stability under the Republican regime. Monet had finally come to be grudgingly accepted by the critics and was gaining a reputation as one of the leading landscape artists of the time. In the summer of 1884 Monet started to paint landscape scenes around Giverny that were reflective of the paintings he had produced from his travels to the Mediterranean at the end of 1883.

Haystack at Giverny, with the brilliant use of colour suggestive of the rolling fields of poppies and the strong horizontal planes with vertical accents, typifies Monet's treatment of his landscape subjects at this time. The scenery of Giverny was to provide him with the perfect quality of light and the topographical framework to evolve his continuing treatment of light and atmosphere. It gave him a subject that he was to return to in the 1890s with his famous haystack series, dedicated to the visualization of reflective light through different periods of the day.

PAINTED

Giverny

MEDIUM

Oil on canvas

SERIES/MOVEMENT/PERIOD

Impressionist landscape

SIMILAR WORKS

The Haystack, Pontoise, Camille Pissarro, 1873

Haystacks at Moret, Morning, Alfred Sisley, 1891

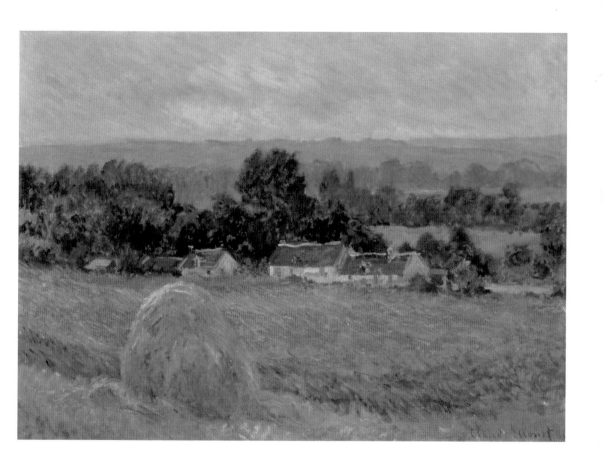

The Boat at Giverny, c. 1887

Having turned away from including figurative elements in his landscape painting for some years, in 1886 Monet began to reintroduce them, most notably in two paintings of Alice's daughter Suzanne. The impetus for this change is unclear, but it may possibly have been connected to the increasing stability he felt with his 'new' family, who now provided the focus that had previously been centred on his first wife Camille.

In 1887–88 he painted at least six large canvases depicting Alice's daughters boating, a return to one of Monet's earlier subjects undertaken at Argenteuil. The Giverny paintings are quite different, however, both stylistically and in structure. Here the artist presents the figures as individuals rather than shadowy, light-bathed silhouettes, and they take on the fullness of a living entity. The composition, and that of the other boating paintings, with its oblique angles and intense colours, reveals the influence of Japanese woodcuts. Monet admired these Oriental works and had quite a collection of authentic Japanese works. This painting is almost Symbolist in its dreamy, ethereal atmosphere and gives the impression of an enclosed and private world.

PAINTED

Giverny

MEDIUM

Oil on canvas

SERIES/MOVEMENT/PERIOD

Impressionist

SIMILAR WORKS

Three Women in a Boat Fishing by Moonlight, Utagawa Toyokuni, before 1825

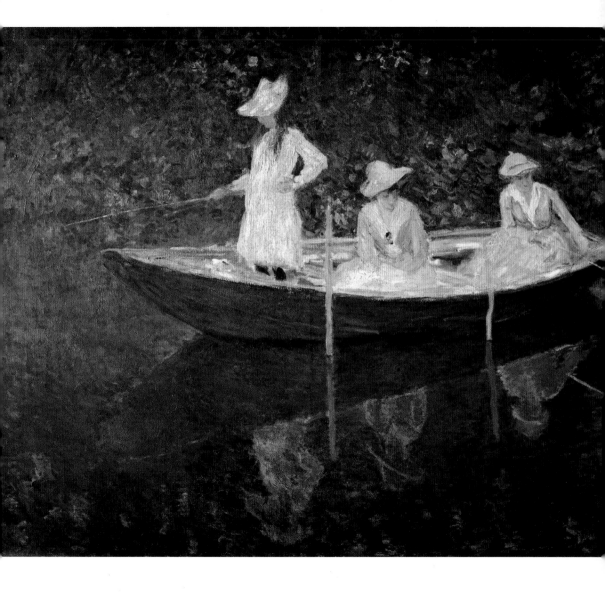

The Old Fort at Antibes, 1888 (detail)

Monet declined to exhibit in the eighth Impressionist Exhibition in 1886, having realized that the group was disseminating and that his style was moving in a different direction from that of the others. It was also the year of his American debut through the efforts of Durand Ruel, who organized an exhibition of Impressionist works in New York. Around the same time Monet began to exhibit with Georges Petit (1856–1920), another and rival dealer to Durand Ruel, selling a number of paintings to Theo Van Gogh (1857–91), younger brother to Vincent (1853–90), who worked for the dealers Boussod and Valadon (formerly Goupil's).

This painting was one of 10 painted at the sun-bathed Antibes on the Côte d'Azure, bought by Theo and exhibited at the Boussod and Valadon Gallery off Boulevard Montmartre. The exhibition received a mixed reaction, and was bitterly criticized by Pissarro, who had turned to Neo-impressionism and considered Monet's Antibes paintings to be superficially decorative without expressing the nuances and harmony of nature at a more fundamental level. These paintings, however, sold well and are beautifully worked and so delicately coloured that they appear almost as pastels.

PAINTED

Antibes

MEDIUM

Oil on canvas

SERIES/MOVEMENT/PERIOD

Antibes

SIMILAR WORKS

Landscape, Armand Guillaumin, c. 1872

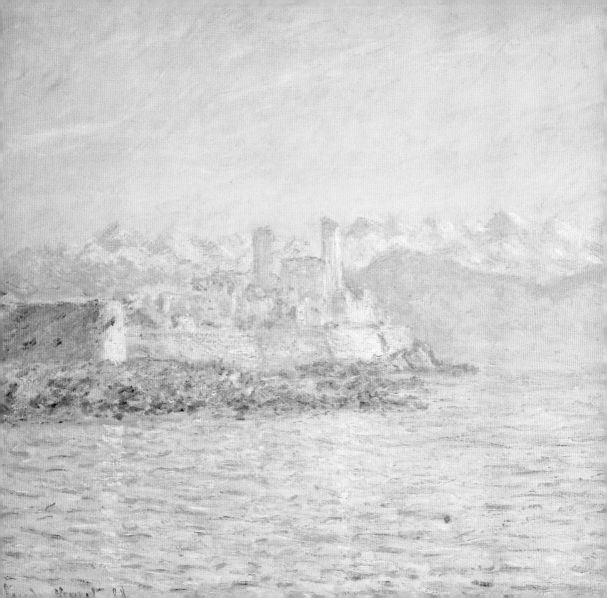

Chrysanthemums, c. 1897

The 1890s saw new developments for Monet, who ceased to paint his family in landscape backgrounds and concentrated all his efforts instead on producing monumental series paintings. Through these he was able to take a single motif and experiment with the effects of light and colour through the changing time of the day or the season. Rather than direct representations of the passing moment, these images transcended reality to become the artist's own interpretation of the natural world before him.

In 1890 he was finally able to buy the rented house and garden in Giverny and, as a further mark of stability, Alice and Monet were married in 1892. He was financially secure and had achieved public acclaim through his giant series paintings.

The garden at his house in Giverny was Monet's great passion, especially towards the end of his life. He employed a number of gardeners and designed his garden according to colour and contrast, as though it were a painting. *Chrysanthemums* is a study of just such colour and contrast, with the natural world reduced to an abstract pattern.

PAINTED

Giverny

MEDIUM

Oil on canvas

SERIES/MOVEMENT/PERIOD

Post-impressionist

SIMILAR WORKS

The Little Gate of the Old Mill, Henri Matisse, 1898

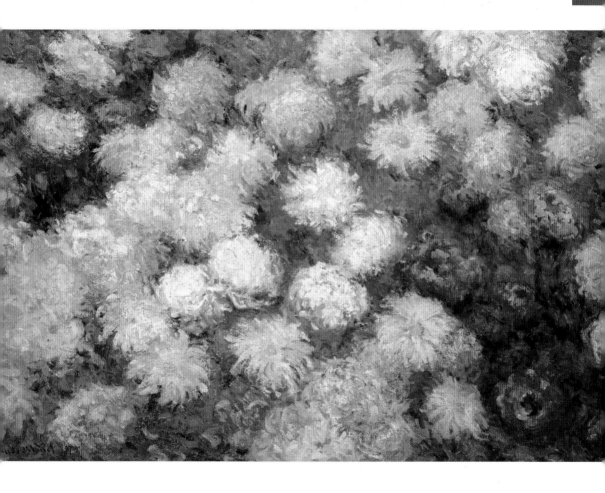

The Water Lily Pond with the Japanese Bridge, 1899 (detail)

The end of the 1890s were marred by tragedy for Monet, though this was not apparent in his tranquil, quiet paintings of his beloved water lily pond in the garden at Giverny. In 1898 Monet's good friend and supporter Stéphen Mallarmé died, and at the end of year Sisley, who had been friends with Monet for nearly 40 years, developed throat cancer. Sisley died in January 1899 and Monet later organized an exhibition and sale of his works to raise funds for his family. Further disaster struck when Alice's daughter Suzanne died suddenly, aged just 30. It was a devastating blow to Monet and his wife, who never recovered from the grief.

From out of this despair, Monet painted his exquisite canvases based on his water lily pond and the wooden Japanese bridge that he had had constructed in 1895 (Monet had long been an admirer of Japanese woodcuts and design). He first painted his water lilies in 1897, but in 1899 he produced a series of 18 contemplative works of the lilies and the bridge, each demonstrating his unsurpassed skills as a colourist.

PAINTED

Giverny

MEDIUM

Oil on canvas

SERIES/MOVEMENT/PERIOD

Water lily series

SIMILAR WORKS

Footbridge over River with Wisteria in Foreground in Full Bloom, Ando of Utagawa Hiroshige, 1856

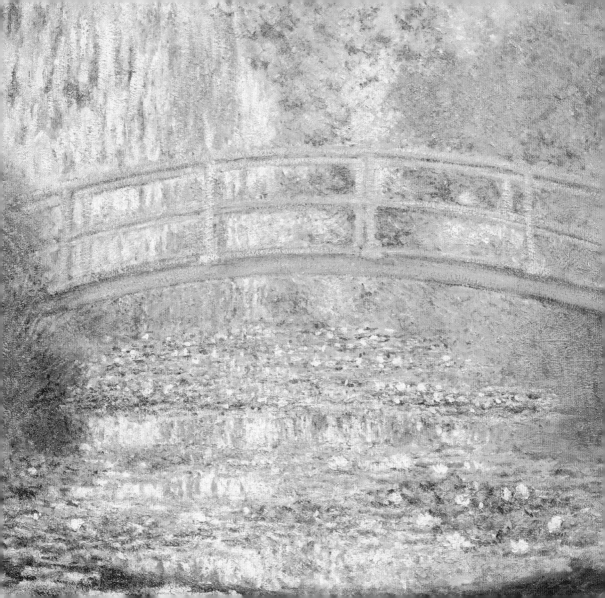

Printemps à Giverny, 1903

In 1887 Monet had travelled to London, spending two weeks with James Abbott McNeil Whistler (1834–1903), and in 1889 the exhibition *Impressions by Claude Monet* opened in London at the Goupil Gallery. Monet's work was received well and his influence on Whistler was noted in the reviews. He returned to London in the winter of 1899 to paint the curling, dense fog that characterized the city at this time, and made repeated trips to the British capital over the next few years, maintaining an exhausting level of production.

Printemps à Giverny was painted in his peaceful garden at Giverny. He had finished his massive London series, an undertaking that produced close to 100 paintings from 1899 to 1903, and was close to exhaustion. The garden at Giverny, which the artist had lovingly created since he first moved there in 1883, would now become one of the few subject matters to preoccupy him. His increasing use of broad brushstrokes and creation of brilliant sunlight are seen in *Printemps à Giverny*, as he perfects capturing the essence of the fleeting moment.

PAINTED

Giverny

MEDIUM

Oil on canvas

SERIES/MOVEMENT/PERIOD

Garden at Giverny

SIMILAR WORKS

The Poplar Avenue at Moret, Alfred Sisley, 1888

Verger en Fleurs, Matin de Printemps, Pierre Prins, 1878

The Doge's Palace in Venice, 1908

Monet and Alice travelled to Venice for the first time in October 1908. Venice had been the destination of the eighteenth-, nineteenth- and early twentieth-century landscape masters, amongst whom were Turner, Richard Parkes Bonnington (1802–28), Whistler, Renoir, Manet, John Singer Sargent (1856–1925) and Paul Signac (1863–1935). It is not insignificant that Ruskin's *The Stones of Venice* had been printed in French translation in 1906, sparking an even greater interest in the city of artistic treasures.

The Monets stayed in some style in the Palazzo Barbaro, which was ideally located and provided the artist with excellent views of the Grand Canal. He started a number of canvases, although he returned home with many of them unfinished. His sketches allowed him to work up the paintings at a later date, in a similar way to his London series. *The Doge's Palace in Venice* offers an interesting perspective of the building, suggesting that the artist may have been close to the water in a boat, looking across and up. The clarity with which the reflective light is rendered is typical of his later painting technique.

PAINTED

Venice

MEDIUM

Oil on canvas

SERIES/MOVEMENT/PERIOD

Impressionist Venice

SIMILAR WORKS

Canal in Venice, Hercules Brabazon, *c.* 1890

The Grand Canal, Venice, James Holland, 1835–55

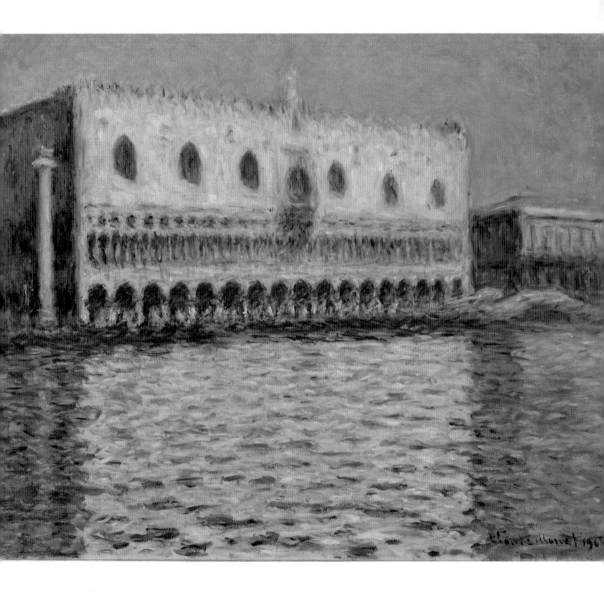

Water Lilies and Agapanthus, 1914–17

In the first few years of the 1900s Monet developed a passion for motorcars. When not painting, he would take Alice on day trips to try to console her following the death of her daughter. In 1904 the pair travelled to Madrid for the first time, where Monet admired the paintings of Diego Velásquez (1599–1660).

Monet was mostly occupied at this time with painting his garden and lily pond. It was of great distress to the artist when, in the winter of 1910, the Seine broke its banks and flooded the pond. As the waters receded, mud and rotten plants covered his idyll, but just months later Alice wrote that the garden paradise had been restored. She had become ill before the flood and died in the spring of 1911, leaving Monet devastated. With tragedy chasing tragedy, Monet's sight began to fail and in 1914 his son Jean also died.

This painting was done during these difficult times, but tells little of Monet's emotional state. His abstraction has increased, the plants reduced to fluid geometric shapes, shot through with pale purple, delicate yellows and powder blue.

PAINTED

Giverny

MEDIUM

Oil on canvas

SERIES/MOVEMENT/PERIOD

Garden at Giverny

SIMILAR WORKS

Lake in the Mountains, Achille Emile Othon Friesz, 1907

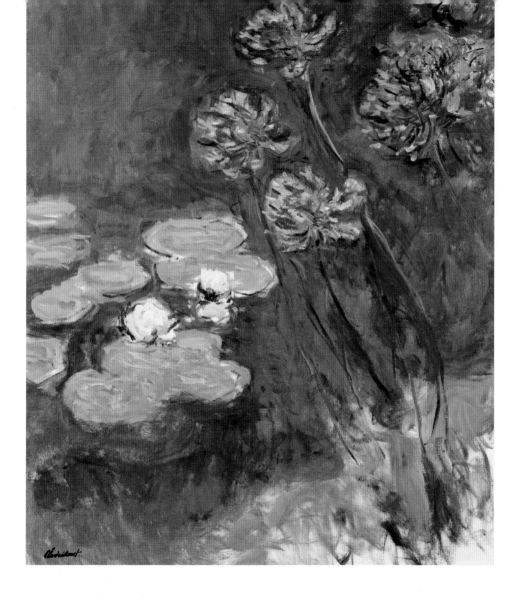

Claude Monet

Water Lilies: The Japanese Bridge, or Japanese Bridge at Giverny, c. 1923

The elderly Monet was devastated by the death of his wife Alice, who had long been the centre of his life, running his business affairs and providing him with endless support. He was further knocked by his loss of vision in 1912 and the death of his son in 1914. The deterioration of his eyesight was horrifying to the artist, who wrote, 'I realized with terror that I could see nothing with my right eye ... a specialist ... told me that I had a cataract and that the other eye was also slightly affected. It's in vain that they tell me it's not serious, that after the operation I will see as before. I'm very disturbed and anxious.' In 1923 he was operated on three times to try and correct his right eye.

The brilliant fiery reds and yellows of *Japanese Bridge at Giverny* are indicative of the impaired sight of the artist, seeing his bridge within a reduced palette. Yet it is the most evocative sum of colour and light and composition, creating an overall startlingly emotive effect.

PAINTED

Giverny

MEDIUM

Oil on canvas

SERIES/MOVEMENT/PERIOD

Water lily series

SIMILAR WORKS

Rocks and Branches a Bibemus, Paul Cézanne, 1900–04

Study for a Sluice, Wassily Kandinsky, 1901

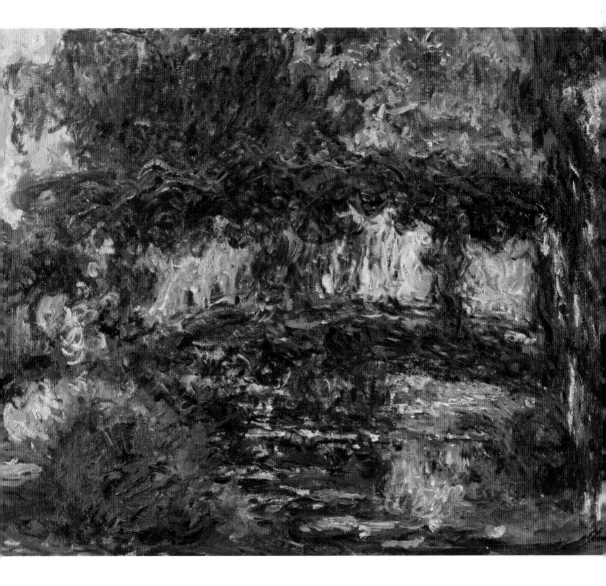

Portrait of Claude Monet in front of his paintings, 'The Water Lilies', in his studio at Giverny, c. 1922

The declaration of war in August 1914 brought with it a mass exodus of Parisians from the capital. Monet's stepson, Jean Pierre Hoschedé, and his own son, Michel, were called up and Monet saw his family steadily disappearing from him, leaving just his daughter-in-law to look after him. Typically of Monet, his paintings never revealed his despair. He embarked on a massive project, the *Grandes Décorations*, a huge series of studies of his pond and water lilies and a vast undertaking in both numbers and scale. The paintings were executed with great strokes, the actual rendering of the paint adding to the rhythm and flow of the pictures. The water lilies are suggested, hinted, captured on canvas by colour and light, and it is the depths of the water beneath them that create the biggest impact.

Henri Manuel (*fl.* 1900–38) sets the artist in the context of his pictures through his studio photograph. The elderly Monet is dwarfed by the sheer magnitude of his paintings, their physicality and the enormous significance of their legacy to modern art.

PAINTED

Giverny

MEDIUM

Black and white photograph

SERIES/MOVEMENT/PERIOD

The artist in his studio

SIMILAR WORKS

Monet's Studio, The Grandes Décorations photograph, Paul Durand Ruel, 1917

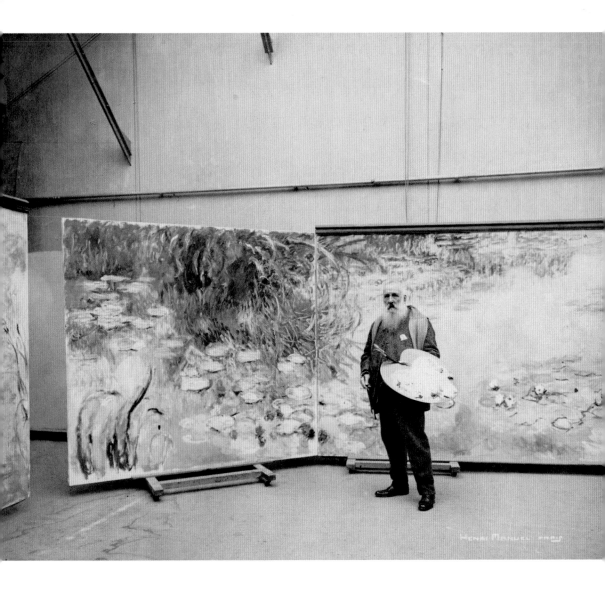

Water Lilies Series
in the Orangerie, Paris

The atrocities of the First World War I (1914–18) took their toll on Monet. Alice's daughter Blanche, herself a painter, took over Monet's care while he threw himself into the production of his giant water lily canvases. He had a new, huge studio built to house the works that would form a giant decorative scheme, and he worked relentlessly on the paintings that projected an alternative, beautiful world, one far removed from reality.

In 1917 Monet's friend, the politician Clemenceau, was elected Prime Minister of France (for the second time) and told Monet that the State would purchase 12 of the monumental paintings and house them in a specially designed building. Clemenceau was not re-elected in 1920, but the commission continued and, after extensive communications, it was decided to adapt the Orangerie in the Tuileries to create the space required to display Monet's works. In early 1926 he told Clemenceau he was 'waiting for the paint to dry'. On 5 December 1926 the artist died. The canvases were taken from his studio and the Orangerie was opened to the public in May 1927.

PAINTED

Giverny

MEDIUM

Oil on canvas

SERIES/MOVEMENT/PERIOD

Water lily series

SIMILAR WORKS

Gourds, John Singer Sargent, 1905

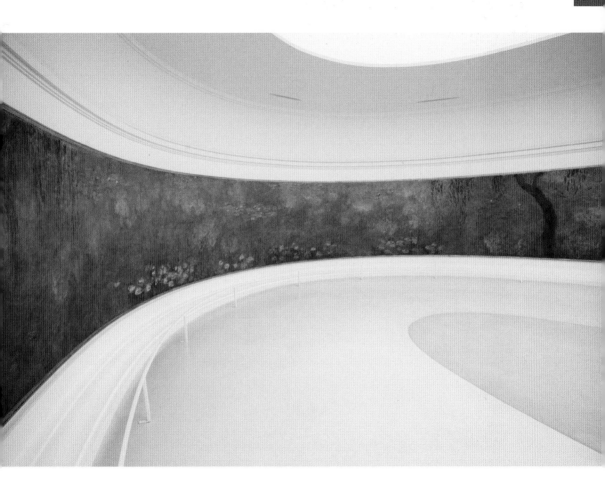

Monet

Society

A Farmyard in Normandy, c. 1863

Monet was 11 years old when Louis-Napoleon's (1808–73) *coup d'etat* demolished the Republic in 1851, ushering in a new era of glittering wealth. His childhood in Le Havre unfolded against a backdrop of regeneration in France that saw the rise of the bourgeoisie (the wealthy middle classes), rapid economic expansion and the development of France into a capitalist, consumerist society. The pursuit and the acquisition of art became fashionable pastimes, and it was in this spirit that the young Monet first received drawing lessons.

His skill as a draftsman was quickly apparent through his witty and searing caricatures. A painting trip with Eugène Boudin (1824–98) introduced him to the practice of *plein air* painting and the natural world. The influence of Boudin, along with that of Charles Daubigny (1817–78) and Edouard Manet (1832–83), is clearly present in his early landscape painting, *A Farmyard in Normandy*. The painting reveals Monet's individualism through his use of strong vertical and horizontal lines, contrasted with the flat, luminous pond producing a faint abstract effect.

PAINTED

Normandy

MEDIUM

Oil on canvas

SERIES/PERIOD/MOVEMENT

Early

SIMILAR WORKS

The Return from the Market, Constant Troyon, c. 1855

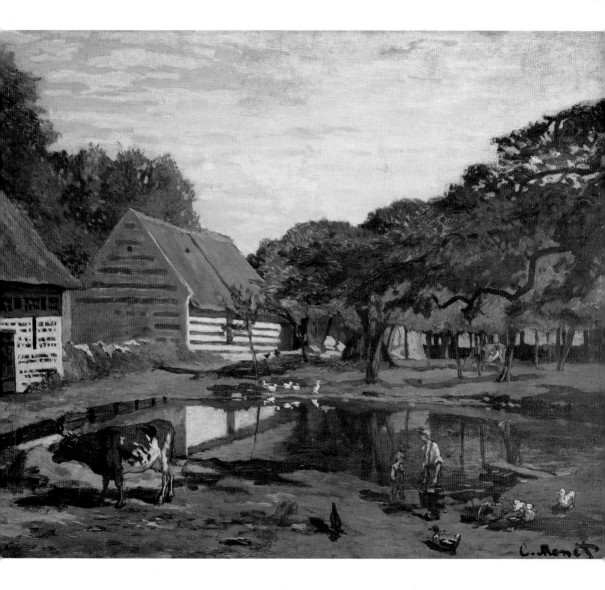

The Quai du Louvre, 1866–67

During the years of the Second Empire, Paris was undergoing a transformation that would project an image of glittering affluence. The capital city became a Mecca for artists and artisans, for labourers, workers and all those from the rural environs who were seeking a new and better life. It was the hub of all significant activities and paraded, at least by Napoleon III, as the jewel of modern endeavour. The expanding middle classes had more time to spend on leisure pursuits, parading the town, boating and swimming, all of which were painted by the artists of the day.

Monet spent most of the 1860s living in the city, although he travelled out on painting excursions, particularly to the Normandy coastline and to the forest of Fontainebleau. His paintings of Paris are marked by their sense of pattern across the picture surface and his disinterest in the specifics of individual people. His figures populate his canvas, as seen here, for a greater end, for structure, colour and aesthetics, but the people themselves are unidentifiable.

PAINTED

Paris

MEDIUM

Oil on canvas

SERIES/PERIOD/MOVEMENT

Early

SIMILAR WORKS

Quai de la Gare, Snow Effect, Armand Guillaumin, c. 1875

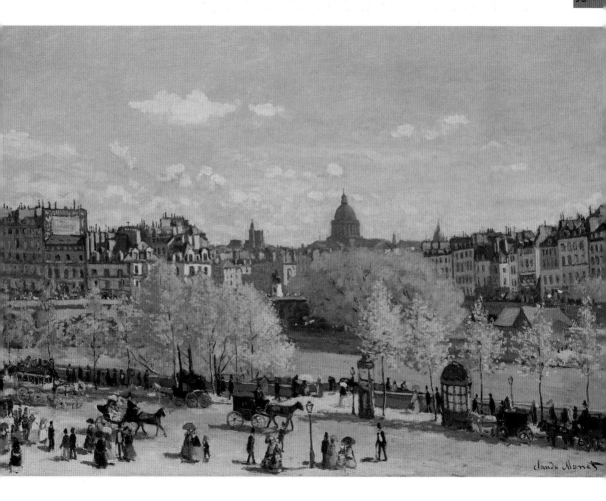

Claude Monet

Portrait of Madame Louis Joachim Gaudibert, 1868

© Musée d'Orsay, Paris, France, Lauros/Giraudon/The Bridgeman Art Library

Louis Joachim Gaudibert was a successful industrialist from Le Havre, who paid for Monet to live in a chateau near Le Havre to undertake portrait commissions for his family. This was fortuitous timing for Monet, who had just been evicted from his lodgings in Bennecourt on the Seine and was virtually destitute. He wrote to his friend Frédéric Bazille (1841–70), 'Thanks to this gentleman in Le Havre who has come to my aid, I enjoy the most perfect tranquillity, since I am free from all worries, so I'd like to remain always in this situation in a corner of nature as tranquil as this.'

The portrait of Mrs Gaudibert is unusual in its composition. By painting the subject facing away from the painter, he chose a pose that arguably defeats the purpose of portraiture. The emphasis is placed on the dress of the subject instead of the subject herself. The movement through the fabric, of her body and hands, suggests that she has just turned, giving the picture a photographic snapshot feel and the immediacy of the moment.

PAINTED

Le Havre

MEDIUM

Oil on canvas

SERIES/PERIOD/MOVEMENT

Impressionist, portrait

SIMILAR WORKS

Arrangement in Black, No. 2: Portrait of Mrs Louise Huth, James Whistler, 1870–72

Kate Perugini, Sir John Everett Millais, 1880

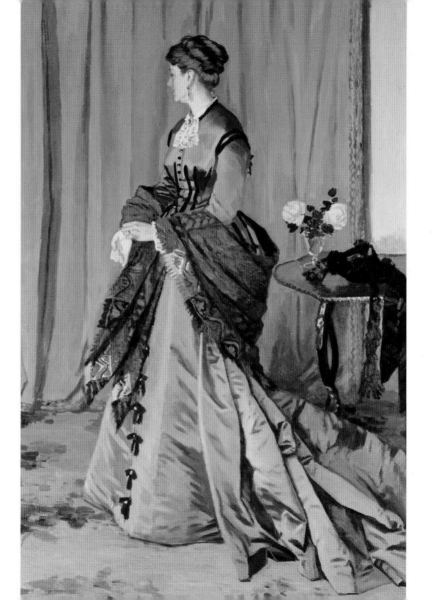

The Dinner, 1868–69 (detail)

The Salon, first held in 1725, was the annual art exhibition of the Académie des Beaux-Arts in Paris, and was the most respected exhibition throughout the Western world. To have works on show at the Salon was a mark of acceptance by the art establishment, spelling success for artists and helping to secure commissions and wealthy patrons. The Salon jury was overwhelmingly conservative and flatly rejected the work of the Impressionists and avant-garde artists.

Monet began his long career with two canvases being accepted in 1865. By the following year he had embarked on the mammoth *Picnic*, a new approach to painting contemporary life and the beginning of his deviation from mainstream art. He would have only three more pictures accepted by the Salon.

By the end of 1867 Camille had given birth to Monet's son, Jean, and the family were in desperate financial shape. Rejection from the art establishment had increased the importance of the support and acceptance that family provided for Monet. *The Dinner* shows the close family unit during the communal ritual of the evening meal. Monet was to paint the family group again in *The Luncheon*, an intensely personal painting of his family; the artist's chair is significantly empty, awaiting his return.

PAINTED

Le Havre

MEDIUM

Oil on canvas

SERIES/PERIOD/MOVEMENT

Impressionist, interior

SIMILAR WORKS

Luncheon in the Studio, Edouard Manet, 1868

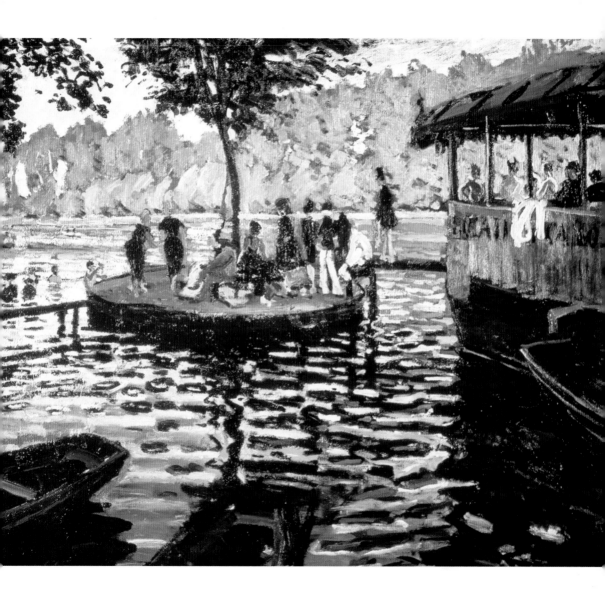

The Beach at Trouville, 1870

In 1869 the working classes were swelling with resentment against the emperor resulting in a huge demonstration in January 1870. Against this, Monet continued to paint his charming depictions of the middle class at leisure. In June of that year Monet married Camille against fierce opposition from his family and the couple travelled to Trouville for the summer months. Boudin had had great success with his paintings of Trouville, which was a popular holiday destination, and Monet no doubt wished to follow suit. It was during that summer that Napoleon III declared war on Prussia, after which Monet fled to London.

The spatial arrangement of *The Beach at Trouville* is unusual, having a frieze-like structure with the figures pressed up into the foreground and a wide, virtually empty background, with a distinct lack of middle ground. The two people, probably Camille and a nanny, are typical in their lack of interaction with each other. Monet's figures invariably exist as contained within their own world, irrespective of those around them.

PAINTED

Trouville

MEDIUM

Oil on canvas

SERIES/PERIOD/MOVEMENT

Impressionist

SIMILAR WORKS

The Harbour of Lorient, Brittany, Berthe Morisot, 1869

Beach at Trouville, Eugène Boudin, 1863

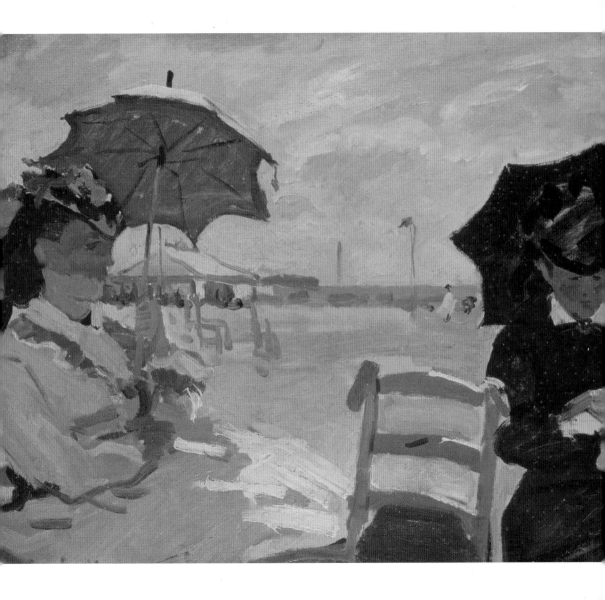

Infantrymen of the Flanant Guard on the Water, 1870

Private Collection/Photo © Christie's Images Ltd/The Bridgeman Art Library

Monet spent the summer of 1870 in Trouville with Camille and his young son Jean, painting France's fashionable middle classes as they paraded the picturesque town. Trouville, just across the Seine estuary from Monet's hometown Le Havre, was a lively and buzzing resort. Monet's paintings of that summer reflect nothing of the political strife that was unfolding in the capital.

This lonely, rather desolate scene is one of the very few references Monet made to France's war against the Prussians, a war that was quickly over as the French fell beneath the superior Prussian powers. It is a strangely surreal scene with the small, dark figures incongruous against the muted landscape. The strongly geometric structure of the composition adds to the abstract feel of the scene along with a sense of displacement and isolation. In order to avoid being called up and the atrocities of war, Monet and his family left France just before the Siege of Paris and fled to London. It was a time of personal tragedy for Monet, whose close friend Bazille was killed in action.

PAINTED

Normandy

MEDIUM

Oil on canvas

SERIES/PERIOD/MOVEMENT

Impressionist

SIMILAR WORKS

Snow in Louveciennes, Alfred Sisley, 1878

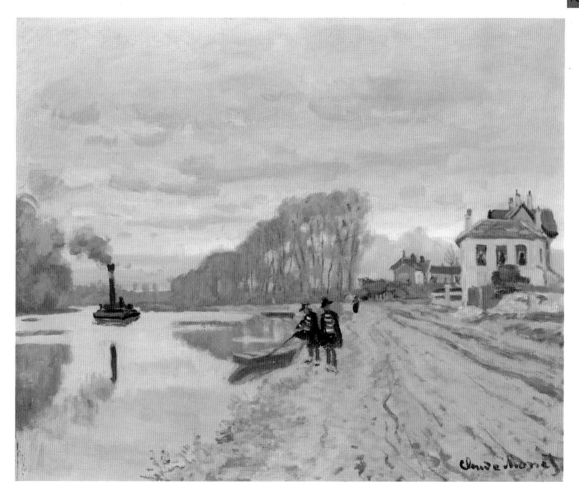

The Hotel des Roches Noires at Trouville, 1870

Monet and Camille had married in June 1870 with Gustave Courbet (1819–77) serving as one of the witnesses. Just a few days later Monet's beloved aunt died and, shortly after, Monet, his new wife and son moved to Trouville for the summer months.

It is possible that Monet was influenced in this move by his friend Boudin, who had painted the fashionable resort town a number of times with some success. Unlike Boudin, who tended to place his figures grouped on the sweeping beach with the sea in the background, Monet chose to depict the town with its newly regenerated buildings and bustle of cosmopolitan life. His painting of the Hotel des Roches Noires with its bold, but light colouring and strong structural composition is a work of light and movement, striking in its originality. With just a few brushstrokes Monet has caught the flags fluttering in a strong sea breeze as dappled light falls across the promenade below. The figures wrought with minimal brushstrokes are animated, particularly the gentleman who raises his hat in the foreground.

PAINTED

Trouville

MEDIUM

Oil on canvas

SERIES/PERIOD/MOVEMENT

Impressionist

SIMILAR WORKS

La Rue Mosnier, Edouard Manet, 1878

Beach Scene near Trouville, Eugene Boudin, c. 1863–66

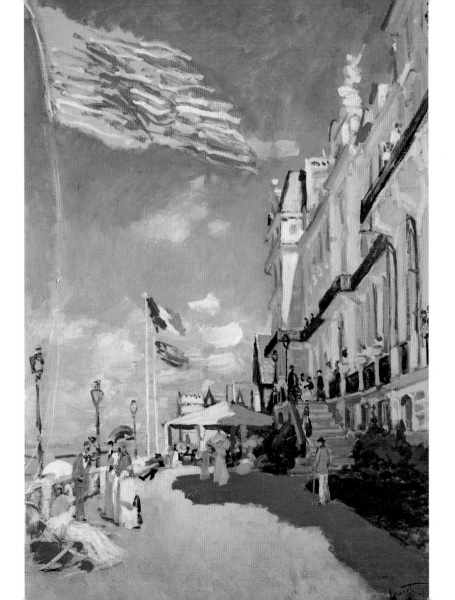

The Marina at Argenteuil, 1872

Monet spent around seven months in London from 1870–71 while the Franco-Prussian war raged in France, followed by the bloody Paris Commune that saw an uprising of the working classes. Monet was one of many French artists who arrived in London to escape the atrocities, including his friends Camille Pissarro (1830–1903), Boudin and Daubigny. While in London Monet met Paul Durand Ruel (1831–1922), a picture dealer who would become his most loyal supporter and buyer.

On his return to France he moved to Argenteuil into a house rented to him by friends of Manet. He would spend the next seven years in the bustling town on the Seine, a period considered the height of Impressionism. This painting with the striking linear shadows of the trees is full of life and atmosphere evoked through Monet's dazzling use of fragmented brushstrokes and light touch of colour. It is not an exact representation of the scene (he reduced the number of arches in the bridge and raised the height of the tollbooths), but is instead a painting of a moment, of an impression of a scene.

PAINTED

Argenteuil

MEDIUM

Oil on canvas

SERIES/PERIOD/MOVEMENT

Impressionist

SIMILAR WORKS

The Seine at Argenteuil, Alfred Sisley, 1872

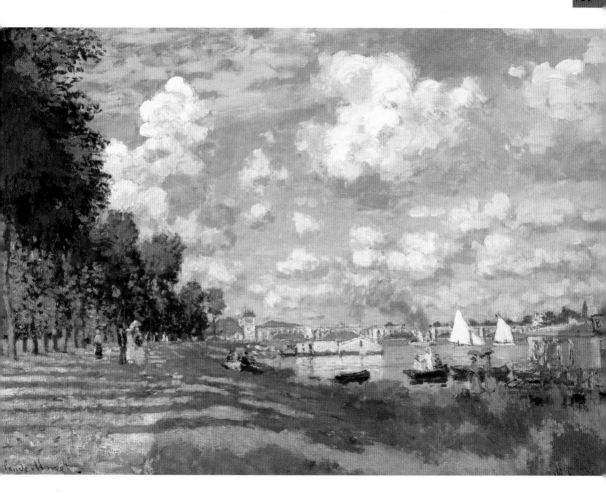

The Fourteenth of July, Argenteuil, 1872 (detail)

Bastille Day, celebrated annually on 14 July is a French national holiday to celebrate the storming of the Bastille in 1789. The prison, which represented royal power, was ransacked by the people, a key event in the French Revolution. The day is recognized as pivotal in the emergence of the new, modern France and represents a unification of the French people.

For artists it has long been a subject matter for immortalizing in paint, and Monet and his contemporaries were no exception. In this painting by Monet, the figures have been reduced to mere daubs and strokes of paint, merging into each other and so emphasizing the sense of unity and collaboration. It is an approach also seen in the painting *Boulevard des Capucines* (1873) where again his figures are a mass of dark, indiscriminate brushstrokes that nevertheless come alive on the canvas. In *The Fourteenth of July* he used a restricted palette, the figures tonally dark, contrasting light, while above their heads flutters a single line of red, white and blue flags.

PAINTED

Argenteuil

MEDIUM

Oil on canvas

SERIES/PERIOD/MOVEMENT

Impressionist

SIMILAR WORKS

The Grand Boulevards, Pierre-Auguste Renoir, 1875

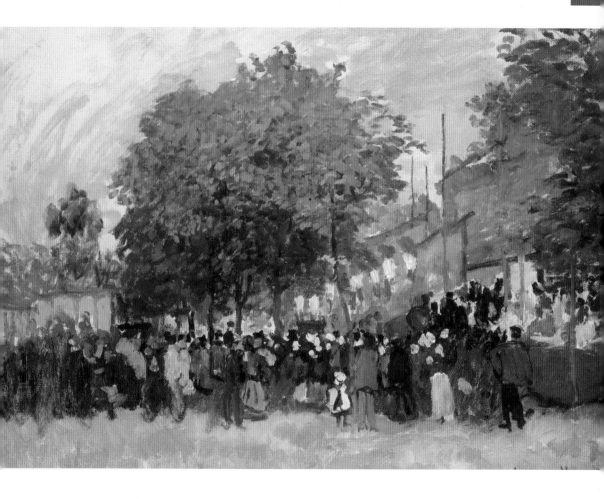

Promenade near Argenteuil, 1873

During this period Argenteuil was experiencing a period of enormous growth as Parisians sought to move to the suburbs. Monet documented the town at different times of the day and under different weather conditions. Any aspects of the modernization process that he depicted, he transformed into something of beauty and harmony. He continued to paint pictures of light and beauty, ignoring the political and social violations of the time. Both Emile Zola (1840–1902) and Théophile Gautier (1811–72) expressed surprise that paintings in the Salon of 1872 (which did not include Monet's) made no references to the atrocities that had occurred in Paris and the surrounding areas during the bloodbath of 1871.

During 1872 and 1873 Monet enjoyed an upturn in his finances. He was able to provide a comfortable home and living for his family in Argenteuil and paintings such as *Camille in the garden with Jean, and his Nursemaid* (1873) reflect this. *Promenade near Argenteuil* is a typical painting of this period for Monet. The contented family group, probably based on his own, is enjoying a sunny day in beautiful countryside.

PAINTED

Near Argenteuil

MEDIUM

Oil on canvas

SERIES/PERIOD/MOVEMENT

Impressionist, Argenteuil

SIMILAR WORKS

The Fields, Alfred Sisley, 1874

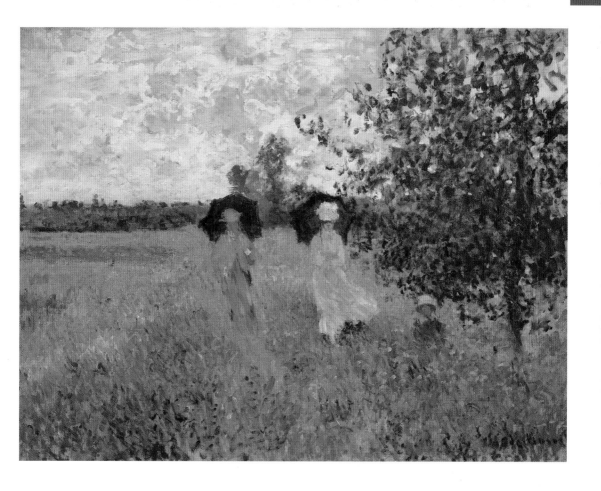

The Coal Workers, 1875 (detail)

The Coal Workers is unusual in that it is the only painting Monet executed showing people in an industrial context. However, he has removed the human element by focusing on the pattern and arrangement of the scene rather than the workers themselves. The figures on their planks are reduced to anonymity and become simply a decorative element within the composition. In 1875 an auction was held at the Hotel Drouot in which Monet, Berthe Morisot (1841–95), Alfred Sisley (1839–99) and Renoir sold off their works. *The Coal Workers* was bought by a banker, but the overall outcome of the auction was very poor. The event was derided in the press and marked the beginning of an eight-year period of severe financial difficulties for Monet.

Monet rarely used active industry as the primary subject for his paintings, with the exception of his *La Gare St Lazare* pictures of the late 1870s. He did, however, enjoy the juxtaposition of structural or industrial elements within the natural environment, using the structures to create an often abstract surface pattern.

PAINTED

Asnières

MEDIUM

Oil on canvas

SERIES/PERIOD/MOVEMENT

Impressionist

SIMILAR WORKS

The Coast of Kujukuri in the Province of Kazusa, Utagawa Hiroshige, 1853–56

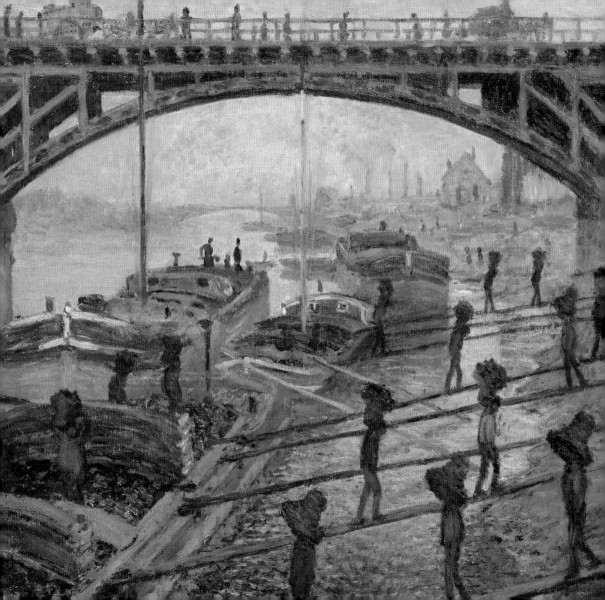

The Locomotive, 1875

Musée Marmottan, Paris, France/Giraudon/The Bridgeman Art Library

Continuing rejection by the Salon and increasing financial difficulties led Monet and a band of his friends – Monet, Renoir, Boudin, Sisley, Pissarro, Paul Cézanne (1839–1906), Edgar Degas (1834–1917) and Berthe Morisot along with others – to stage their own exhibition in 1873. The *Société Anonyme des Artistes* staged their first exhibition in 1874. The exhibition was unsuccessful with poor attendance and acerbic reviews.

Monet spent the winter of that year depicting Argenteuil under a blanket of snow, all details reduced to the pale, glowing chill colours of winter. The year before he had concentrated on scenes of the Seine, with the railway bridge often carrying a train in the background. Now he turned to the train itself, painting *The Locomotive*, with the bullet-like vehicle all blustery red and black penetrating the landscape. He would return to the theme of trains two years later with his monumental Gare Saint-Lazare series. *The Locomotive* reflects Monet's love of combining man-made elements within the landscape, and he has amplified this through the use of searing perspective that sees the train rocket forwards while the fence dramatically recedes.

PAINTED

Argenteuil

MEDIUM

Oil on canvas

SERIES/PERIOD/MOVEMENT

Impressionist

SIMILAR WORKS

Sunset near Ivry, Armand Guillaumin, 1874

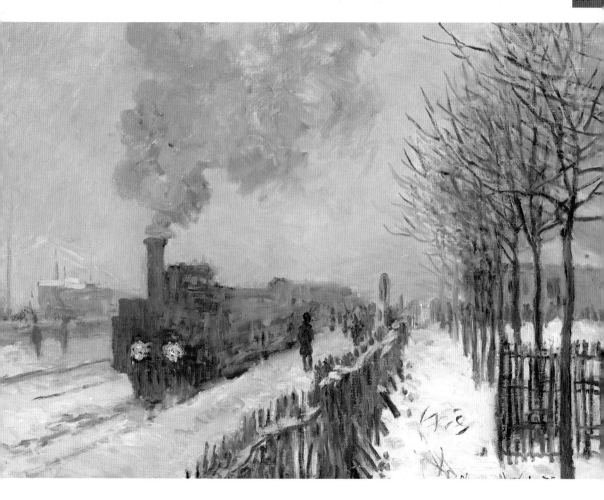

Madame Monet Embroidering, 1875

Monet's wife Camille and son Jean appear frequently in his paintings done during the Argenteuil period. He concentrated on his family as subject matter, projecting a pure, beautiful world unaffected by the turbulent political scene or by his own unstable financial situation. Monet chose to shut himself away from the horrors around him, the violence that had escalated in Paris during the Commune, the death of family and friends, and the sustained rejection of his art by the critics, public and academics. Instead he presented the impression of the world he wished to create, one that was stable where his own was not.

The artist's absorption with landscape extended to his own garden, which would by the end of his life become his own personal landscape. His garden at Argenteuil appears in a number of his paintings, and even in this one the plants impinge on the quiet scene of domesticity. The colours here are rich and vibrant. Monet the colourist is at his most brilliant and his brushstrokes reduced to short, rapid, almost dot-like daubs express an energy all of their own.

PAINTED

Argenteuil

MEDIUM

Oil on canvas

SERIES/PERIOD/MOVEMENT

Impressionist

SIMILAR WORKS

Portrait of Madame Pissarro Sewing, Camille Pissarro, c. 1885

The Shoot, 1876 (detail)

The second Impressionist Exhibition took place in 1876 with 252 works on display by 20 artists. The exhibition was even more poorly received than the first one, partly because fewer artists exhibited and those that did reflected a much more unified style. In highly fraught political times, where the overriding atmosphere was one of stultifying conservatism that rebounded throughout society and the arts, the Impressionists came under serious fire.

It was at this time that Monet was commissioned by wealthy businessman Ernest Hoschedé to paint four large decorative panels for his dining room at the Chateau de Rottenbourg at Montgeron. Monet spent several months on these and a number of smaller paintings. *The Shoot*, which was painted around this time, is an interesting composition where the dark figures sit rather uneasily amongst the Impressionist landscape. The spatial arrangement, however, is strong, aided by the trees on the left of the canvas in part balancing the figures to the right.

PAINTED

Montgeron

MEDIUM

Oil on canvas

SERIES/PERIOD/MOVEMENT

Impressionist, Hoschedé paintings

SIMILAR WORKS

The Butterfly Hunt, Berthe Morisot, 1874

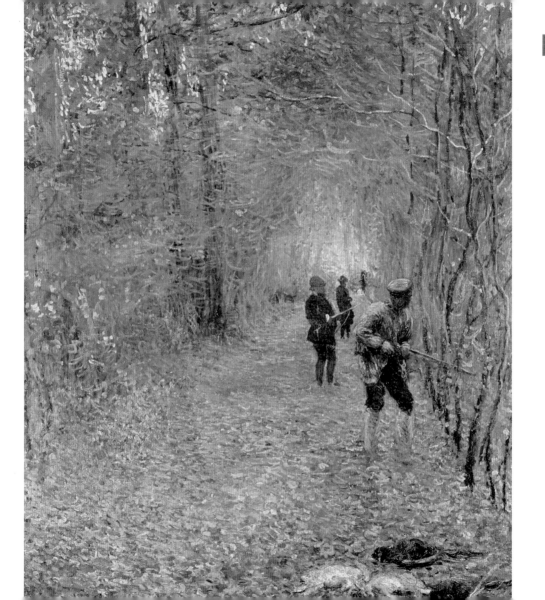

View of the Tuileries Gardens, Paris, 1876

In February 1876, some months before the disastrous second Impressionist Exhibition, Paul Cézanne introduced Monet to Victor Chocquet, a minor French government official. It was a fortuitous meeting. Chocquet was a great supporter of the avant-garde painters and became an important patron for Monet. He invited Monet to paint from his Paris apartment in the Rue de Rivoli and during the Impressionist Exhibition spent much time speaking to visitors enthusiastically about the works on display.

In the spring of 1876 Monet stayed in Paris and painted four views of the Tuileries gardens from the window of Chocquet's apartment. The Tuileries paintings present a bird's-eye view that reflects the artist's detachment and have a fragmentary feel, as though they are a snapshot of a larger scene. Photography, which was in its infancy during this period, was of great influence on the Impressionists (especially Degas) who began to introduce asymmetrical cropping to their compositions. The fragmenting of traditional compositional elements, such as line and colour, leading towards a central focal point, was a further development of the avant-garde artists away from the works of traditionalists.

PAINTED

Paris

MEDIUM

Oil on canvas

SERIES/PERIOD/MOVEMENT

Impressionist

SIMILAR WORKS

Place du Theatre Francais, Afternoon Sun in Winter, Camille Pissarro, 1898

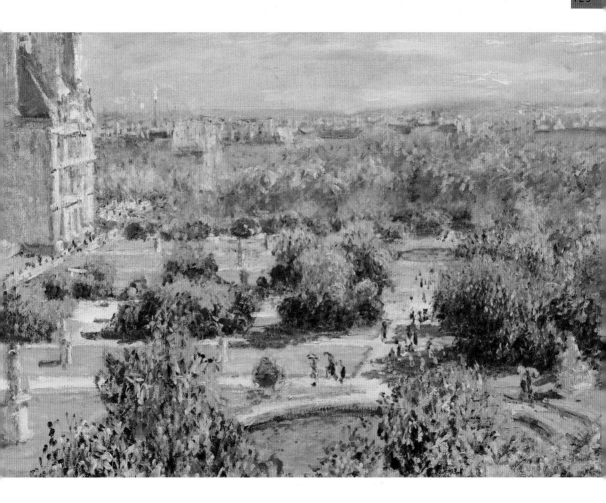

Woman in a Garden, 1876

The second exhibition was called *La Deuxieme Exposition de Peinture* and, although the response to the exhibition was poor and Monet sold no paintings at all, there were small pockets of supporters. After the exhibition he was able to sell his huge painting *La Japonaise* for 2,010 francs at auction and secured several private collectors. Overall, however, the outlook was grim and described by Edouard Manet as, 'The whole clan of painters is in trouble. The dealers are overstocked ... Let's hope that buyers will return.'

Woman in a Garden was one of the works Monet showed at the exhibition and clearly demonstrates the artist's interest in the effects of light, colour and shadow. The beautiful garden backdrop containing the figure of Camille is a vehicle for the artist's expression of light, and as such becomes quite abstract with its luminous dinner-plate patches of sunlight. He has also created an enclosed world within his garden that excludes even the sky. This technique is one he used frequently, culminating in his last giant water lily series of the 1920s.

PAINTED

Argenteuil

MEDIUM

Oil on canvas

SERIES/PERIOD/MOVEMENT

Impressionist

SIMILAR WORKS

Woman with Parasol, Pierre-Auguste Renoir, 1875

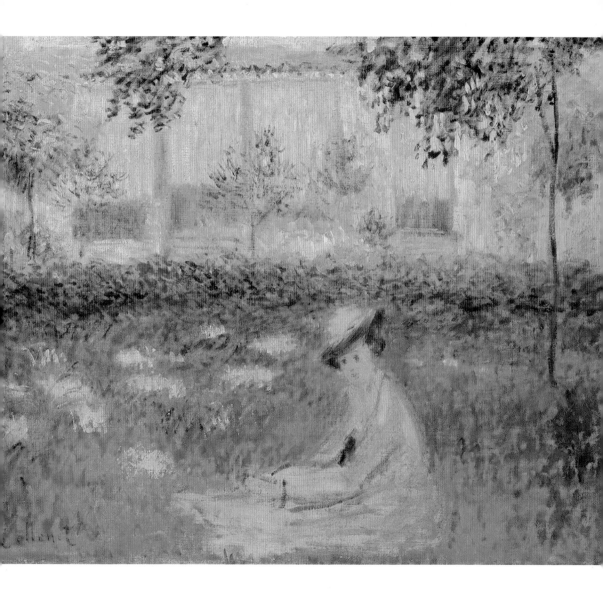

A Corner of the Garden at Montgeron, 1876–77

Monet met wealthy businessman and art collector Ernest Hoschedé and his wife Alice in 1876. Hoschedé commissioned Monet to paint four large panels for his dining room at his Chateau de Rottenbourg at Montgeron, near Paris. The timing was fortuitous. Monet's paintings had been selling for less and less, and he was struggling to stay afloat. He spent several months at Hoschedé's home working on the panels and other pictures, painting in the studio at Montgeron and his studio in Argenteuil. *A Corner of the Garden at Montgeron* combines two of Monet's favourite subjects, water and flowers, and evokes the immediacy of a *plein air* painting, although it was probably finished in the studio. The barely discernible reflection of a woman is probably Alice Hoschedé, whom Monet would later marry.

The meeting with the Hoschedés must have seemed perfect for the artist who had high hopes of them as patrons. Sadly, just a year later, Ernest declared bankruptcy, bringing his patronage to an untimely end. In a bizarre twist the two families would end up living in a house together to save money.

PAINTED

Montgeron

MEDIUM

Oil on canvas

SERIES/PERIOD/MOVEMENT

Impressionist, Hoschedé paintings

SIMILAR WORKS

The Pink House, Camille Pissarro, 1870

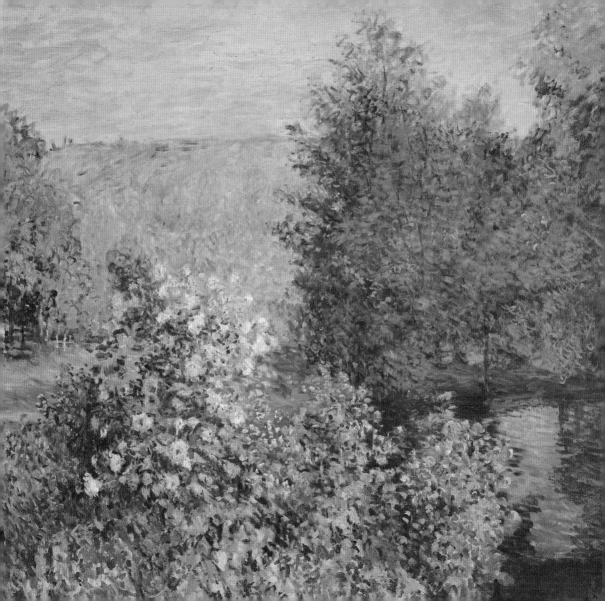

The Turkeys at the Chateau de Rottembourg, Montgeron, 1877

Around the time of the second Impressionist Exhibition, Monet changed his approach towards his landscape painting. He started to make a distinction between his paintings of modern life and those of nature. He no longer painted pictures of modern life within the countryside, choosing instead to keep his themes separate. At Argenteuil he turned to painting time through nature, the same scene at different times of the day, and purely rural subjects, limiting his open-air pictures of modern life to either public parks or private gardens.

During the course of his stay at the Chateau de Rottembourg, Monet painted *The Turkeys*, an innovative picture that placed the lowly turkey as primary motif over the distant chateau, a unique inversion of propriety and place. The arrangement is unusual and distinctly modern, with the turkey popping up from the bottom of the canvas. The picture becomes very much a window on the moment and would, as such, suggest that it was executed *en plein air*, although it was probably finished in the studio.

PAINTED

Montgeron

MEDIUM

Oil on canvas

SERIES/PERIOD/MOVEMENT

Impressionist, Hoschedé paintings

SIMILAR WORKS

The Farmyard, Camille Pissarro, 1877

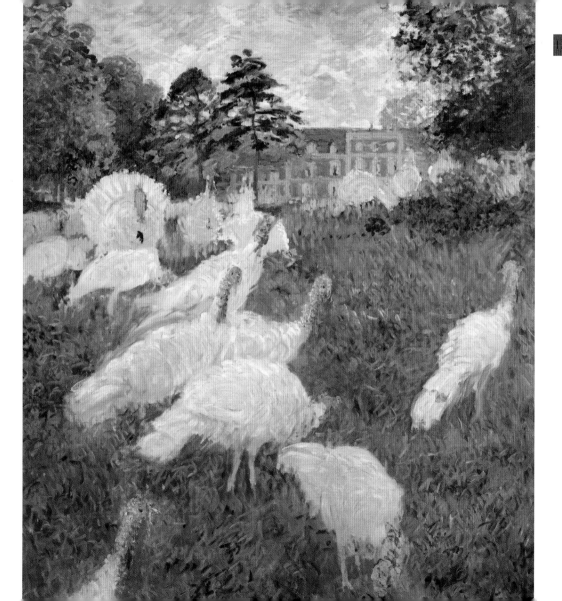

The Pont de l'Europe, Gare Saint-Lazare, 1877

After Monet's stay at Montgeron with the Hoschedé family, he returned home to Argenteuil where he set about planning a series of paintings of the Gare Saint-Lazare in Paris. Monet was fascinated by the train as a potent symbol of progressive France with her burgeoning industries and the effects of the steam. Train travel was still a relatively young endeavour and had opened up new horizons, which extended to the working classes as well as those more wealthy, and the trains along with their lofty stations were viewed with a sense of almost reverence.

In January 1877 Monet moved back to Paris, leaving Camille and Jean in Argenteuil, and shared a studio with his friend Gustave Caillebotte (1848–94) in Rue Moncey. He obtained permission to set up his easel and work in the station, often bringing the place to a standstill. Works were then completed in the studio. The series of Gare Saint-Lazare paintings can be considered his first great, Impressionist series, and reflect his absolute ability to depict the steam and atmosphere surrounding the train.

PAINTED

Paris

MEDIUM

Oil on canvas

SERIES/PERIOD/MOVEMENT

Gare Saint-Lazare

SIMILAR WORKS

The Pont d l'Europe, Gustave Caillebotte, 1876

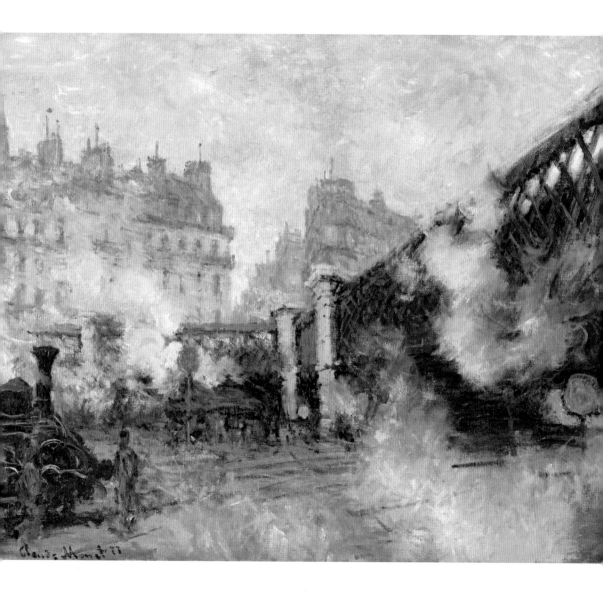

The Rue Saint-Denis, Celebration of June 30, 1878

By 1877 Monet was again in financial turmoil and was dealt a further blow when Ernest Hoschedé, one of his main patrons, went bankrupt. Monet and Camille moved from Argenteuil to Paris for a short time. In April 1877 the third Impressionist Exhibition was held in rooms opposite Durand Ruel's gallery on Rue le Peletier. Monet exhibited 30 canvases including his recent paintings of Gare St Lazare, which were well received.

The following year the *Exposition Universelle*, designed to promote the regeneration of France, opened on 30 June. The day was marked with a national holiday, *Fête du 30 Juin*, which was the first national holiday to be observed since 1869. Monet's painting is a brilliant evocation of the gaiety and energy of the day. He used a bird's-eye view and executed the picture with strong, fast brushstrokes, contrasting jewel-like colour with the dark of the crowds. The crowds merge into one seething mass of humanity, becoming secondary to the flags. His use of perspective is especially interesting, the dominant flag in the middle of the canvas being disproportionately large.

PAINTED

Paris

MEDIUM

Oil on canvas

SERIES/PERIOD/MOVEMENT

Impressionist

SIMILAR WORKS

The Fourteenth of July at Marly-le-Roi, Alfred Sisley, 1875

The Fruit Pickers, 1879

Monet was forced to leave his house in Argenteuil in 1878. He moved the family briefly to Paris before heading down the Seine to the town of Vétheuil. Here Monet and his family and the Hoschedé family set up house together to save money. It was a significant move in terms of the artist's style, and from then on he concentrated almost completely on landscape subjects and moved away from the depiction of urban life. Instead he chose motifs of rural pursuits such as *The Fruit Pickers* or of his family at leisure in the landscape.

Monet used fragmented, rapid and short brushstrokes across *The Fruit Pickers* to produce the effect of brilliant and dappled summer sunlight. In so doing the diminutive figures are barely discernible from the trees around them, but each is part of the same and bigger picture. This is a work of unity and the harmony of the rural worker within his environment, an idealized vision of the world at large, although in reality the life of a seasonal fruit picker was one of hardship and poverty.

PAINTED

Vétheuil

MEDIUM

Oil on canvas

SERIES/PERIOD/MOVEMENT

Impressionist

SIMILAR WORKS

Women Laundering, Alfred Sisley

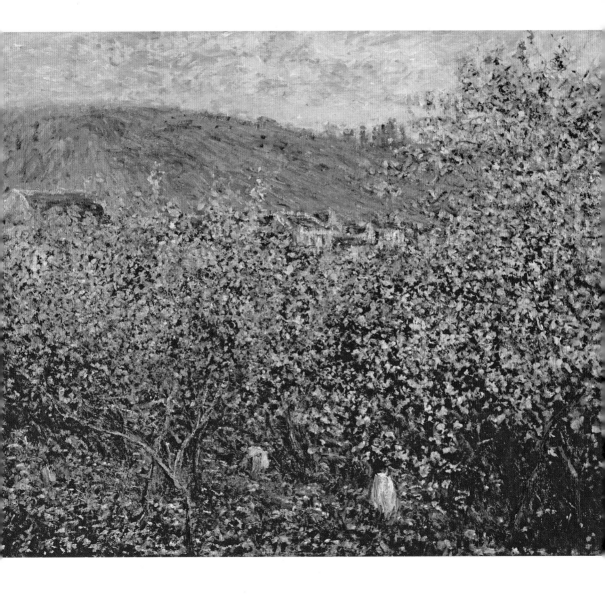

Ship Aground, 1881

Camille died in 1879 and Monet remained close to home in Vétheuil for some time afterwards. Towards the end of 1880 the artist made a trip to the Normandy coast and returned several times during 1881. He first stayed with his brother Leon in the town of Rouen, but then travelled to Leon's holiday home in Petites-Dalles near Fécamp. It was this area of sheer, breathtaking cliffs and sparkling waters that would preoccupy the artist for the next few months, and the marine paintings he produced were received with enthusiasm.

These paintings were densely worked, as seen in this work *Ship Aground*, with its brilliant points of colour and richly dappled surface. The structure of the painting is foremost, with its conflicting horizontals and verticals that lend it an almost abstract air, compounded by his use of rather artificial puff-ball clouds. It is in all respects a work of colour and pattern, even down to the tiny onlookers dwarfed by the great, grounded ship, so roughly painted that they almost disappear into the sands of the beach.

PAINTED

Normandy Coast

MEDIUM

Oil on canvas

SERIES/PERIOD/MOVEMENT

Marine

SIMILAR WORKS

The Seine at Charenton-le-Pont, Armand Guillaumin, *c.* 1885

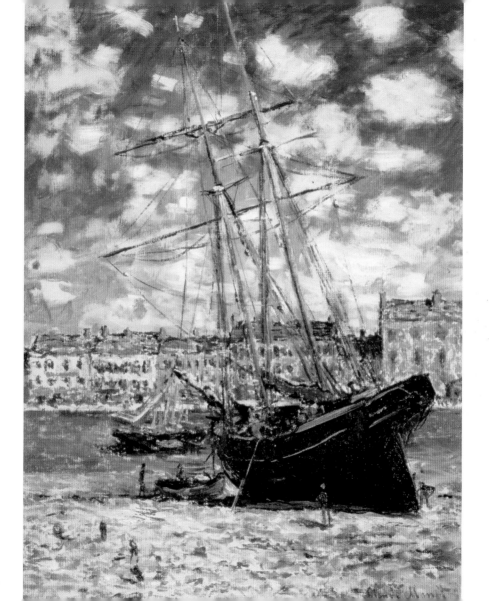

The Nets, 1882

The Hague Municipal Museum, The Hague, Netherlands/The Bridgeman Art Library

Monet spent much of 1882 painting along the Normandy coast from the town of Pourville. Financially he was quite stable, helped greatly by the support of Durand Ruel, but this came to an abrupt end in 1882 with the catastrophic crash of the French stock market. This led to a recession that lasted until the end of the decade, which in turn greatly affected Durand Ruel's own finances. Having initially decided against exhibiting at the seventh Impressionist Exhibition, Monet now changed his mind and exhibited mostly seascapes.

This painting of fishing nets is quite unique within the artist's oeuvre, with the uncharacteristically delicate painting of the translucent nets. It is an extraordinary painting and one of great beauty, particularly in the pale, pink toned sky, the light of which has been caught in the fragile nets and reflected with an eerie glow. The delicate nature of the nets and their poles contrasts with his more typical treatment of the eddying waves and white tops, while the structure also appears to sway gently with the busy movement of the water.

PAINTED

Pourville

MEDIUM

Oil on canvas

SERIES/PERIOD/MOVEMENT

Marine

SIMILAR WORKS

Fishing Boats on the Beach at Saintes-Maries-de-la-Mer, Vincent Van Gogh, 1888

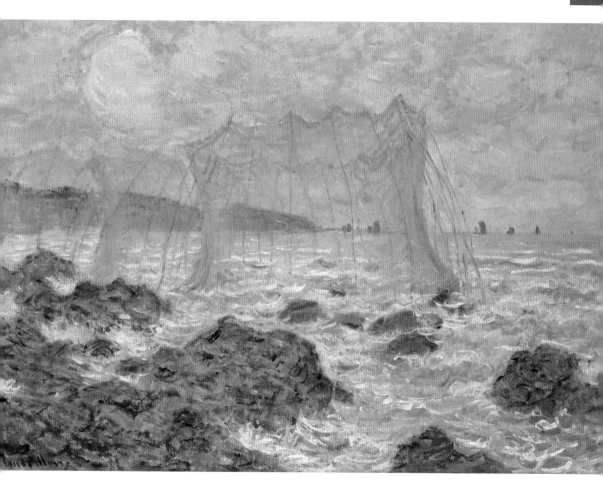

Poly, Fisherman at Belle-Ile, 1886

Water had always been a major motif for Monet, perhaps inspired by his childhood in Le Havre. He made many trips to the Normandy coastline and in the autumn of 1886 he travelled to Belle-Ile off the coast of Brittany to stay with the novelist and playwright Octave Mirbeau (1848–1917). His paintings here for the most part concentrated on the same motif, the stunning rock formations at different times of the day or under different weather conditions, excluding all human subjects.

He did, however, paint the portrait of a local character, Hippolyte Guillaume, known as Poly, while staying there, and the same year painted his first self-portrait. His portrait of Poly is a reminder of the artist's sense of humour and his great talent for caricature, which was his first experience of the art world. There is a clear, sharp wit evident here seen in the tilt of the man's head and his expression, a wit that Monet was frequently chastized for as a schoolboy, and one rarely seen in his mature paintings.

PAINTED

Belle-Ile

MEDIUM

Oil on canvas

SERIES/PERIOD/MOVEMENT

Marine related

SIMILAR WORKS

The Fisherman, Jean Louis Forain, 1884

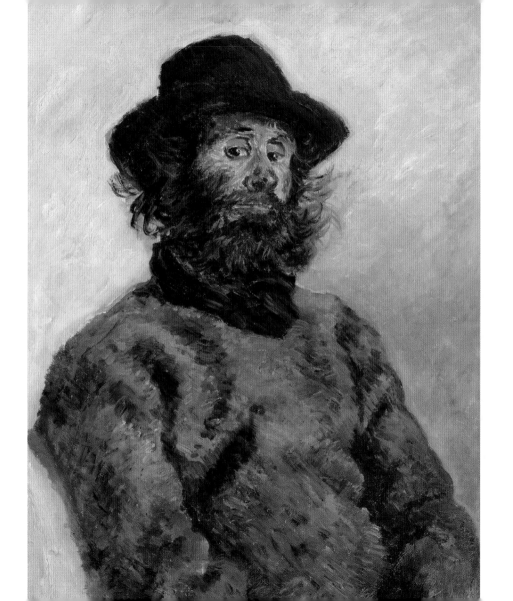

Port-Goulphar, Belle-Ile, 1887

In the autumn of 1886 Monet made two valuable acquaintances. While painting at Belle-Ile off the coast of Brittany he met Gustave Geffroy (1855–1926), an art critic who wrote for the radical paper *La Justice*. Geffroy would become a great champion of Monet's work, and it was through Geffroy that Monet was introduced to Georges Clemenceau (1841–1929). Clemenceau would later serve two non-consecutive terms as the French Prime Minister and was instrumental in the State commission for Monet's final great painting series, *Water Lilies*.

Belle-Ile was a popular haunt for artists and tourists alike, drawn to the Brittany coast with its strong, rural traditions and customs that set it apart from the rest of France. Monet, however was attracted by the rock formations and the wild seas that afforded him a new set of sensations to depict. He concentrated on minimal, tonal palettes of strong, deep blues and greens, producing an astonishing range of paintings of different weather and light effects. Some of the works were exhibited at the sixth International Exhibition at Georges Petits' Gallery in 1887, to mostly favourable reviews.

PAINTED

Belle-Ile

MEDIUM

Oil on canvas

SERIES/PERIOD/MOVEMENT

Marine

SIMILAR WORKS

Evening at Collioure, Henri Martin

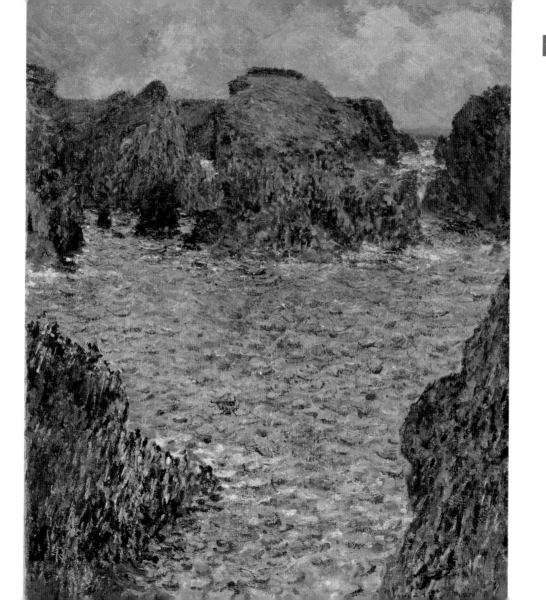

THE W

GREATE

Monet

Places

La Pointe de la Hève, 1864

When Monet was around five years old, his family moved from Paris to the bustling coastal town of Le Havre, situated at the mouth of the great river Seine and overlooking the English Channel. Monet spent his childhood here and developed a lifelong fascination with water. Later as an artist he would return time and again to the sea and coastal areas of Normandy and Brittany as a motif. It was in Le Havre that Monet met Eugène Boudin (1824–98), a successful marine artist whose landscapes of the beaches and coastal life of France would greatly influence the young artist.

Just a short distance from Le Havre is Sainte-Adresse with its beautiful, wide beach and cliff tops that roll down to the sea at the Pointe de la Hève. The little fishing village became very popular during the 1860s and experienced quite some growth, becoming a fashionable place for the wealthy to have their second homes. Monet painted the area many times with his paintings reflecting the area's gradual changes as it developed into the playground of the bourgeoisie.

PAINTED

Sainte-Adresse

MEDIUM

Oil on canvas

SERIES/PERIOD/MOVEMENT

Early

SIMILAR WORKS

The Jetty at Trouville, Eugène Boudin, *c.* 1864

Etretat, Johan Barthold Jongkind, 1865

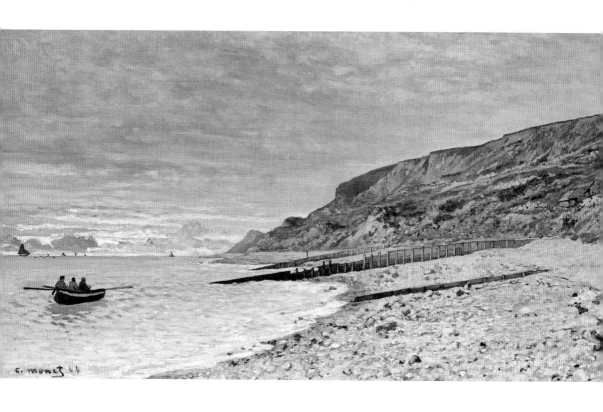

Haystacks at Chailly, 1865

While studying at Gleyre's studio in Paris, which he entered in 1862, Monet met the artist Frédéric Bazille (1841–70) and the two became great friends. They would frequently go on painting excursions and, in 1863, they travelled to the small village of Chailly-en-Bière on the outskirts of the forest of Fontainebleau. After spending a week in the village painting the surrounding areas, Bazille wrote to his mother that he was 'with my friend Monet, from Le Havre, who is rather good at landscapes'.

Monet returned to Chailly in the spring of 1865 and wrote to Bazille urging him to join him as soon as possible. This painting of haystacks precedes his huge and famous series of the same motif by around 25 years, but already with the low horizon and expanse of sky, Monet's interest in the effects of light with the passing time of day is evident. His focus here is the sky not the haystacks, which form a seamless part of the landscape, however the whole is bathed in the wonderful golden light of a spring sunrise.

PAINTED

Chailly

MEDIUM

Oil on canvas

SERIES/PERIOD/MOVEMENT

Early

SIMILAR WORKS

The Isolated Rock, Gustave Courbet, 1862

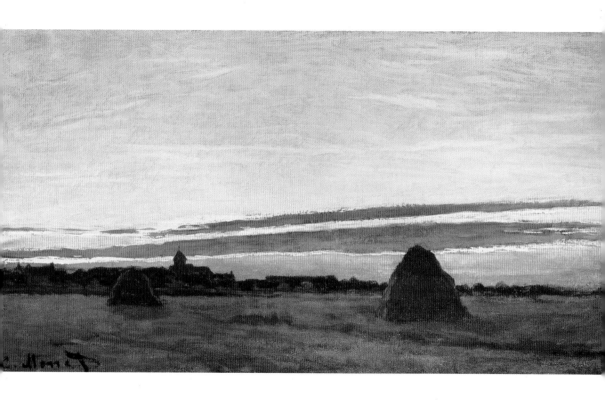

Garden of the Princess, Louvre, 1867

Despite Monet's affiliation to the countryside and the natural world, he maintained strong ties to Paris throughout his life. The city was not only the centre of the arts world, but also the epicentre of developing France, the beating heart of the country's regeneration that extended through the arts, literature, architecture, industry and social advancement. He frequented the city throughout his life, spending short periods of time painting from different studios and remaining involved in the social scene of his artist and writer friends.

Typically of the artist, even when painting in the city he managed to find a 'landscape' motif, as seen in his painting of the Garden of the Princess, painted from a window in the Louvre. Monet has adopted his 'bird's-eye view', a technique that he often used in Paris, and has depicted the scene without a single focal point. Instead he has treated the composition as a fragment of a larger scene, drawing on the influence of photography. His figures are represented through tiny daubs of paint and rapid brushstrokes with any sense of individual identity removed.

PAINTED

Paris

MEDIUM

Oil on canvas

SERIES/PERIOD/MOVEMENT

Cityscapes

SIMILAR WORKS

The Garden of the Tuileries on a Winter Afternoon, Camille Pissarro 1899

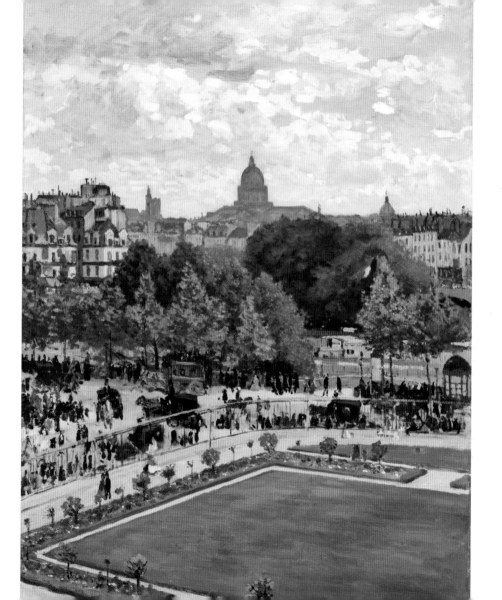

The Windmill, Amsterdam, 1871 (detail)

In 1871 Monet stopped in Holland on his way back from London to France, staying in the small town of Zaandam near Amsterdam, which had been recommended to him by his friend Charles-Francoise Daubigny (1817–78). He remained there for four highly productive months, during which time he painted at least 24 canvases of the surrounding area. Zaandam and nearby Amsterdam with their extensive system of canals were the perfect location for Monet with his love of water. The picturesque and distinctively Dutch houses that lined the sleepy canals, throwing vibrant reflections into the waters, were inspiration for the artist.

This painting, which shows Monet the colourist at his richest, depicts the old Rozenboom mill that sat along the Onbekende Canal in Amsterdam. The mill was used for extracting yellow, red and blue dyes from coloured woods, but with the development of chemical dyes the mill went bankrupt, and in 1876 it was torn down. Monet's vibrant use of colours in the work would seem to reference the dyes from the historic use of the building, the colours appearing to seep out into the canal.

PAINTED

Amsterdam

MEDIUM

Oil on canvas

SERIES/PERIOD/MOVEMENT

Dutch works

SIMILAR WORKS

Vegetable Gardens and the Moulin de Blute-Fin on Montmartre, Vincent Van Gogh, 1887

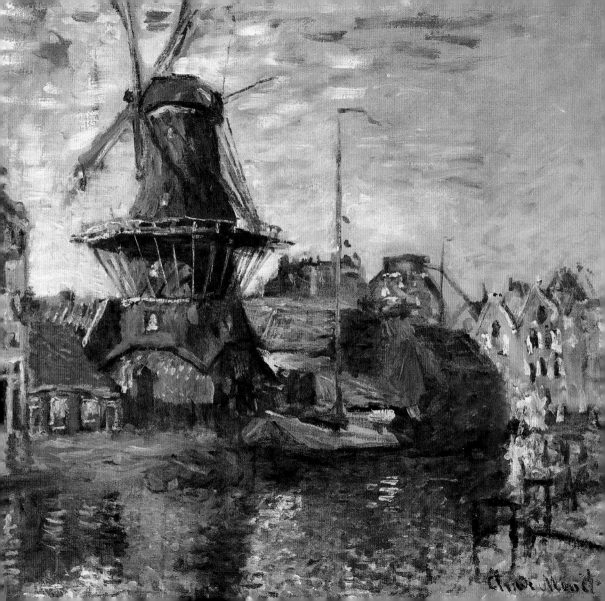

The Seine at Rouen

The Seine and its surrounding countryside were often painted by Monet throughout his life. He spent much of his life living within close proximity to the river and her tributaries.

In this painting of the Seine at Rouen, Monet has used a wonderful balance of verticals and horizontals. The line of houses and buildings that winds into the distance provides a strong horizontal, enhanced by the expanse of sky reminiscent of Dutch landscapes. Monet has treated the sky and the water in a similar way, and the reflection of the sky in the water draws the two elements together. The delicate verticals of the finely painted ship and the trees and mooring posts offset the low vanishing point. He has used quite broad areas of colour, with merged paint application for the most part, and has imposed brushstrokes suggestive of the ripple of the water and its reflections. The small figure walking down the gangplank to the shore is an interesting addition, as he hovers above the water on barely more than a sliver of wood.

PAINTED

Rouen

MEDIUM

Oil on canvas

SERIES/PERIOD/MOVEMENT

Impressionist

SIMILAR WORKS

Entrance to the Port Honfleur, Johan Bartold Jongkind, 1864

Honfleur the Port, Stormy Weather, Eugène Boudin, 1852

Claude Monet

Regatta at Argenteuil, c. 1872

Monet moved to Argenteuil at the end of 1871 and stayed there until January 1878, these productive years representing the main impetus of Impressionism, during which Argenteuil became a great draw to many of the Impressionist artists. The large and growing town situated north-west of Paris provided artists easy access to the capital via a 30-minute rail link straight into the Gare Saint-Lazare, also immortalized by Monet. The town combined picturesque aspects with industrial elements, such as the two great bridges whose man-made, dominant structure appealed to Monet. It was in all senses representative of the emerging modern France, yet Monet managed to paint it with an idyllic beauty overlooking the ugly side of regeneration. Perhaps most importantly for the artist, the town extended down to the river Seine and had a strong boating history and association.

He painted scenes along the Seine frequently incorporating man-made structures such as boats, bridges and buildings into his natural landscape. Here the reflections of the white-sailed boats and the buildings are cast across the water, joining the natural and the man-made with seamless fluidity.

PAINTED

Argenteuil

MEDIUM

Oil on canvas

SERIES/PERIOD/MOVEMENT

Impressionist

SIMILAR WORKS

The Seine at Argenteuil, Pierre-Auguste Renoir, 1874

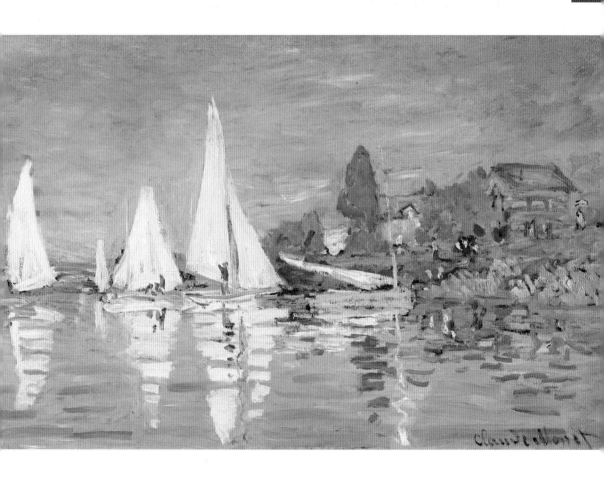

View of Le Havre, 1873 (detail)

In 1873 Camille Pissarro (1830–1903) referred to Monet's art as, 'a highly conscious art, based upon observation, and on a completely new feeling; it is poetry through the harmony of pure colours, Monet adores real nature'.

One of the most extraordinary aspects of Monet's painting was his ability to create intense light, especially that reflected on water. By the time of *View of Le Havre*, Monet had developed his method of short, separate brushstrokes and achieved a complete unity of vision through a single technical device. Le Havre, Monet's childhood home, was a place that he painted often. Boats were a favourite motif, the wide expanse of sails creating an excellent plane for reflective light. Here Monet has depicted the buildings along the harbour at Le Havre with strong architectural details and has placed the viewer within the direct light that falls onto the canvas from the left. It was an unusual composition for Monet, who tended to depict his boats against an empty sky, although the recurrent vertical theme of the masts and sails of the boats with the tall buildings is very effective.

PAINTED

Le Havre

MEDIUM

Oil on canvas

SERIES/PERIOD/MOVEMENT

Impressionist

SIMILAR WORKS

The Pilots Jetty Le Havre, Morning, Cloudy and Misty Weather, Camille Pissarro, 1903

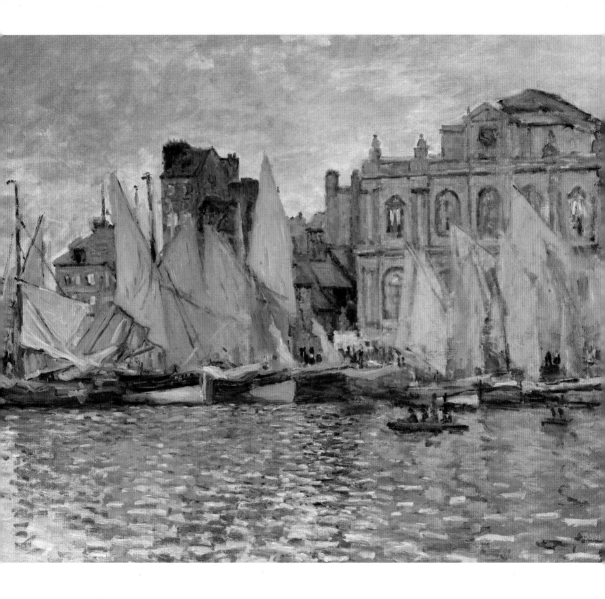

Seine at Asnières, 1873

Although it has greatly changed now, in the late nineteenth century Asnières was a relatively modest fishing and boating town. Situated just under five miles from Paris, it was a popular destination for day-trippers and tourists wishing to escape the bustle of the capital. During the late nineteenth century the small town began to undergo a massive expansion with an increase in industry, buildings and population. Asnières was frequently painted by the Impressionists and their successors, perhaps most famously by Georges Seurat (1859–91) in his *Bathers at Asnières*, 1884, where holidaymakers can be seen swimming in the river with the telltale chimneys of industry in the background.

Monet has depicted Asnières from the Parisian bank of the river Seine, with the giant barges in the foreground set against a curious mixture of different buildings along the horizon. He has excluded any reference to the town's fashionable holiday status, and has instead focused on its more traditional aspect, bathing the whole in a glittering, iridescent light.

PAINTED

Asnières

MEDIUM

Oil on canvas

SERIES/PERIOD/MOVEMENT

Impressionist

SIMILAR WORKS

Bathers at Asnières, Georges Seurat, 1884

The Port, Nice, Berthe Morisot, 1882

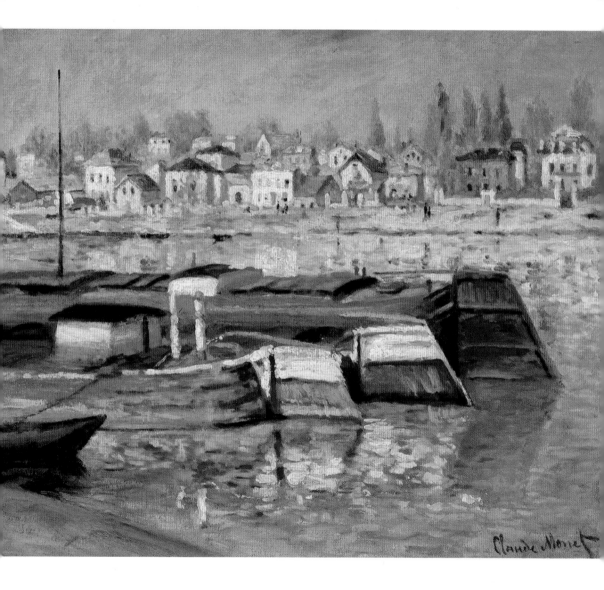

Claude Monet

Canal à Amsterdam, 1874

Amsterdam was one of Monet's favourite places and, like Venice, which he visited in 1908, afforded him the scenes of buildings along water that he so loved. He first travelled there in the early 1870s, having spent some time in London avoiding the conflicts within France. The bridges in Amsterdam were a major motif for him, indeed bridges in general, and it is interesting to compare this *Canal à Amsterdam* with *The Drawbridge Amsterdam*, painted in the same year. Both paintings are full of life, bustling with people going about their daily business and also with the life of the water itself. He has treated water and sky in the same way in *Canal à Amsterdam*, so that one almost appears a continuum of the other. Although this was not uncommon for the artist, it is worth considering that the actual weather in Amsterdam can be damp and overcast, with moisture in the air. He has used small brushstrokes throughout the canvas and has created a unified whole by treating the entire painting with the same brushstroke approach.

PAINTED

Amsterdam/Argenteuil

MEDIUM

Oil on canvas

SERIES/PERIOD/MOVEMENT

Amsterdam landscapes

SIMILAR WORKS

The Bridge of L'Estacade, Johan Barthold Jongkind, *c.* 1853,

Wooden Bridge, Sir Augustus Wall Callcott, *c.* 1835

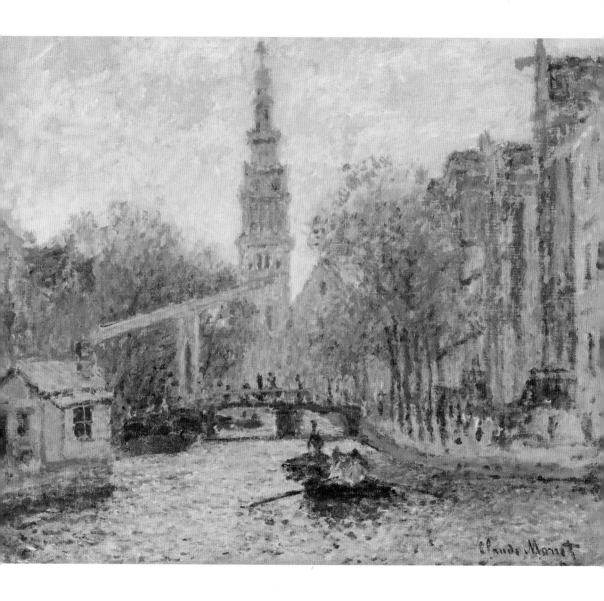

Boulevard Saint-Denis, Argenteuil in Winter, 1875

Monet was an avid painter of snow and ice, their reflective quality giving the artist great scope for his experiments in the depiction of light and colour over time. The great, heavy wet blankets of snow also had a totally transforming effect on the familiar landscapes of Argenteuil, giving an old motif a new façade.

The winter of 1874–75 was an extreme one with plummeting temperatures and heavy snowfall. In this painting he has taken his view from a spot on a small pathway, between the railway embankment and the Boulevard Saint-Denis, and created an interesting multi-directional composition. The blustery snowstorm drives across the canvas, with the sun, weakly yellow and pink, barely breaking through the wet sky. He has used soft pink and blue hues throughout, from the colouring in the sky to the warm exterior of the buildings and the snow itself, giving it great density. The dark tones of the fence and the bowed, bustling figures provide a strong contrast to the delicacy of the rest and give the picture solid form and depth.

PAINTED

Argenteuil

MEDIUM

Oil on canvas

SERIES/PERIOD/MOVEMENT

Impressionist

SIMILAR WORKS

Snow Effect at Marly, Alfred Sisley, 1876

The Road to L'Hermitage in the Snow, Camille Pissarro, c. 1874

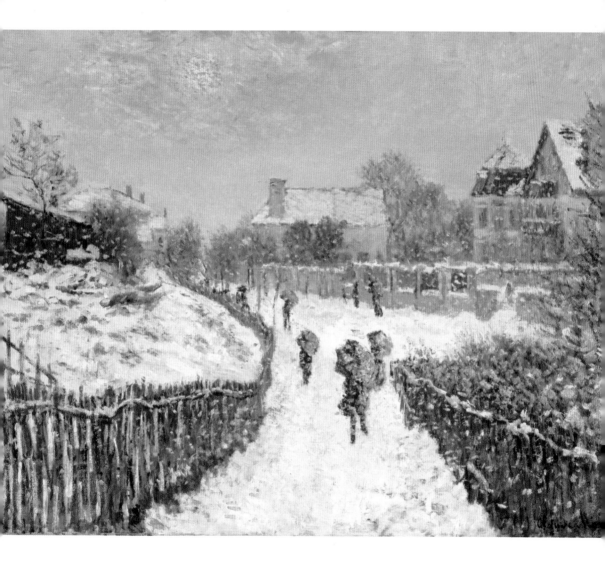

The Lake at Montgeron, 1876

Monet spent several months in Montgeron at the Chateau de Rottenbourg in 1876 when he was commissioned by the wealthy businessman Ernest Hoschedé to paint four decorative panels for his dining room. While there Monet made a number of other paintings and studies, taking full advantage of the beautiful setting and affluent surroundings.

The Lake at Montgeron is one of the four large decorative panels and is one of Monet's more innovative compositions to that date. He has allocated more than half the canvas to the depiction of the water itself, a subconscious precursor of his giant water lily paintings done at the end of his life. In this work the sky and the water and the reflections all merge into one, where what is real and what is reflected becomes hard to differentiate. In the corner of the painting and only visible after close examination is the figure of a woman fishing, a scant human presence in an overwhelmingly organic scene. The woman is thought to be Alice Hoschedé (1844–1911), who would later become the second Mrs Monet.

PAINTED

Montgeron

MEDIUM

Oil on canvas

SERIES/PERIOD/MOVEMENT

Impressionist

SIMILAR WORKS

Sunset Over the Lake, Berthe Morisot, 1894

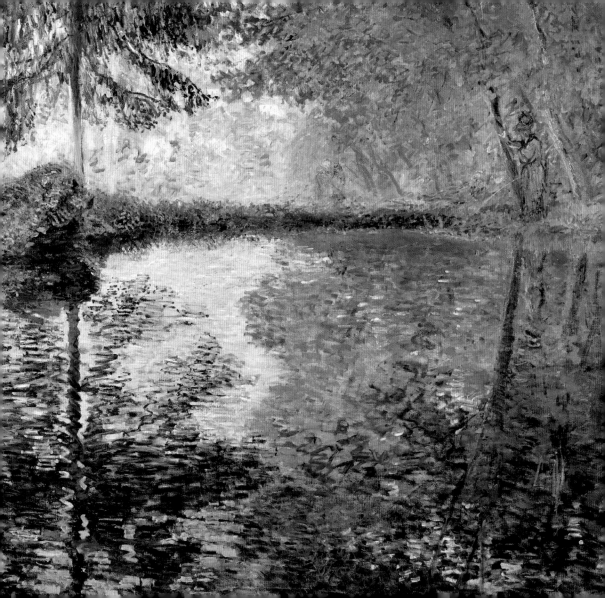

Path through the Poppies, Ile Saint-Martin, Vétheuil, 1880

In 1878 Monet moved from his temporary home in Paris to Vétheuil, an idyllic, rural village that sits along a loop in the river Seine. The following year he wrote, 'I am a countryman again, and I shall not come to Paris save at intervals, to sell my pictures.' Monet was quite entranced by the countryside surrounding Vétheuil, describing it as 'ravishing', and was particularly taken by the views along the banks of his beloved Seine. The village sits on the bank of the Seine near an area of the river that has many small wooded islands, all beautifully picturesque.

In the summer of 1880 he produced a large number of sun-filled canvases of the surrounding area, including *Path Through the Poppies*. He painted the work from the Ile Saint-Martin, one of the small islands on the Seine, using brilliant colour and rapid, fragmented brushstrokes. He has used tiny dots and flecks of pure colour to evoke the blanket of poppies that stretches away into the distance, with the animation of his brushwork breathing life into the expansive, organic landscape.

PAINTED

Vétheuil

MEDIUM

Oil on canvas

SERIES/PERIOD/MOVEMENT

Impressionist

SIMILAR WORKS

Path Climbing Through the Tall Grass, Pierre-Auguste Renoir, 1876–77

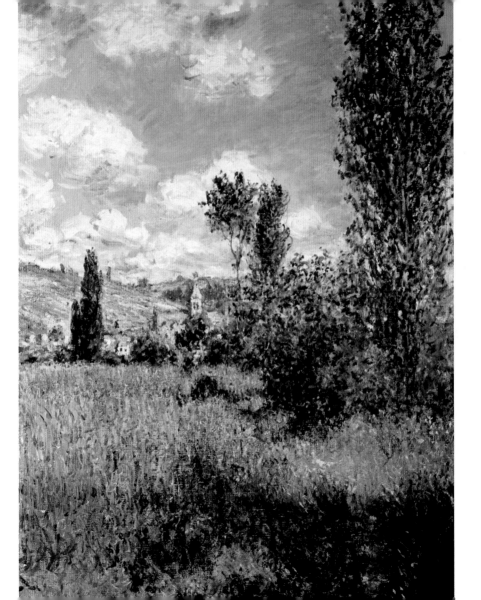

The Customs Officers' Hut at Varengeville, 1882 (detail)

Private Collection/Photo © Lefevre Fine Art Ltd, London/The Bridgeman Art Library

Monet spent much of 1882 travelling the Normandy coastline from Dieppe to Pourville, and spent considerable time painting the dazzling cliffs around the small village of Varengeville. This tiny fishing village sits atop sublime chalk cliffs that Monet focused intently on, producing a large number of paintings of the location from slightly different angles, in varying weather and different times of the day. He was particularly fascinated by Varengeville's medieval church, which he painted seven times, and by the tiny customs officers' cabin that, from certain angles, appeared to cling perilously to the vertiginous cliffs. He painted this little cabin a number of times from different viewpoints: sometimes it appears secured in the rocky landscape, while at others it seems to defy its steep location. In these paintings he has tended to reduce the compositional elements to a simple structure, often recalling Japanese woodcuts, and has concentrated on producing the effect of atmosphere, weather and light. These compositions are daring and innovative, producing unusual scenes of simple, geometric shapes and stunning visual effects, which are both dramatic and often exhilarating.

PAINTED

Varengeville

MEDIUM

Oil on canvas

SERIES/PERIOD/MOVEMENT

Impressionist

SIMILAR WORKS

Cliffs at Pourville, Pierre-August Renoir, 1879

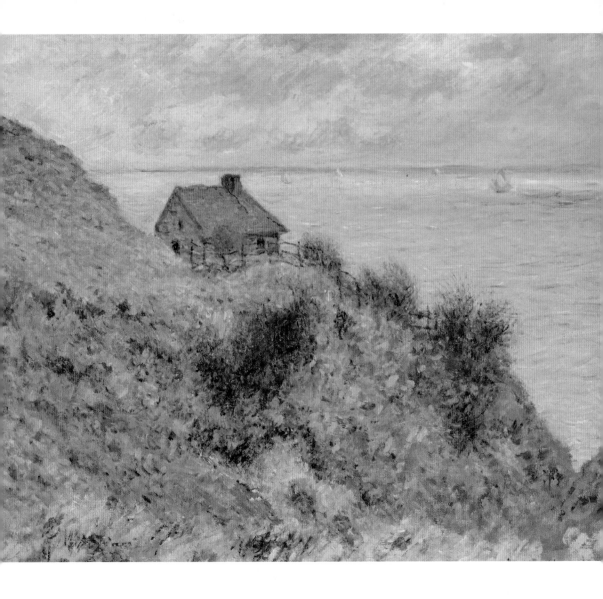

Dieppe, 1882

Monet's painting excursions along the coast of Normandy in 1882 were incredibly productive and resulted in a large number of finished oil paintings and several sketchbooks. This area of coastline, particularly around Pourville and Dieppe, was of great inspiration to the artist due to the dramatic scenery of its vertiginous cliffs and wide, sandy beaches. During the late nineteenth century this coastal area was a fashionable holiday destination for the middle classes, as well as being a great draw for artists. Not only did the stunning scenery provide suitable subject matter, but the wealth and growing tourist trade there also provided potential customers.

Monet visited Dieppe a number of times and returned again in 1896 taking his sketchbooks from 1882 with him. Dieppe was by that time a large, bustling town and was one of the most popular tourist resorts along that stretch of coastline. In this painting Monet has concentrated on the town and one of her churches, using sketchy brushstrokes and a strong tonal base of subdued colours to create the effect of an electric, pre-storm atmosphere.

PAINTED

Dieppe

MEDIUM

Oil on canvas

SERIES/PERIOD/MOVEMENT

Impressionist

SIMILAR WORKS

Portal of the Church of St Jacques, Dieppe, Camille Pissarro, 1901

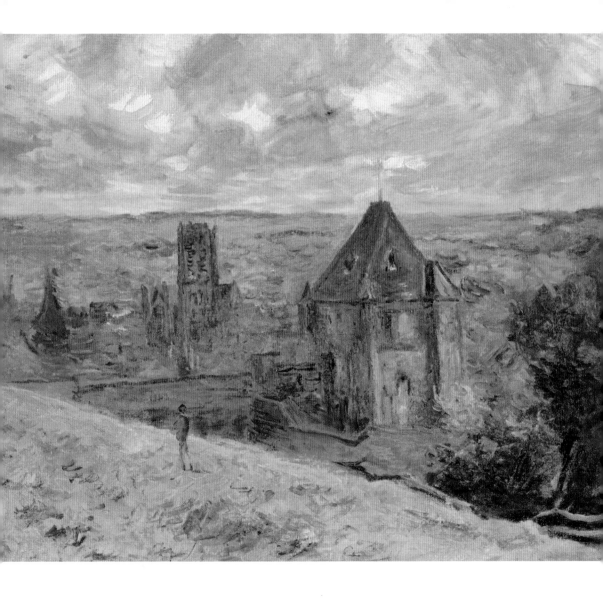

Boats on the Beach at Etretat, 1883 (detail)

Private Collection/Photo © Christie's Images Ltd/The Bridgeman Art Library

In January of 1883 Monet visited the small town of Etretat, where he had lived with Camille and his son Jean in 1868. Originally a fishing village, the town had become a fashionable holiday resort and a favourite destination for artists. The soaring cliffs at Etretat are famous for their giddying heights and for three natural rock arches that extend into the sea. The beach too forms a sweeping curve, and with its wide, yellow sands and backdrop of cliffs is amongst the most beautiful of the region.

Eugène Delacroix (1798–1863), Johan Barthold Jongkind (1819–91) and Gustave Courbet (1819–77) had all painted at Etretat, and Monet followed in their footsteps. He was particularly taken by Courbet's painting *The Cliff at Etretat after a Storm* (1869), and there is some similarity between Courbet's and Monet's treatment of the boats.

Monet's trip to Etretat in 1883 was cut short due to appalling weather, and he was unable to complete the large oil paintings that he had planned to undertake there and exhibit on his return.

PAINTED

Etretat

MEDIUM & DIMENSIONS

Oil on canvas

SERIES/PERIOD/MOVEMENT

Impressionist

SIMILAR WORKS

The Cliff at Etretat after a Storm, Gustave Courbet, 1869

Etretat, Johan Barthold Jongkind, 1865

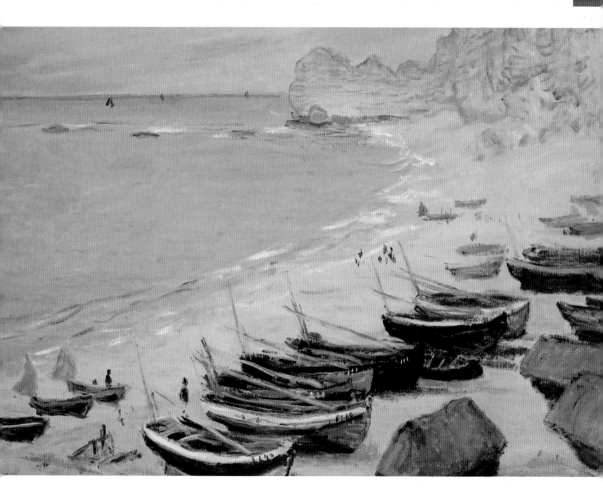

The Seine at Port-Villez, 1883

Private Collection/Photo © Christie's Images Ltd/The Bridgeman Art Library

In April 1883 Monet moved to the tiny, rural village of Giverny on the bank of the river Seine between Normandy and the Ile de France. He immediately set about exploring the surrounding countryside as well as undertaking excursions up and down the Seine in his studio boat. He painted many views of the Seine and, some years later in the spring and summer of 1897, undertook a series called *Morning on the Seine*, painting the river in the early morning as fingers of light crept across the waters, changing their aspect and bathing the landscape in translucent colours.

He painted the views at Port-Villez often, in 1883 and again in 1896/7. The little hamlet between Vernon and Bonnières-sur-Seine was close to his home in Giverny. It was most noted for its spectacular cliffs, seen in this painting in a brilliant light. His brushstrokes are tighter here and the painting appears to have been finished in the studio, although it would have been started on site. This was not unusual for Monet, who frequently completed his works under studio conditions.

PAINTED

Port-Villez

MEDIUM & DIMENSIONS

Oil on canvas

SERIES/PERIOD/MOVEMENT

Impressionist

SIMILAR WORKS

The Banks of the Seine, Champrosay, Pierre-Auguste Renoir, 1876

View of Rouen, 1883

The magnificent city of Rouen, historic capital of Normandy and present-day capital of the Upper Normandy region, was a great inspiration to Monet, who produced his famous series of paintings of the city's cathedral between 1892 and 1894. His ties to the city were more than just artistic as his brother Léon lived nearby. Monet visited him in 1872, when he painted two pictures of factories belching their plumes of smoke, one also including a train, both emphasizing the growth and progress of modern France.

He visited his brother in 1883, when he produced this rather more idyllic vision of Rouen, wrought in black crayon. The structure of this drawing is perfectly balanced through its triangular form, peaking in the church spire that forms the centre of the view. Typically of Monet he has captured the city across the waters of the Seine, turning the cityscape into a landscape. Later, when painting the majestic cathedral, he removed all reference to the city completely, focusing purely on the façade of the cathedral under different effects of light and weather.

PAINTED

Rouen

MEDIUM & DIMENSIONS

Black crayon on white scratchboard

SERIES/PERIOD/MOVEMENT

Impressionist

SIMILAR WORKS

L'Ile la Croix a Rouen, Camille Pissarro 1883

Claude Monet

The Valley of Falaise, Calvados, France, 1883

During his extensive painting excursions around Normandy, Monet visited the picturesque and historic area of Falaise, Calvados, where he painted this richly autumnal work. This area of Normandy is popular with visitors given its long history, beautiful scenery, sweeping beaches and culture. But Monet chose to avoid all reference to human presence and instead focused on the charming, rural valley of Falaise. During this period his landscapes were largely devoid of people, and when they were included they appear as tiny, irrelevant figures, often barely discernible from their surroundings, creating the sense of a rural utopia, unaffected by human interference.

This painting is quite unusually structured for Monet, who has placed the tree in the foreground and darkened it sufficiently that it is almost separate from the scene behind. He has also used strong horizontal bands of colour that focus on the brilliant strip of green that dissects the canvas through its centre. The colours evoke the fiery shades of autumn under a glowing sky, perhaps as the sun starts to set.

PAINTED

Calvados

MEDIUM & DIMENSIONS

Oil on canvas

SERIES/PERIOD/MOVEMENT

Impressionist

SIMILAR WORKS

Port-en-Bessin, Calvados, Paul Signac, c. 1884

Monte Carlo: view of Roquebrune, 1884

Private Collection/Photo © Connaught Brown, London/The Bridgeman Art Library

In December 1883 Monet travelled with Pierre Auguste Renoir (1841–1919) to the Mediterranean coast. It would be a revelation to the artist, who was transfixed by the region's brilliant sun and vibrant colours. The two artists stopped at Aix-en-Provence to visit Paul Cézanne (1839–1906) before journeying on to Italy. Monet spent three weeks travelling with Renoir before returning home finding it difficult to work in company. He returned alone to the Mediterranean in January of the following year.

On his second trip Monet painted this view of Roquebrune situated between Monaco and Menton, above the bay of Monte Carlo. The colours, which are predominantly purple with touches of green and white, are quite magical. He has worked quickly and sketchily, merely hinting at the actual structure of the landscape formations. It is primarily a work of colour and light, with the specifics of the location of less importance. During the trip he wrote frequently to Alice Hoschedé and spoke of the rapidity with which the light and colours changed, describing the colours as 'of a brandy flame or of a pigeon's breast'.

PAINTED

Monte Carlo

MEDIUM & DIMENSIONS

Oil on canvas

SERIES/PERIOD/MOVEMENT

Mediterranean paintings

SIMILAR WORKS

Mont Sainte-Victoire, Paul Cézanne, 1900

Cap Martin, 1884

Monet was particularly taken with the Italian town of Bordighera where he stayed on his first trip in 1883, and again in 1884. The town was close to Roquebrune-Cap-Martin, and Monet travelled there from his base in Bordighera to paint the stunning scenery. These Mediterranean works reflect the influence of Japanese woodcuts (of which Monet was a collector) in their simple structure and often oblique viewpoint.

He painted the view of Cap Martin several times, but always depicting it as a majestic slice of nature quite separate from the area's burgeoning tourist trade. In this painting his rapid, strong and loaded brushwork evokes the sense of a stiff sea breeze, emphasized by his treatment of both the water and the rocks. Barely discernible in the distance, a tiny sailing boat is whisked along on the rough waves with hardly any differentiation between the white caps and the sail. Although the painting is one of a fashionable tourist scene, he has removed this element and instead it is serves as a record of nature only.

PAINTED

Roquebrune-Cap-Martin

MEDIUM

Oil on canvas

SERIES/PERIOD/MOVEMENT

Mediterranean paintings

SIMILAR WORKS

The Gulf of Marseilles seen from L'Estaque, Paul Cézanne, 1878–80

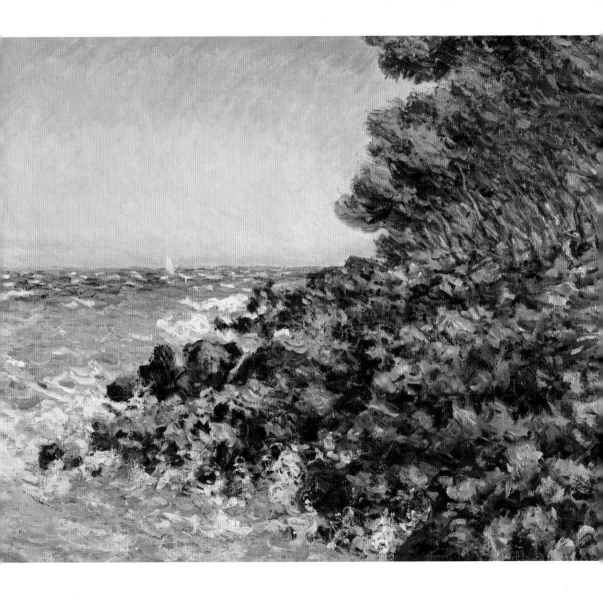

Villas at Bordighera, 1884

The brilliant colours of the Mediterranean had a profound effect on Monet. His pictures of Bordighera in particular show the verdant foliage and exotic lushness in a riot of colour. During this trip he chose to paint places popular with the middle classes, although he did not reference specific human influence, concentrating instead on aspects of nature. Tourist views were very popular at the time, made more so with increasing travel and the development of the railways; they sold well and many artists undertook them purely for financial gain. While Monet did not compromise his artistic aims, he almost certainly chose to paint views that would sell. At this stage of the artist's career his financial position was still precarious.

Monet worried about how these paintings would be received on his return to France and he greatly reworked many of them. He wrote to Alice Hoschedé frequently and in one letter described his battle to capture the light and colour of the Mediterranean: 'The palms will make me despair ... so much blue in the sea, and the sky it is impossible!'.

PAINTED

Bordighera

MEDIUM

Oil on canvas

SERIES/PERIOD/MOVEMENT

Mediterranean paintings

SIMILAR WORKS

House and Tree, Paul Cézanne, *c.* 1873

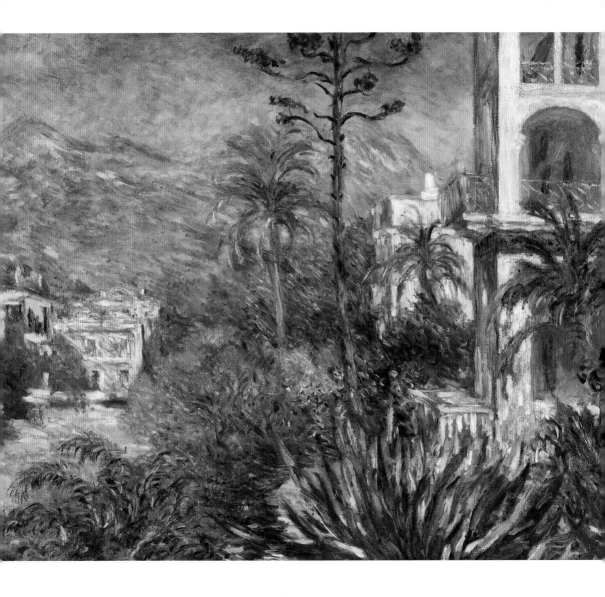

The Castle of Dolceacqua, 1884

Many of Monet's paintings of the Mediterranean countryside and villages reveal the artist struggling to capture the effects of the rapidly changing, brilliant sunlight, with this becoming the primary objective over the depiction of the site itself. Here however, although he has evoked the sparkling light of midday, the motif of the castle and the small village is clearly his objective.

The village of Dolceacqua sits along the border of France, close to the Italian cities of Genoa and Imperia. A picture-perfect hideaway nestled in the hillside, it was built originally as a fortified village around its castle. Monet has chosen to depict the castle from across the river – unsurprisingly given his fascination with water – using a viewpoint that has allowed the insertion of the beautiful arched bridge. He has reduced the structure of his composition to simple, geometric shapes that create a perfect balance throughout, and recalls Japanese woodcuts. Just three years after painting this image, the castle suffered badly during an earthquake, but has since been restored.

PAINTED

Dolceacqua

MEDIUM

Oil on canvas

SERIES/PERIOD/MOVEMENT

Mediterranean paintings

SIMILAR WORKS

The Chateau de Medan, Paul Cézanne *c.* 1880

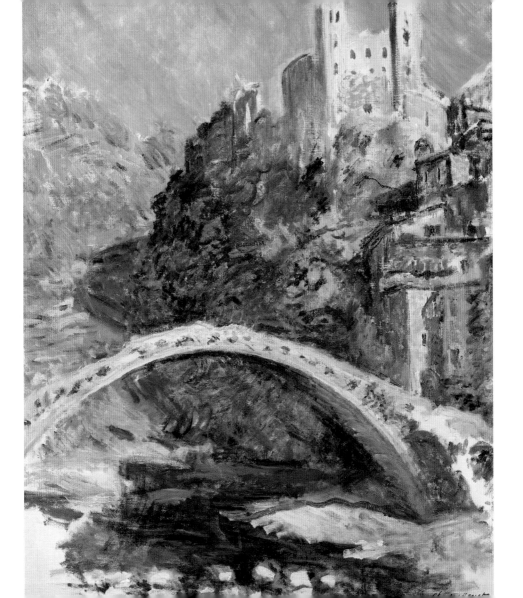

Tulip Fields with the Rijnsburg Windmill, 1886

© Musée d'Orsay, Paris, France/The Bridgeman Art Library

In the spring of 1886 Monet spent a few days painting in Holland, delighting in the vast fields of tulips that stretched as far as the eye could see. Fields of flowers were not a new motif for the artist, but he had never had the opportunity to paint two such opposing elements – that of the natural tulip grown in regimented, man-made format. These fields of tulips, split into different colours that formed geometric bands of solid contrasting colour across the flat landscape, were an ideal subject for Monet. Furthermore, the fields were frequently bordered by ribbon-like canals, in whose waters the brilliant colours of the tulips were sharply reflected.

On his short trip Monet started five canvases, which he then finished back in his studio in Giverny. Two of these were exhibited at the fifth International Exhibition of Painters and Sculptures at the Georges Petit Gallery. On visiting the exhibition, the novelist Georges Huysman (1848–1907) wrote in a letter to Odilon Redon (1840–1916), 'There are fields of tulips in Holland by Claude Monet, which are overwhelming! A true feast for the eyes.'

PAINTED

Holland

MEDIUM

Oil on canvas

SERIES/PERIOD/MOVEMENT

Dutch poppy fields

SIMILAR WORKS

A Flat Dutch Landscape under a Summer Sky with Clear White Clouds, Paul Baum, c. 1890

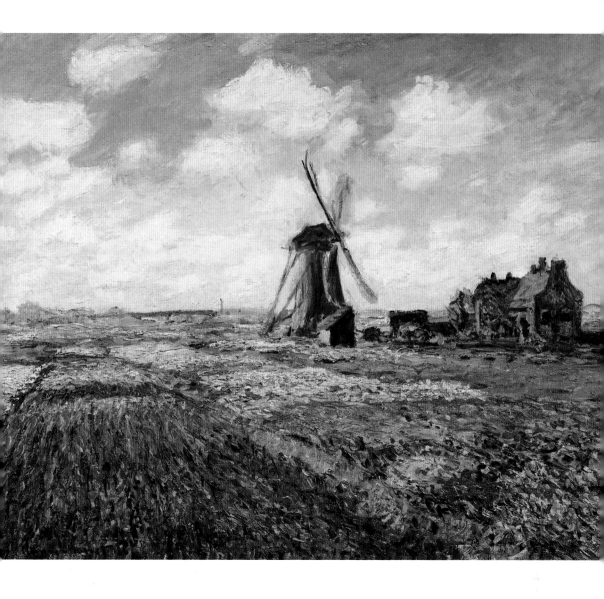

The Bridge at Vervy, 1889

Monet travelled to the wild Creuse Valley of central France in February 1889 and stayed until May. This painting trip resulted in one of his early major series of paintings that depict the same, or similar motifs under different weather and time conditions. The huge, rocky faces of the Creuse Valley provided him ample opportunity to investigate the changing colours on a solid form subjected to different types of light and atmosphere, and he produced around 20 canvases from the trip.

He set off with his friend, the art critic Gustave Geffroy (1855–1926), and the pair went to stay with Geffroy's friend, the poet Maurice Rollinat (1846–1903), in the Creuse Valley. From there Monet was able to travel to locations including the one pictured here. This dramatic view of the valley crossed by the elegant bridge at Vervy uses very different brushwork to contrast the rigid man-made structures of bridge and houses with the wild, organic river and hillside.

In June Monet shared an exhibition in Paris with Auguste Rodin (1840–1917), where he exhibited 14 of his Creuse Valley paintings.

PAINTED

Vervy

MEDIUM

Oil on canvas

SERIES/PERIOD/MOVEMENT

Creuse Valley series

SIMILAR WORKS

The Creuse in Summertime, Armand Jean Baptiste Guillaumin, 1895

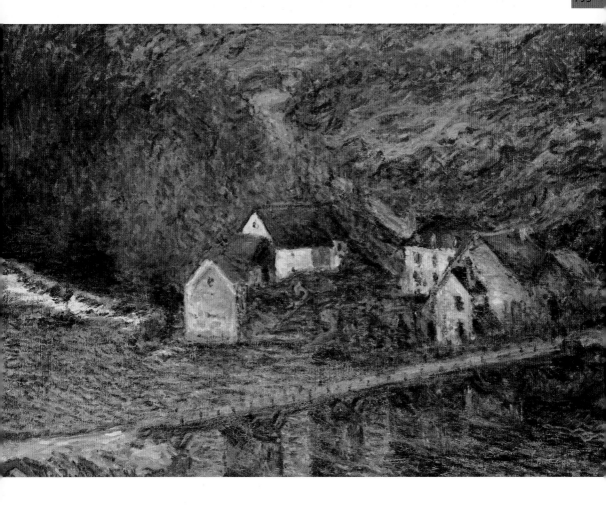

The Three Trees, Autumn, 1891

The poplar trees that lined the bank of the river Epte had been a favourite of Monet's for many years. In 1891, having completed his monumental and critically acclaimed haystacks series, he started on a new series depicting the poplars under the subtle effects of changing light and seasons. He worked on 23 paintings between the late spring and late autumn, mooring his boat on the Ile aux Orties on the bank of the river Epte above Giverny.

The thin trunks and small foliage of the poplars provided a wonderful grid composition. He painted all but four of the paintings from his boat, so that his viewpoint was from below, looking up to the trees. He further extended his dramatic composition by depicting the reflections of the trees as straight verticals, when they would actually not have appeared so in nature. The diagonal line of trees disappearing into the distance creates an added dimension.

The interplay of decorative composition and vivid colours, which go beyond nature, seem at once to represent the actual landscape and also the 'idea' of the landscape with an almost dreamlike quality.

PAINTED

Giverny

MEDIUM

Oil on canvas

SERIES/PERIOD/MOVEMENT

Poplars on the banks of the Epte

SIMILAR WORKS

Landscape with a River, Alfred Sisley, 1881

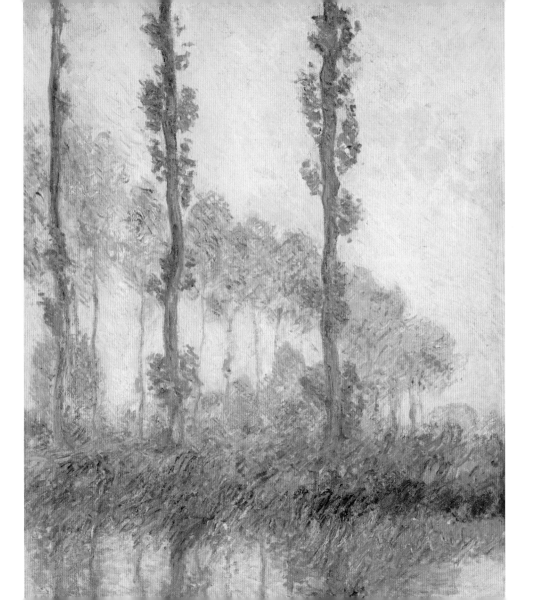

Mount Kolsaas in Sunlight, 1895

The first few winters at Giverny were relatively mild, certainly in comparison to those Monet had experienced at Vétheuil. He was fascinated by the effect of snowfall that would both transform a landscape and add a reflective quality to sunlight, and he missed painting this. In the winter of 1895 he went to stay with his stepson Jacques Hoschedé (1869–1941) in Norway. The vast snow-filled landscapes and the iced-over fjords provided the perfect subject matter for the artist, who eventually settled in Bjørnegaard, a small commune of artists.

There he painted a series of pictures based on Mount Kolsaas, which vividly recall the work of Japanese artists. He even said that the mountain made him 'dream of Fujiyama'. In another letter, this one to his stepdaughter Blanche Hoschedé (1865–1947), he wrote, 'it is impossible to conceive lovelier effects than there are here', implying that he was finding it difficult to capture the precise effect of colour and atmosphere as it appeared to him on the snow. The works were well received, and Prince Eugene of Sweden (1865–1947) travelled to Christiania (Oslo) to personally congratulate Monet.

PAINTED

Norway

MEDIUM

Oil on canvas

SERIES/PERIOD/MOVEMENT

Norwegian paintings

SIMILAR WORKS

Fuji in Clear Weather, Katsushika Hokusai, 1831

Winter Landscape, Pierre Bonnard, 1910

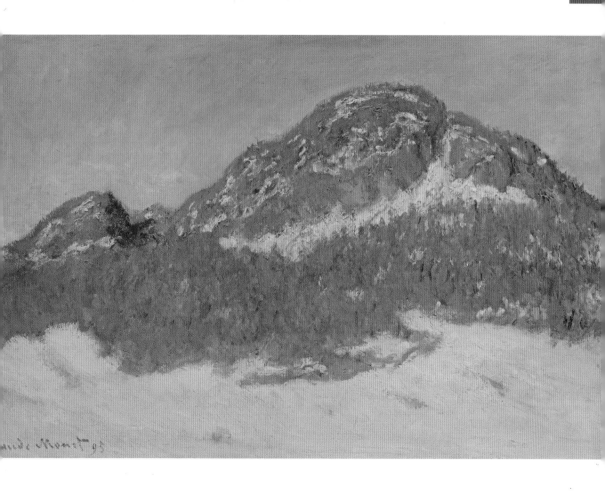

The Artist's Garden at Giverny, 1900

Throughout his life Monet had been an avid and knowledgeable gardener. It was at Giverny, however, his last home and the place he lived at for the longest, that his vision for a garden became a reality. He was meticulous in his approach to planning the garden, which expanded over the years to incorporate his now famous pond. Monet undertook extensive research for his garden and planned and planted his flowerbeds with the colour of his blooms and the time of their flowering foremost in his mind to produce a coherent aesthetic throughout.

His garden was a constant source of inspiration to him, particularly in later life, and included one especially important flowerbed planted in memory of his beloved aunt. The flowerbed was below the artist's bedroom window and was an exact copy of one that his aunt had had, and he had painted, at her home in Sainte-Adresse.

This painting, which was one of many of the garden, epitomizes Monet's use of brilliant colour to produce the effect of a radiant summer sun.

PAINTED

Giverny

MEDIUM

Oil on canvas

SERIES/PERIOD/MOVEMENT

Monet's garden

SIMILAR WORKS

The Garden at Arles, Vincent Van Gogh, 1888

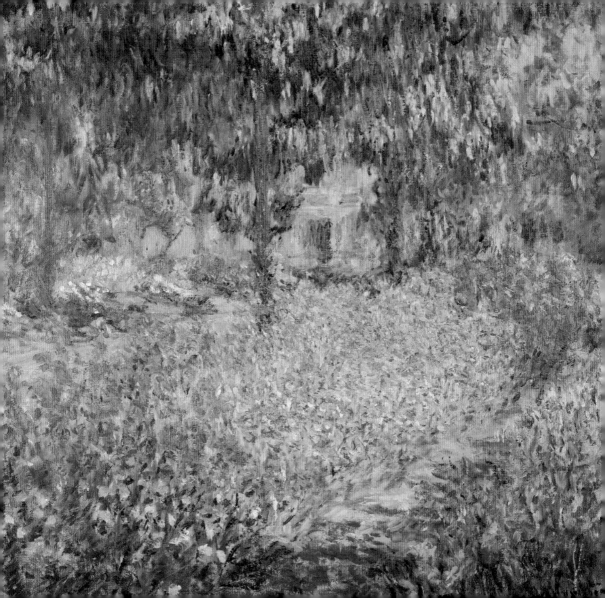

Charing Cross Bridge, The Thames, 1900–03

Private Collection/Photo © Christie's Images Ltd/The Bridgeman Art Library

During Monet's trips to London he would stay at the Savoy Hotel, which afforded him an excellent view of Waterloo Bridge in one direction and Charing Cross Bridge in the other. He painted a huge number of canvases of each of his subjects and would work on a number of canvases simultaneously. He worked extremely quickly and would, depending on the weather conditions and light, either start a new canvas or continue working on one that was closest to the conditions at the time.

The distinct horizontality of these paintings, especially those of Charing Cross Bridge and Waterloo Bridge, have been likened in compositional format to J. M. W. Turner's (1775–1851) technique of counterbalancing the verticality of the sun and its reflection with the horizontal planes of the bridges, and Monet was familiar with and enthusiastic about Turner's work. Bridges, however, had long been a recurrent motif for Monet, who found the bridges in London particularly appealing as they rose as solid structures from the fluid Thames, appearing from a thick veil of often opaque fog.

PAINTED

London

MEDIUM

Oil on canvas

SERIES/PERIOD/MOVEMENT

Late London series

SIMILAR WORKS

Sunrise – Gold and Grey, James Whistler, 1884

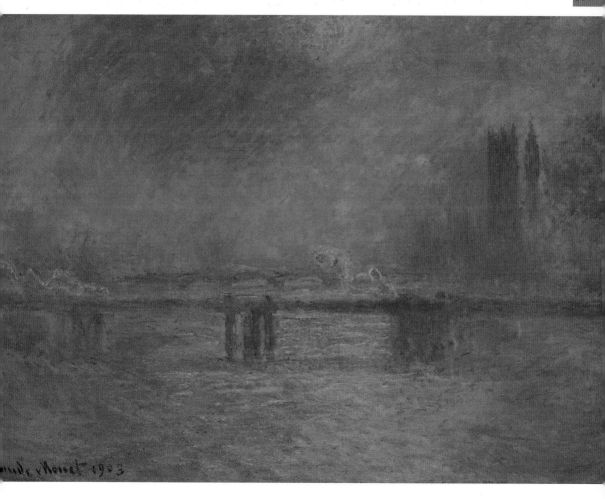

Parliament at Sunset, 1904

Monet had visited and painted London on three separate occasions by the time of his last major London series. He was particularly drawn to the effects of industrialism. The famous London smog provided Monet with a unique medium through which to convey his paintings of light and atmosphere. There was nowhere else where this particular effect was caught so well as in London and, in the hands of Monet, the ugly consequence of London's industrial growth was transformed into a thing of beauty.

His late London series produced around 95 canvases, grouped around three themes – Charing Cross Bridge, Waterloo Bridge and the Houses of Parliament. Monet and James Abbott McNeill Whistler (1834–1903) were friends having lodged together in the past. Monet's use of the subtitle *Symphonie en Rose* to his *Houses of Parliament* (1901) painting was a clear reference to Whistler's (who had just died) paintings. Monet's paintings of the Houses of Parliament were almost always painted at sunset or early evening, which afforded the greatest light effect on the buildings.

PAINTED

London

MEDIUM

Oil on canvas

SERIES/PERIOD/MOVEMENT

Late London series

SIMILAR WORKS

Dulwich College, Camille Pissarro, 1870

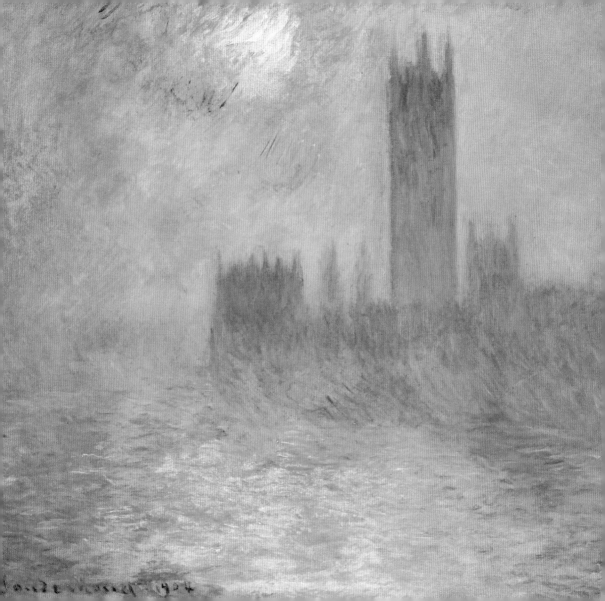

Le Palais Contarini, 1908

Monet travelled to Venice in 1908 with his wife Alice. Remarkably it was the artist's first trip to the artistic Mecca. He had been working intensively for five years on his monumental water lily paintings and had reached a period of stagnation and disappointment. Venice was to be a time of brief relaxation before returning to his series suitably revived. Instead, on arrival in Venice he was immediately gripped by the beauty of the city on the water, his favourite motif along with flowers, and embarked on an exhaustive period of intense creativity. The end result was 37 canvases, nearly all of which were completed after he returned home to Giverny.

Typically of his style, Monet chose just a few motifs and concentrated on producing series of paintings that captured the colours of the sun's reflection in the water and on the façades of the buildings. On arrival in the city he is said to have commented that it was 'too beautiful to be painted'. This seems not to have held him back as he produced vibrant, glowing canvases of an almost ethereal nature.

PAINTED

Venice

MEDIUM

Oil on canvas

SERIES/PERIOD/MOVEMENT

Venice series

SIMILAR WORKS

The Pink Palace, Hercules Brabazon, 1892

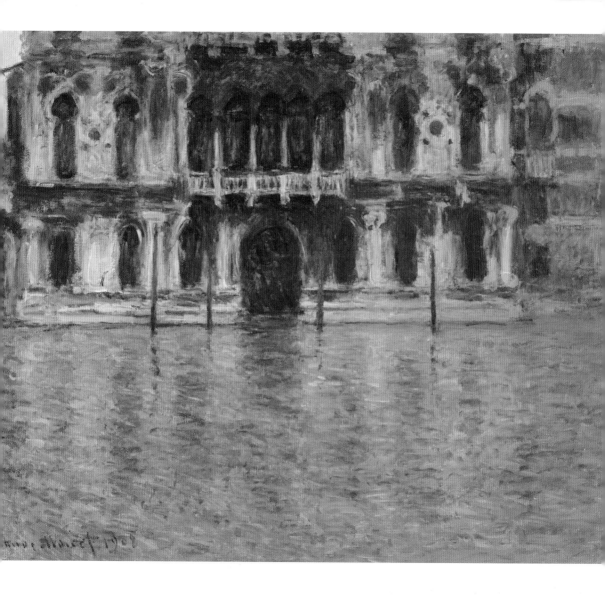

San Giorgio Maggiore, Venice, 1908

It is perhaps odd that Monet did not travel to Venice earlier in life. Indeed, it would have been interesting to compare the difference in his approach to the city had he painted it as a young man. These late pictures from Venice and his famous water lily series are truly the culmination of a career studying light and how to translate it through paint. His painting of San Giorgio Maggiore seen here positively vibrates with colour, energy and light, although the clear identification of place and subject are not lost.

In the preface to the exhibition of his Venice paintings in Paris, Octave Mirbeau (1848–1917) wrote, 'Claude Monet no longer captures light with the joy in conquest of one who, having seized his prey, holds on to it with clenched hands. He conveys it as the most intelligent of dancers conveys an emotion. Movements fuse and combine and we do not know how to break them down again. They are so smoothly interconnected that they seem to be but a single movement, and the dance is perfect as a circle.'

PAINTED

Venice

MEDIUM

Oil on canvas

SERIES/PERIOD/MOVEMENT

Venice series

SIMILAR WORKS

The Piazzetta and the Old Campanile, Venice Walter Sickert, c. 1901

San Giorgio and the Salute, Hercules Brabazon

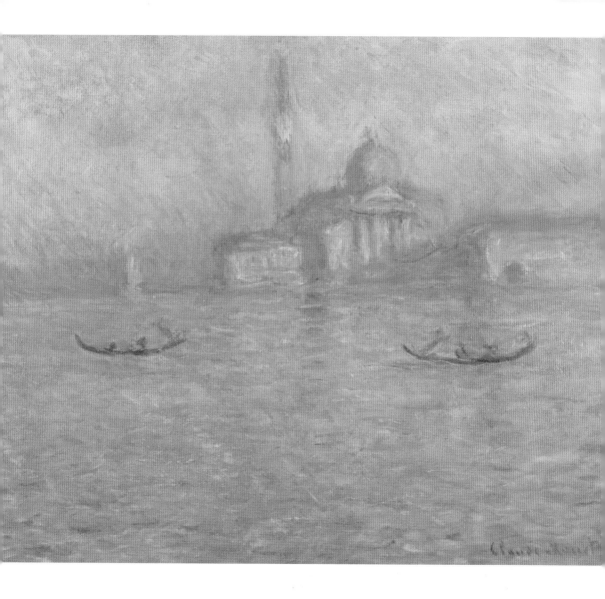

Venice – Rio de Santa Salute, 1908

Monet had spent some months struggling with his paintings of his beloved water lilies and pond, and was then further struck by failing eyesight, which his wife Alice put down to stress. These factors led to Monet's decision to take a break and travel to Venice. He was hugely productive while in the Italian city and returned to Giverny with a large number of canvases that he worked on in his studio. The Venice interlude also allowed him to tackle his water lily paintings with renewed vigour and enthusiasm.

His trip to Venice with Alice in the autumn was accompanied by rain. The poor weather had the effect of shrouding the city in mists and giving it a richly atmospheric effect. This painting of the Rio de Santa Salute is exquisitely coloured with the full force of a brilliant sun light after a period of rain, rendering the buildings and water in a wash of rose-pinks and underlying purple. The buildings appear an organic extension of the watery canals along which they sit, the one hardly distinguishable from the other.

PAINTED

Venice

MEDIUM

Oil on canvas

SERIES/PERIOD/MOVEMENT

Venice series

SIMILAR WORKS

San Giorgio Maggiore, Venice, Henri Eugene Augustin Le Sidaner, 1906

Boats in the Port of Honfleur, 1917

Monet had spent the summer and early autumn of 1868 painting in and around Honfleur. Late in life he returned to his earlier subject matter, and despite the most appalling tragedies in his personal life, not to mention the atrocities of the First World War, managed to paint this view of Honfleur's historic and picturesque port full of light and movement. Typically of Monet, his personal distress was not obviously present in his canvases, although manifested itself obliquely, for example through his creation of an enclosed and introverted world in his water lily paintings.

The port of Honfleur is famous for its beauty, lined with slate-fronted buildings and home to a plethora of active boats, but little of the specifics of the area's details are evident in this late painting. The artist's failing eyesight could in part account for the sketchy rendering, however it is probable that he was simply intending to capture a fleeting impression of the place from his younger days – much like a memory in which the details have faded but the essence remains.

PAINTED

Honfleur

MEDIUM

Oil on canvas

SERIES/PERIOD/MOVEMENT

Late works

SIMILAR WORKS

The Port at Honfleur, Eugène Boudin, 1896

Claude Monet on the Japanese Bridge in his garden at Giverny, c. 1920

© Musée Clemenceau, Paris, France/Archives Charmet/The Bridgeman Art Library

In 1893, 10 years after moving to Giverny, Monet managed to buy a piece of land adjacent to his garden dissected by the Ru, a tiny brook that came off the river Epte, a tributary of Monet's beloved Seine. On purchasing the property Monet set about constructing a pond to form a water garden, planting it with many beautiful and exotic plants.

In 1900, on his return from an exhausting painting trip in London, Monet set about an extensive enlargement of his pond, much to the chagrin of his neighbours who feared for their water supply and contamination through the artist's 'strange plants'. He employed a team of gardeners to work on the water garden and had his famous Japanese bridge constructed to which he added a wisteria arch. His final years were spent in this personal arcadia painting his giant water lily canvases, works of reflection and light presented in a wholly enclosed world. This photograph shows Monet in his idyll, his favourite place, but sadly at the end of his life without the companionship of his wife.

PHOTOGRAPHED

Giverny

MEDIUM

Black and white photograph

SERIES/PERIOD/MOVEMENT

Monet in his garden

SIMILAR WORKS

Monet on the Wisteria Covered Japanese Bridge, unknown, c. 1920

Twentieth-century French photographer, Dates unknown

THE W

GREATE

Monet

Influences

The Surrender at Breda, 1625, c. 1635

The Surrender at Breda has been called both the most 'Spanish' of Velasquez's works and also one of his most accomplished. The painting was one of 12 great works by various artists to commemorate the military triumphs of Philip IV's (1605–55) reign, and destined to hang in the Great Hall of the Palacio de Buen Retiro in Madrid.

On first glance there seems little in the work of the Spanish master that would be of obvious influence on Monet, but as a young man the French artist experimented with Spanish-style painting in the manner of Velasquez and of Francisco de Goya (1746–1828). This is most evident in Monet's painting, *Camille with a Small Dog*, of his lover, Camille Doncieux, which he made in 1866 two years after meeting her. Velasquez's influence is more prevalent in the work of Monet's contemporary Edouard Manet (1832–83), and it was Manet's painting that was of particular influence on Monet early in his career. Monet's treatment of his figures prior to 1870 reveals a debt to both Velasquez and Manet in his use of flat, dark tonal areas.

PAINTED

Madrid, Spain

MEDIUM

Oil on canvas

SERIES/PERIOD/MOVEMENT

Spanish nationalism

SIMILAR WORKS

Camille with a Small Dog, Claude Monet, 1866

Diego Rodriguez de Silva y Velasquez, *Born* 1599, Seville, Spain

Died 1660

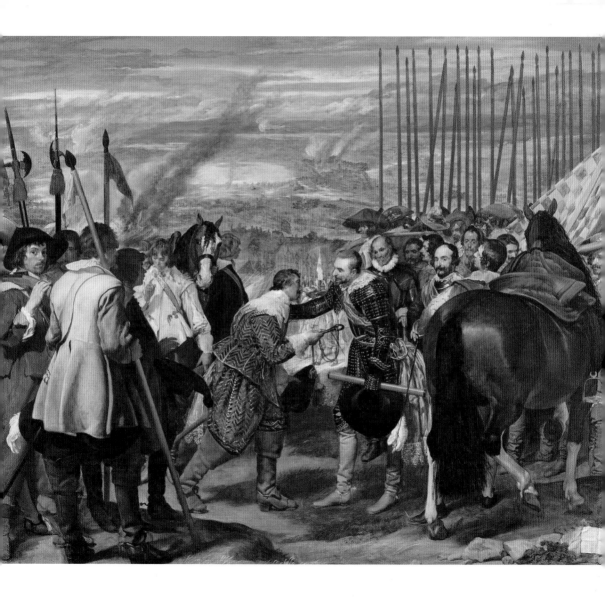

Malvern Hall from the South West, 1809 (detail)

The English landscape artists, such as Joseph Mallord William Turner (1775–1851), John Constable and the artists of the Norwich School, John Sell Cotman (1782–1842) and John Crome (1768–1861), were of enormous influence on the Impressionists. The English landscape artists had also helped to make the genre of landscape more accepted amongst the academics. Constable won a gold medal in the Paris Salon of 1824 for his painting *The Hay Wain* (1821), and Monet was aware of his, and other English artists' work, from an early age. However, he had not seen their works first-hand as Turner and the Norwich School artists had not exhibited in France.

So it was with great enthusiasm that Monet and his friend Camille Pissarro (1830–1903) viewed works by English artists while they were staying in England in 1871. Comparison, between Constable's treatment of the sky in this painting and Monet's treatment of the sky in *Hyde Park* (1871), shows clear similarities. Constable and Turner are both famous for their expression of atmosphere, weather effects and changing skies.

PAINTED

Malvern, England

MEDIUM

Oil on paper

SERIES/PERIOD/MOVEMENT

English landscapes

SIMILAR WORKS

Hyde Park, Claude Monet, 1871

John Constable, *Born* 1776 Suffolk, England

Died 1837

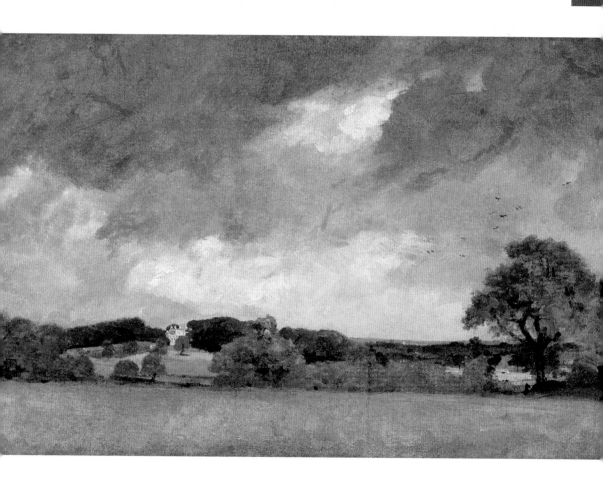

Dardagny, Morning, c. 1853

In 1878 the art critic Theodore Duret wrote a short booklet in praise of the Impressionists entitled, *The Impressionist Painters*. In it he named Jean-Baptiste-Camille Corot (1796–1875), Gustave Courbet (1819–77) and Manet as precursors to their work.

Monet first met Corot while studying at the Académie Suisse in Paris, where he had gone in 1859, and was greatly impressed by the older artist's work that he saw exhibited at the Paris Salon of the same year. Monet described Corot's paintings as 'simple marvels' and was much influenced by his depiction of pure, clear light. The Académie Suisse allowed students to work from live models and attracted a large number of artists. Corot frequented the studio, as did Courbet, and it was here that these artists, along with Pissarro and later Paul Cézanne (1839–1906) became friends. Over a decade later Corot, along with Charles-François Daubigny (1817–78) and Jean-François Millet (1814–75), championed Monet's cause at the Salon jury. When the rest of the jury rejected Monet's work, Corot and Daubigny were so outraged that they resigned their places on the jury.

PAINTED

Dardagny, Switzerland

MEDIUM

Oil on canvas

SERIES/PERIOD/MOVEMENT

Landscape

SIMILAR WORKS

The Road to Chailly, Claude Monet, 1865

Jean-Baptiste-Camille Corot, *Born* 1796 Paris, France

Died 1875

Footbridge over River with Wisteria in Foreground in Full Bloom, 1856

During the 1860s trade relations between Europe and Japan opened again and France in particular was flooded with Japanese art and artefacts, resulting in a fashion for all things Japanese. Japanese *Ukiyo-e* prints, which included landscape scenes, became hugely influential on the avant-garde artists especially Edgar Degas (1834–1917) and many of the Impressionists. Monet was fascinated by Japanese art and design, and throughout his life collected a substantial number of prints.

Monet structured his paintings using oblique angles often seen in Japanese woodblock prints. He was also interested in the concept of contemplation, which often underlies both Japanese prints and paintings, and can also be seen in the Japanese approach to the creation of gardens. Monet had probably seen examples of Japanese gardens at the *Exposition Universelle* of 1867 and 1878, and in 1891 a Japanese gardener advised Monet on the construction of his garden, and the bridge that spanned his pond is clearly Japanese in inspiration. Monet painted his water garden and bridge innumerable times, often recalling Hiroshige's print of 1856.

PAINTED

Japan

MEDIUM

Colour woodblock print

SERIES/PERIOD/MOVEMENT

Japanese landscapes

SIMILAR WORKS

The Water Lily Pond Harmony in Green, Claude Monet, 1899

Ando or Utagawa Hiroshige, *Born* 1797 Tokyo, Japan

Died 1858

The Picnic, 1862–63

Just before Manet's death in 1883, Monet commented that seeing the older artist's work for the first time in 1863 had been a 'revelation' and his own 'road to Damascus'. These were interesting words from Monet whose work eventually developed along very different lines from those first paintings of Manet. The works that had such impact were *Music in the Tuileries* (1862) and *The Picnic* (1862–63), exhibited at the Salon des Refuses.

The Picnic outraged the sensibilities of a conservative public, shocked by the two nude women juxtaposed with two dressed gentlemen eating lunch. Manet had looked to the mythological work of Titian (*c.* 1487–1576) and Giorgione (*c.* 1476–1510), but reworked these within a thoroughly modern context, producing a scene that reflected his own interest in Japanese techniques. Two years after seeing Manet's painting, Monet embarked on his own version, a mammoth canvas that was never completed and now exists in several large fragments only. There are clear parallels between the two in subject and style, but Monet's objective was to celebrate contemporary life, not to criticize the establishment.

PAINTED

Paris, France

MEDIUM

Oil on canvas

SERIES/PERIOD/MOVEMENT

Realist

SIMILAR WORKS

The Picnic, Claude Monet, 1865

Edouard Manet, *Born* 1832, Paris, France

Died 1883

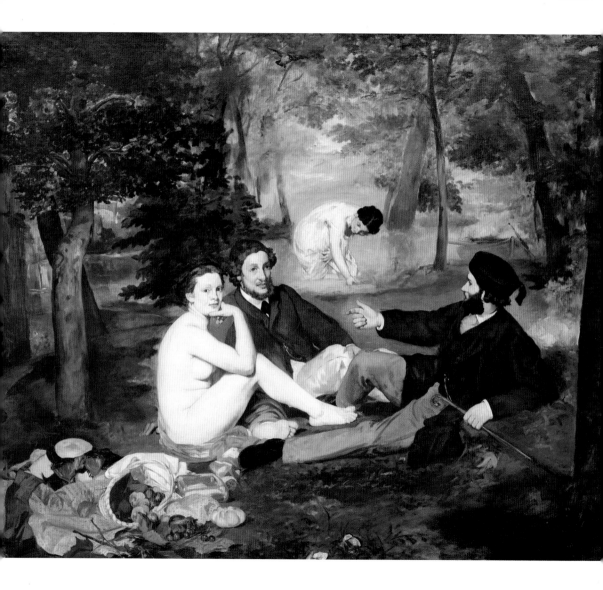

Blue and Silver: Trouville, c. 1865

The American-born artist Whistler arrived in Paris four years before Monet, quickly immersing himself in the bohemian artistic circles and joining Charles Gleyre's (1806–74) studio. Monet enrolled at *Atelier Gleyre* in 1862. By this time Whistler had met Henri Fantin-Latour (1836–1904) and joined the circle of friends that included Courbet and Manet. Whistler exhibited his painting *Symphony in White No 1: The White Girl* at the 1863 Salon des Refuses, the same exhibition in which Monet saw Manet's *The Picnic*.

In 1871, Monet visited Whistler in London and in 1886 the French artist spent a further two weeks with Whistler. At this time the two friends agreed to promote each other's work in their respective countries, and it was with Whistler's help that the Impressionists gained a credence in England.

Although Whistler and Monet differed greatly in their painting techniques, in terms of objective, their paths often overlapped. This is particularly evident in Whistler's atmospheric scenes such as *Blue and Silver: Trouville*, whose clear and sparkling light and soft, modulated colours evoke many of Monet's works, especially *The Shore* (1897).

PAINTED

Trouville, France

MEDIUM

Oil on canvas

SERIES/PERIOD/MOVEMENT

Atmospheric works

SIMILAR WORKS

The Shore, Claude Monet, 1897

James Abbott McNeill Whistler, *Born* 1834, Massachusetts, USA

Died 1903

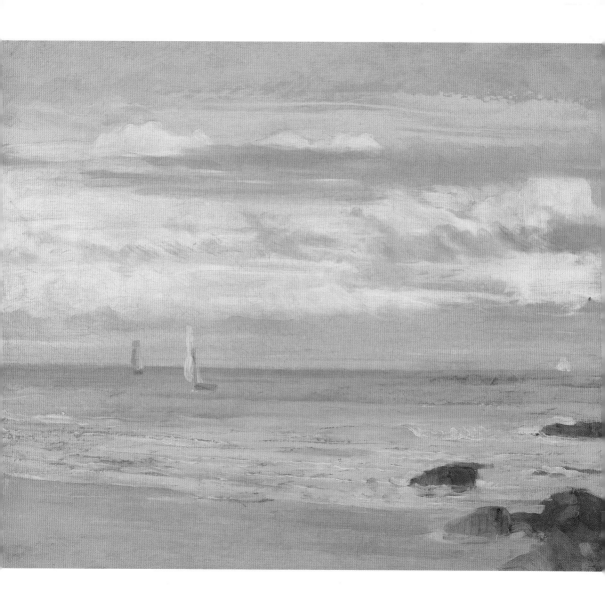

The Promenaders, or Bazille and Camille, 1865

Manet's scenes of contemporary French life greatly influenced Monet at the beginning of his career, although he would later reject painting the bourgeoisie at leisure in favour of his landscape motifs. After seeing Manet's controversial work, *The Picnic* in 1863, Monet later embarked on his own super-sized version and completed a number of studies for his giant work.

 The Promenaders was one of these, and depicts Monet's young lover Camille Doncieux and his close friend Frédéric Bazille (1841–70). There are aspects of Manet's influence here in, for example, the dark and flat rendering of Bazille's jacket and the heavy use of dark tones. However, Monet has concentrated predominantly on capturing the effect of brilliant sunlight as it filters down through the tree's canopies, using heavy white highlights with soft purple undertones. This approach and the attention to brilliant light is seen again in Manet's painting, *Argenteuil*, (1874), that depicts two young lovers bathed in the crystal light of a hot midday summer sun. Though achieved through different painterly techniques, a similar outcome can be seen in Bazille's painting *Family Reunion* (1867).

PAINTED

Fontainebleau Forest, France

MEDIUM

Oil on canvas

SERIES/PERIOD/MOVEMENT

Figurative

SIMILAR WORKS

Argenteuil, Edouard Manet, 1874

Family Reunion, Frederic Bazille, 1867

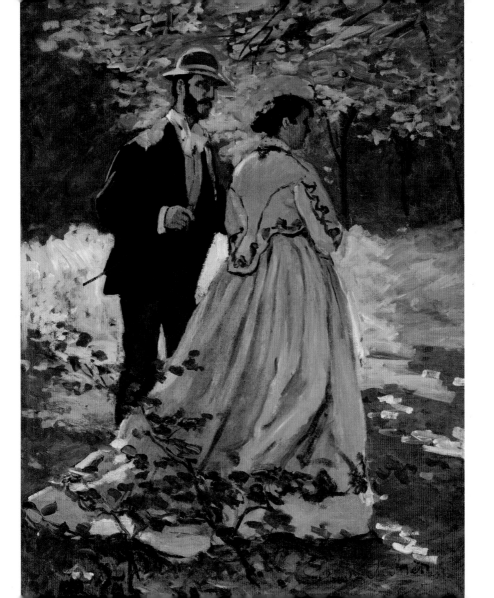

Sunset on the Sea Coast, 1865

When Monet first arrived in Paris in 1859, he wrote to his friend and mentor, the artist Eugène Boudin (1824–98), that he was greatly taken with the work of the Barbizon school, a group of Realist painters who worked in the environs of Barbizon on the edge of the forest of Fontainebleau. Amongst these were Constant Troyon (1810–65) and Boudin's friend, Daubigny. Daubigny was especially influential on the young group of Impressionist artists, and Monet wrote at the end of his life, 'Everything you have heard said of Daubigny and me is true, and I have reason to be very grateful to him ... he was enthusiastic about some of my Thames studies and he put me in touch with Monsieur Durand Ruel ... help like that one doesn't forget.'

This painting by Daubigny was one of many the artist made of the coast at Villerville, and is particularly richly coloured and impressionistic in style with rapid brushstrokes and bold use of pale highlights seen in the wave crests. He considered this area to be 'so beautiful that (I) have no desire to go anywhere else'.

PAINTED

Villerville, France

MEDIUM

Oil on panel

SERIES/PERIOD/MOVEMENT

Seascapes

SIMILAR WORKS

Impression, Sunrise, Claude Monet, 1872

Charles Francois Daubigny, *Born* 1817, Paris, France

Died 1878

The Evening (Lost Illusions), 1865–67

Monet entered Gleyre's studio in 1862 and later commented, 'Truth, life, nature, everything which aroused my emotions, everything which for me constituted ... the unique *raison d'etre* of art, did not exist for this man.' Pupil and the teacher had a strained relationship at times, but Monet's time there was defining in many ways. It was there that he met Pierre-Auguste Renoir (1841–1919), Alfred Sisley (1839–99) and Frédéric Bazille, who, along with Pissarro, formed the core of the avant-garde Impressionist artists.

Gleyre was a successful and respected Salon artist who retired early from public exhibiting and lived out a quiet life teaching. As the leader of the Neo-Greek painters, he worked in a meticulous, polished and highly finished manner, favouring subjects from the Classical world. Gleyre had a reputation for encouraging individualism, his only insistence being that his pupils study drawing, which Monet had already spent many years doing. It is likely that this was a primary objection between the two. Gleyre's style itself had marginal influence on Monet, but working alongside the other young, innovative painters was important, to all of them.

PAINTED

Paris, France

MEDIUM

Oil on canvas

SERIES/PERIOD/MOVEMENT

History painting

SIMILAR WORKS

Summer Scene, Frederic Bazille, 1869

The Luncheon, Claude Monet, 1868

Marc Charles Gabriel Gleyre, *Born* 1806, Chevilly, Vaud, Switzerland

Died 1874

View of the Port, or *The Windmills in Rotterdam*, 1870

© Musée des Beaux-Arts, Reims, France/Giraudon/The Bridgeman Art Library

Manet declared Jongkind to be 'the father of modern landscape' and Monet wrote that Jongkind 'completed the training that I have already had from Boudin. He became from this moment, my true master, and it is to him that I owe the final development of my painter's eye.'

Monet was already familiar with Jongkind's work when he met the artist in the summer of 1862 in Le Havre. Eugène Boudin, whom Monet often accompanied on painting trips was away painting in Honfleur and Trouville, and in his absence Monet affiliated himself with the Dutch artist. Jongkind's use of broad, rapid brushstrokes and his interest in the effects of weather and light were prominent early influences on Monet. Increasingly through his career Jongkind moved away from the Dutch landscape influence of his upbringing towards the fresh, brilliance of colour and light that is now most associated with the Impressionists. His work was greatly influential on the Impressionists as a group, and he is rightly cited as one of the early precursors to the movement.

PAINTED

Rotterdam, Holland

MEDIUM

Oil on canvas

SERIES/PERIOD/MOVEMENT

Realist, Dutch scenes

SIMILAR WORKS

The Wooden Bridge, Argenteuil, Claude Monet, 1872

Moonlight on Boulogne Harbour, Edouard Manet, 1868

Johan-Barthold Jongkind, *Born* 1819, Lattrop, the Netherlands *Died* 1891

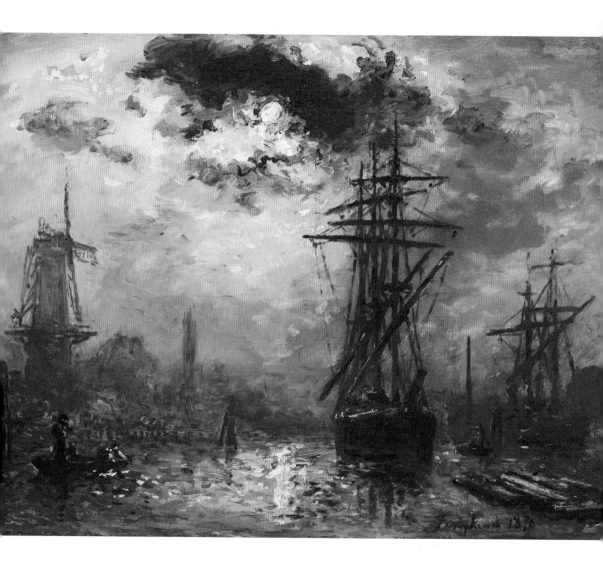

Hyde Park, c. 1871

Monet first travelled to London in October 1870, staying there for just under a year, during which time he met up with Pissarro. Both artists were taken under the wing of Paul Durand Ruel – 'But for him we would have starved in London,' Pissarro said of the dealer.

In London Monet and Pissarro visited museums and art exhibitions, and exposure to the works of Thomas Gainsborough (1717–88), Sir Thomas Lawrence (1769–1830), Sir Joshua Reynolds (1723–92) and the artists of the Norwich School was influential on both Monet and Pissarro, but the greatest influences would be those of Constable and Turner.

Whistler, too, had quite an impact on Monet's works, especially his paintings of Hyde Park. After Monet's first trip to London there was significant change in his application of colour and tone. Although they seem an unlikely pairing, the two artists became good friends and were very familiar with each other's work. This painting of Hyde Park is particularly reminiscent of Whistler, with its simple tonal base, and is an unusually sombre painting for Monet.

PAINTED

London

MEDIUM

Oil on canvas

SERIES/PERIOD/MOVEMENT

Early London paintings

SIMILAR WORKS

Limay, Jean-Baptiste-Camille Corot, 1870

The World's Fair in Paris, Edouard Manet, 1867

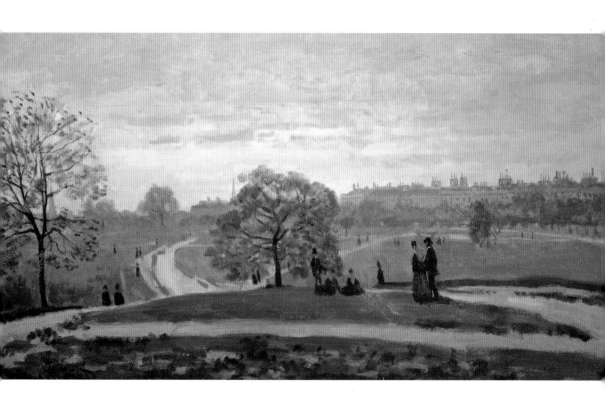

The Thames Below Westminster, 1871

Monet was one of a number of artists who fled to London during the Franco-Prussian war, including Pissarro, Boudin and Daubigny. It was, as it turned out, a prodigious move for Monet and Pissarro, who were greatly affected by seeing the work of British landscape artists.

Monet had met the artist Whistler in Paris, both of them part of the social scene that revolved around Café Guerbois. When Monet moved to London he would doubtlessly have visited the American artist and Whistler's atmospheric works were of some influence on the French artist. Monet was not particularly productive on this first trip to London, although he did paint several highly atmospheric scenes of the river Thames, with the characteristic London smog curling across the sky. The soft glow of the foggy sky behind the Houses of Parliament and the delicately painted bridge in this painting is reminiscent of Whistler's *Nocturne: Blue and Silver – Cremorne Lights* (1872). However, Monet makes the painting entirely his own by the inclusion of the dark jetty and the Impressionistic painting of the embankment, the dark boats and the trees.

PAINTED

London

MEDIUM

Oil on canvas

SERIES/PERIOD/MOVEMENT

Early Thames paintings

SIMILAR WORKS

Chelsea in Ice, James Whistler, 1864

Charing Cross Bridge, Camille Pissarro, 1890

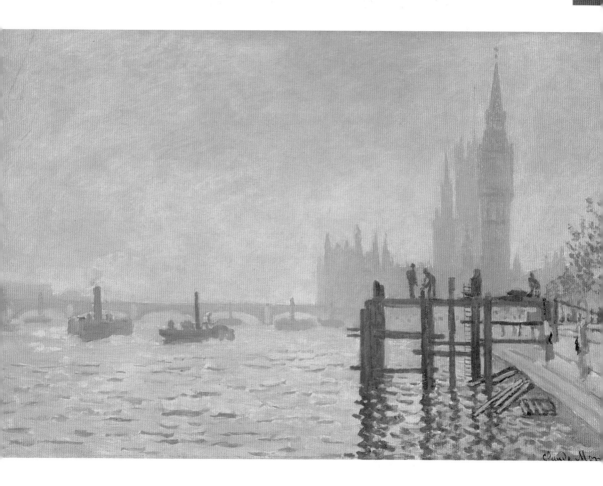

Claude M...

Meditation, or *Madame Monet on the Sofa*, c. 1871

Monet left London and his friend Whistler in 1871 and travelled to Holland, where he was much more productive, possibly because he was joined by his wife Camille and son Jean.

In the same year Monet painted this most untypical work depicting Camille reclining on a highly patterned sofa in an elegant room. Although Monet painted Camille frequently, he rarely painted with such attention to detail. He has borrowed much from the work of Whistler, who painted a number of pictures in a similar style, showing a single figure seated within a strongly structured background, such as his painting, *Portrait in Grey and Black No. 1, Portrait of the Artist's Mother*. The dark, tonal treatment of the figure and the use of weighty background tones also recall the work of Monet's friend Manet, in turn influenced by Velasquez. In start contrast to Monet's painting is a work of the same subject by Renoir several years later. Renoir's is all airy lightness, with the figure of Camille more Impressionist in style and wrought in pale, pastel tones.

PAINTED

Paris, France

MEDIUM

Oil on canvas

SERIES/PERIOD/MOVEMENT

Figurative

SIMILAR WORKS

Madame Monet Lying on a Sofa, Pierre-Auguste Renoir, 1874

Portrait in Grey and Black No. 1, Portrait of the Artist's Mother, James Whistler, 1871

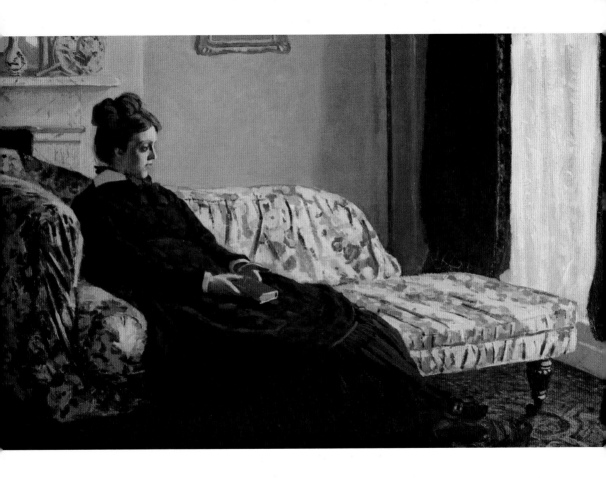

Wild Poppies near Argenteuil, 1873

'It takes immense genius to reproduce simply and sincerely what you see in front of you.' So wrote Edmond Duranty in *Le Realisme* (1856).

The paintings of the 1870s show Monet experimenting with the visualization of pure colour within the landscape, a practice that would be seen some years later in the work of the Neo-impressionists and Post-impressionists. He used contrasting colours, such as the red of his poppies and the green of the fields, to create the vividness so associated with Impressionist landscapes. Scenes such as *Wild Poppies near Argenteuil* provided him with the perfect subject matter for his exploration of colour. For Monet, Renoir and fellow Impressionists, the green of grass was not simply green, but made up of blues and yellows and all the colours that different light effects would produce; there were colours within colours; a shadow was more than just brown or black. Monet's dabs of pure colour and his understanding of the effects of tone and colour were later seen in the work of Georges Seurat (1859–91) as he developed his style of Neo-Impressionism.

PAINTED

Argenteuil

MEDIUM

Oil on canvas

SERIES/PERIOD/MOVEMENT

Impressionist

SIMILAR WORKS

Path Winding up through Tall Grass, Pierre-Auguste Renoir, 1876

Le Crotoy Looking Upstream, Georges Seurat, 1889

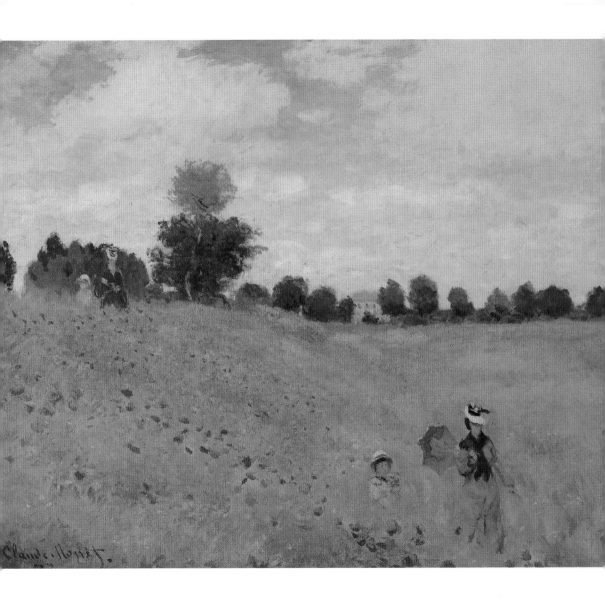

Effect of Snow at Argenteuil, 1874

At Gleyre's studio Monet became good friends with Sisley, Pissarro, Renoir and Bazille. Despite their very different temperaments and backgrounds, the four shared similar artistic goals and all were great proponents of painting *en plein air* and in front of the motif. Working closely together, they helped and influenced each other's development.

When Monet moved to Argenteuil, Sisley was one of the first guests to visit him and he stayed for some time, the two artists exploring and painting the area. Throughout his life Sisley devoted himself to painting landscape and to painting *en plein air*, to capture the subtle nuances of nature and atmosphere. He was captivated by snowy landscapes, much like Monet, and the opportunities that snow provided for changing light and colour. Both Monet and Sisley painted Argenteuil when blanketed by snow, seen here with a dazzling purity and brilliance under a sharp winter's sun. Although Monet finally earned critical respect and success towards the end of his life, Sisley was less fortunate and it was not until after his death that his importance as an Impressionist artist was recognized.

PAINTED

Argenteuil, France

MEDIUM

Oil on canvas

SERIES/PERIOD/MOVEMENT

Impressionist, winter scenes

SIMILAR WORKS

Entrance to the Village of Vétheuil in Winter, Claude Monet, 1880

Effect of Snow at Eragny, Camille Pissarro, *c.* 1886

Alfred Sisley, *Born* 1839, Paris, France

Died 1899

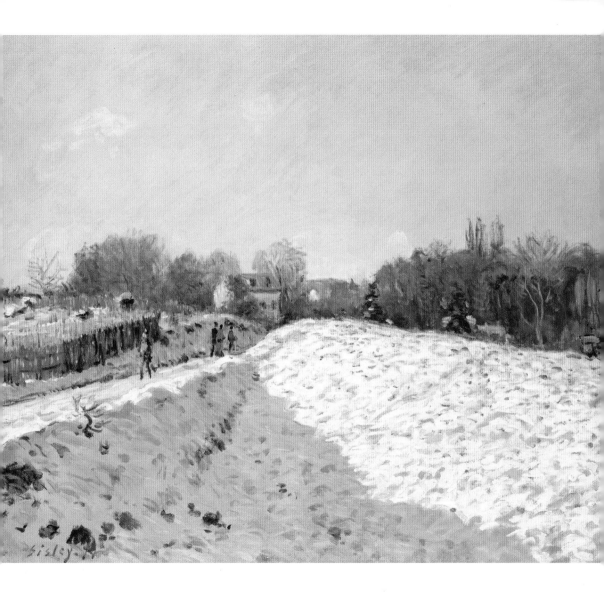

Camille Monet and a Child in the Artist's Garden in Argenteuil, 1875

© Museum of Fine Arts, Boston, Massachusetts, USA/Anonymous gift in memory of Mr and Mrs Edwin S. Webster/The Bridgeman Art Library

During Monet's lifetime there was a huge circle of artists and writers who shared and nurtured a bohemian culture. New ground was being broken in art and literature and there was an atmosphere of new ideas and theories, many of which were aired at the Café Guerbois in Paris. It was here that Monet was exposed to a wide range of work by many artists. Early influences on him were the works of Boudin and Jongkind, the Barbizon school of landscape artists, especially Daubigny, Corot and Millet, the Realist Courbet and the colours of Eugène Delacroix (1798–1863). Through Gleyre's studio he became involved with Renoir, Bazille, Sisley, Pissarro and later met Whistler. These artists frequently painted together, and influenced the development of each other's work, with many similarities seen between the early work of Renoir and Monet.

During the 1870s Monet was working from Argenteuil and produced a series of paintings of Camille in garden settings. These beautiful pictures full of golden light and blooming flowers were charming representations of the bourgeoisie at leisure, painted to sell to this market.

PAINTED

Argenteuil, France

MEDIUM

Oil on canvas

SERIES/PERIOD/MOVEMENT

Impressionist, figurative

SIMILAR WORKS

Young Woman with a Dog, Pierre-Auguste Renoir, 1880

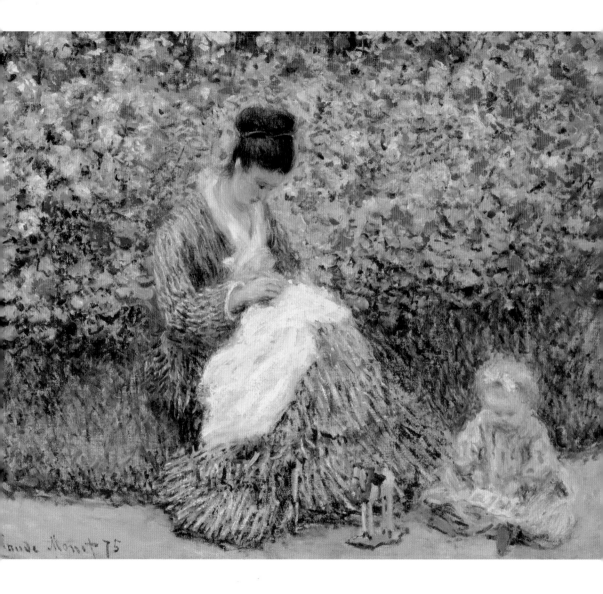

La Japonaise, 1876

This was a highly unusual painting for Monet and it is likely that he produced it in an attempt to match his earlier successful Salon piece, *Camille* (1866). *La Japonaise* depicts Camille in an overtly flirtatious engagement with the spectator, an attitude that was normally significantly absent from Monet's paintings, virtually without exception. The strongly painted Japanese robe and the head of the Japanese figure appear quite separate from the figure of Camille, making the robe an entity of its own. The obvious sexual placement and pose of the Japanese assailant figure is painted with striking realism, almost more so than the painting of Camille herself, who appears flat and stylized in contrast. In later years Monet referred to this painting as 'an obscenity'.

Monet was greatly influenced by Japanese art and culture, although his primary reference in this respect was to the use of oblique compositions in Oriental woodcuts and bird's-eye views. He was a keen collector of Japanese prints and would doubtlessly have attended the Japanese pavilion at the 1867 World's Fair and again in 1878.

PAINTED

Argenteuil

MEDIUM & DIMENSIONS

Oil on canvas

SERIES/PERIOD/MOVEMENT

Japanese-inspired works

SIMILAR WORKS

Caprice in Purple and Gold, No. 2: The Golden Screen, James Whistler, 1864

Purple and Rose: The Lange Leizen of the Six Marks, James Whistler, 1864

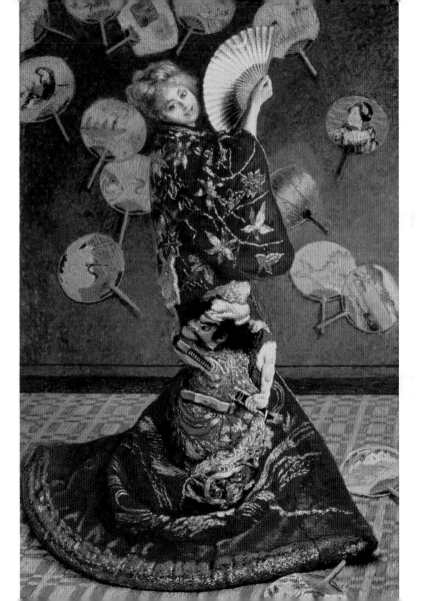

Still Life with Sunflowers, 1881

During the early 1880s Monet produced a number of still-life paintings of flowers in particular, including sunflowers and chrysanthemums. These small paintings were extremely popular with buyers, and Durand Ruel was able to purchase them from Monet and sell them on relatively easily. They were also useful 'poor weather projects' for the artist, who could paint them in his studio. Monet was an enthusiastic gardener and loved plants and flowers, painting his own flowers on frequent occasions. These still-life works are beautifully painted using small, detailed brushwork and a subtle mix of dark undertones with brilliant points of colour and highlights.

Sunflowers turn to follow the course of the sun and are symbolically associated with life-giving forces, making them a popular choice for artists and buyers alike. Some years after Monet's *Sunflower* still life, Vincent Van Gogh (1853–90) set upon a series of sunflower paintings to welcome his friend Paul Gauguin (1848–1903) to his house in Arles in 1888. There is every possibility that his paintings were influenced by Monet's, and there are parallels between the two in the use of colour and undertone.

PAINTED

Vétheuil

MEDIUM & DIMENSIONS

Oil on canvas

SERIES/PERIOD/MOVEMENT

Still life

SIMILAR WORKS

Sunflowers, Vincent Van Gogh, 1887

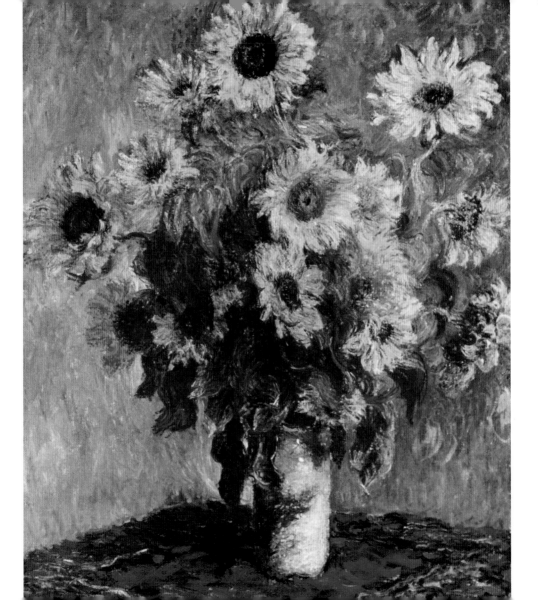

Sun Setting over the Seine at Lavacourt, 1880

In 1870 Monet and Pissarro viewed the works of English artists, including Turner's. There is little doubt that Turner's work made an impression, but Pissarro was somewhat critical. A book by Wynford Dewhurst on Impressionist painting upset the artist, who felt Dewhurst had attached too much significance to the influence of English painters. Pissarro wrote, 'This Mr Dewhurst ... says that before going to London Monet and I had no conception of light.... But what he doesn't realize is that Turner and Constable, while they taught us something, showed us in their works that they had no understanding of the analysis of shadow, which in Turner's painting is simply used as an effect, a mere absence of light.'

But for Monet at least, Turner's treatment of light and atmosphere, use of pure colour and exhaustive experiments with reflections in water would have chimed with the French artist's objectives.

This painting shows Monet using vivid colours to evoke the brilliance of the setting sun reflecting in the water. The sunset is reminiscent of Turner but also references Japanese art.

PAINTED

Lavacourt, France

MEDIUM

Oil on canvas

SERIES/PERIOD/MOVEMENT

Impressionist

SIMILAR WORKS

Entrance to the Straits of Gibraltar, Gustave Courbet, 1848

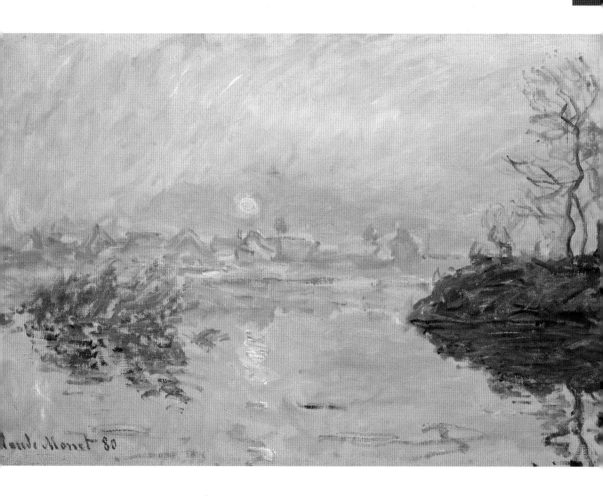

Claude Monet 80

Woman with a Parasol on the Beach, 1880

Monet wrote that as he watched Boudin work he was, 'overcome by a profound emotion ... More, I was enlightened'. Boudin was the first artist to make a significant impression on Monet, and it was Boudin who introduced him to *en plein air* painting.

Boudin was a marine painter and, like Monet, maintained a strong affiliation with water throughout his life. His gentle, quiet coastal scenes often depicting the middle classes at leisure on the beach are characterized by his quality of soft, filtered light and brilliant, translucent skies. Boudin was one of the first artists to consistently paint *en plein air* and believed that this was the only way to capture the scene. Monet considered Boudin his first teacher and referred to him as 'King of the skies'. They remained friends throughout their lives, and 30 years after they first met Monet wrote in a letter to him, 'You know the affection I have always cherished for you, and the gratitude. I have not forgotten that you were the one who first taught me to see, and to understand what I saw.'

PAINTED

Normandy coast, France

MEDIUM

Oil on canvas

SERIES/PERIOD/MOVEMENT

Coastal scenes

SIMILAR WORKS

Camille on the Beach at Trouville, Claude Monet, 1870

Eugène Louis Boudin, *Born* 1824, Honfleur, France

Died 1898

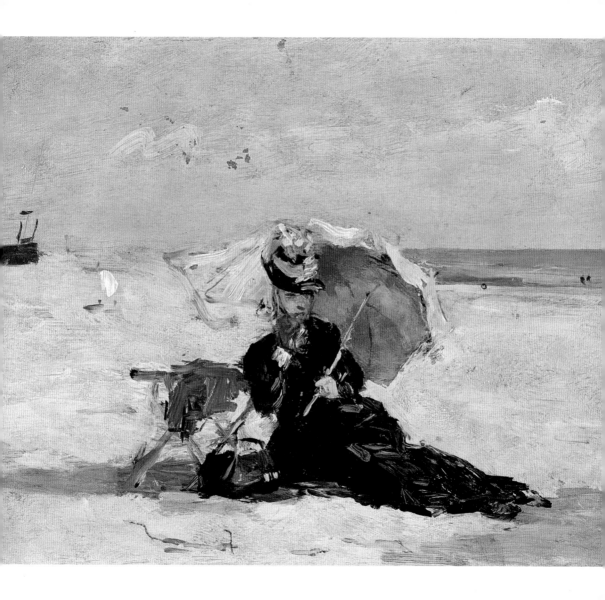

Spring, 1880–82

Depiction of the seasons with the different light, weather and colours that these changing times of year brought was a great inspiration to Monet, who furthered his exploration of light and time effects on scenery from the middle of his career onwards. This scene with its puffy spring clouds and brilliant colours is reminiscent of Renoir's work, and Renoir and Monet borrowed and learnt from one another. Here Monet has treated the foreground and middle ground with short, stubby brushstrokes loaded with pigment. They have the appearance of being worked quickly across the canvas with a rhythm that creates a sense of movement through the grass and the delicately painted tree.

His treatment of the tree with its fine branches and silvery-green leaves, painted with vigorous but small brushstrokes, is also seen in Renoir's work of a similar period. So too is the use of small, dark daubs of paint through the tree, which greatly adds to its depth and three-dimensional structure.

PAINTED

Along the Seine, France

MEDIUM

Oil on canvas

SERIES/PERIOD/MOVEMENT

Impressionist

SIMILAR WORKS

Orchard in Spring, Alfred Sisley, 1881

Railway Bridge at Chatou, Pierre-Auguste Renoir, 1881

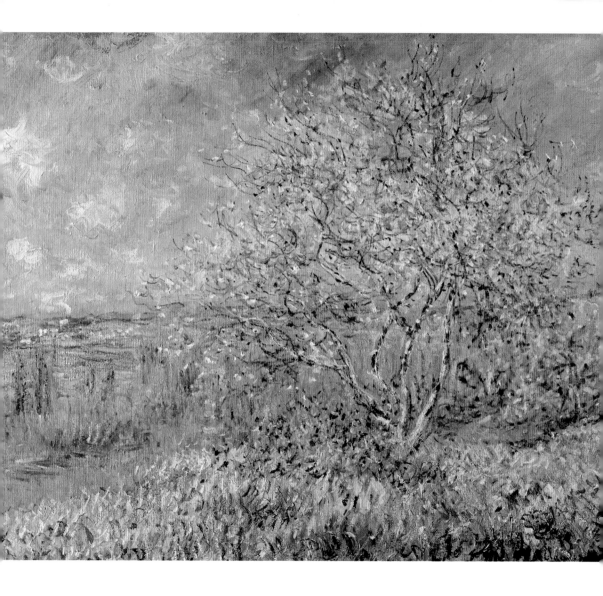

Sunset on the Sea at Pourville, 1882

During 1882 Monet painted over two dozen pictures from Pourville and Varengeville. In almost all these scenes he emphasized the enormity of nature in relation to the frailty of people, and the incongruence of man-made features within the natural landscape. These pictures also highlight his developing approach to depicting different light through colour and effect through his brushstrokes.

In *Sunset on the Sea at Pourville* he has completely removed any subject other than the simple effect of the sun setting on the sea, so the painting is free from any distracting motifs. His colours have become unnatural to the human eye and yet create the very colours that make up the prisms of light in nature. The sea and the sky almost become one, the former reflecting the latter, and the picture can be looked at as being an abstract vision through flat colour planes.

Increasingly Monet was becoming absorbed in the depiction of light, leading towards his great series paintings from the 1880s onwards, the *Haystacks*, the *Poplars, Rouen Cathedral, London, Venice* and the monumental water lily series.

PAINTED

Pourville

MEDIUM

Oil on canvas

SERIES/PERIOD/MOVEMENT

Seascapes

SIMILAR WORKS

Ciel D'Orage Sur Dieppe, Pierre Prins, 1880

Les Iles D'Or, Henri-Edmond Cross, 1891–92

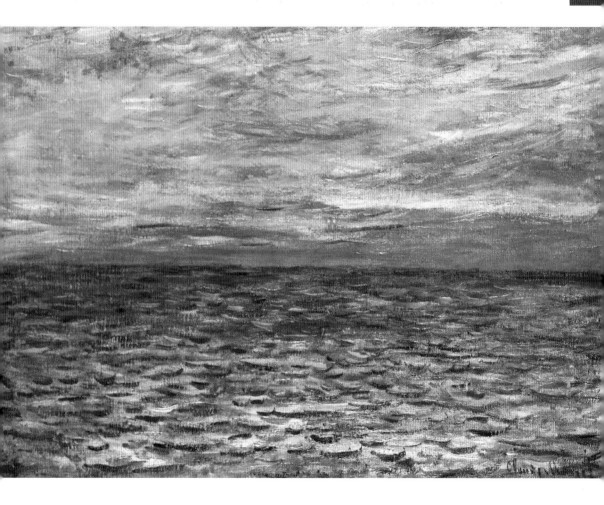

The Blute-Fin Windmill, Montmartre, 1886

Art Gallery and Museum, Kelvingrove, Glasgow, Scotland/© Culture and Sport Glasgow (Museums)/The Bridgeman Art Library

Vincent Van Gogh painted this scene of the historic Blute-Fin mill the year that he arrived in Paris from Antwerp, and already it reveals the influence of the Impressionist artists in his use of clear colour and crystal sky. It had been a big move for the young artist, who found himself immersed in Paris's heady artistic climate. He was exposed to a tremendous range of art and artists, which included the Impressionists and the younger generation of innovative artists such as Georges Seurat (1859–91), Paul Signac (1863–1935) and Emile Bernard (1868–1941). Pissarro was one of the first artists to befriend Van Gogh, and the older, fatherly artist continued their friendship until Van Gogh's death.

Vincent's brother Theo (1857–91) ran the Boussod & Valadon gallery, exhibiting works by the avant-garde artists of the day, and the year after Van Gogh painted this scene, Theo began to purchase works from Monet in sizeable numbers. Following Van Gogh's arrival in Paris his palette lightened and his painting technique showed a direct impressionistic influence, including rapid, loaded brushstrokes and the use of brilliant colour.

PAINTED

Paris, France

MEDIUM

Oil on canvas

SERIES/PERIOD/MOVEMENT

Impressionist, windmills

SIMILAR WORKS

Tulip Fields Near Leiden, Claude Monet, 1886

Vincent Van Gogh, *Born* 1853, Groot-Zundert, Netherlands

Died 1890

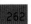

In the Woods at Giverny, 1887

Monet formed a close relationship with his two eldest stepdaughters, Suzanne and Blanche Hoschedé, who appear in this sun-filled painting and many others. Blanche began to paint when she was around 11 years old, and fell under Monet's guiding eye when his family and the Hoschedés moved in together at Vetheuil in 1878. Blanche spent many hours painting alongside Monet, acting as his assistant and carrying his easel for him in a wheelbarrow. She married his son Jean (1867–1913) in 1897, while her sister Suzanne married the American Impressionist Theodore Earl Butler (1861–1936).

Blanche's painting style is very similar to Monet's, her early style based almost purely on his. He helped and guided her with her painting, and she worked in a purely impressionistic style throughout her life. Despite painting for pleasure and not commercially, her works are very accomplished and frequently reflect the same subjects that Monet was painting. After Jean's death in 1914 she devoted her life to looking after Monet and stopped painting altogether after his death.

PAINTED

Giverny, France

MEDIUM

Oil on canvas

SERIES/PERIOD/MOVEMENT

Impressionist, Giverny works

SIMILAR WORKS

House and Garden of Claude Monet, Blanche Hoschedé-Monet

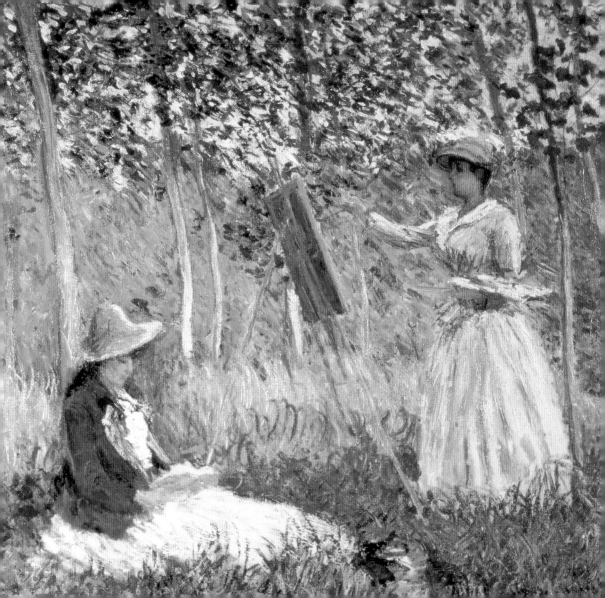

Vernon Church in Fog, 1893

Monet was fascinated by the effects on the landscape of changing colour and light, delivered through different weather conditions. He was particularly inspired by fog, and travelled to London on a number of occasions to paint ghostly skylines shrouded in the city's dense smog. Painting fog allowed him to create a very particular type of filtered light, through which he emphasized the colours of the landscape. His painting of the *Church at Vernon*, for example, contains far greater levels of colour, of soft-pink turning to violet and hazy blue, than would normally be seen, but the artist took the landscape under these conditions as a starting point and then exaggerated the colours to create the precise sensation that he experienced.

He painted a series of six views of the pretty Vernon church under different conditions, creating a sequence of personal experience as typified by his series paintings such as those of *Rouen Cathedral* (1891–94). This practice of exaggerating the colours from the real to the perceived was fundamental to the work of the Post-impressionists following in Monet's footsteps.

PAINTED

Vernon, France

MEDIUM

Oil on canvas

SERIES/PERIOD/MOVEMENT

Impressionist, atmospheric effects

SIMILAR WORKS

The Fog, Alfred Sisley, 1874

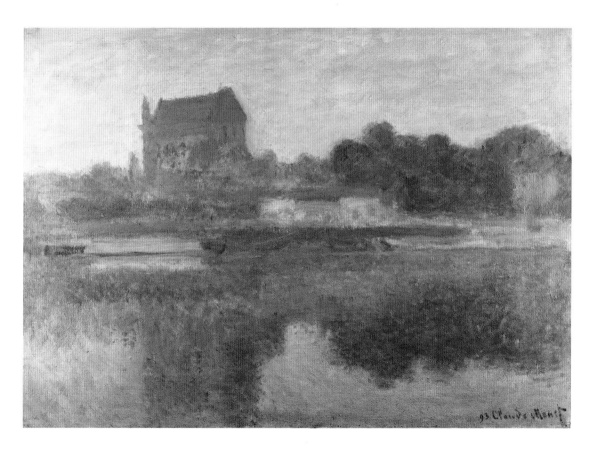

Nympheas, c. 1905

Monet's giant *Nympheas* (water lilies) series was the culmination of his life's work. These paintings show him combining all those motifs that he most loved to paint: his garden, water and the effect of light and seasons on both. By this time Monet was financially stable and able to exhibit and sell his canvases with ease. After a long journey and much hardship he had finally achieved the status he sought, further cemented by the State commission for his water lily paintings, which would eventually hang in the Orangerie in the Tuileries.

His garden became his world in his final years and he spent the last three decades of his life recording it, experimenting with different views and techniques. By 1905 and the time of *Nympheas*, he had eliminated conventional viewpoints with a horizon and instead was solely concentrated on the flat surface of the pond. His compositions focused on the horizontals of the water lilies and cloud reflections and the verticals of the reflected trees and reeds. The juxtaposition of these elements, both real and reflected, added depth and a dream-like quality.

PAINTED

Giverny

MEDIUM

Oil on canvas

SERIES/PERIOD/MOVEMENT

Water lily series

SIMILAR WORKS

A Rose Trellis (Roses at Oxfordshire), John Singer Sargent, c. 1886

Thistles, John Singer Sargent, c. 1883

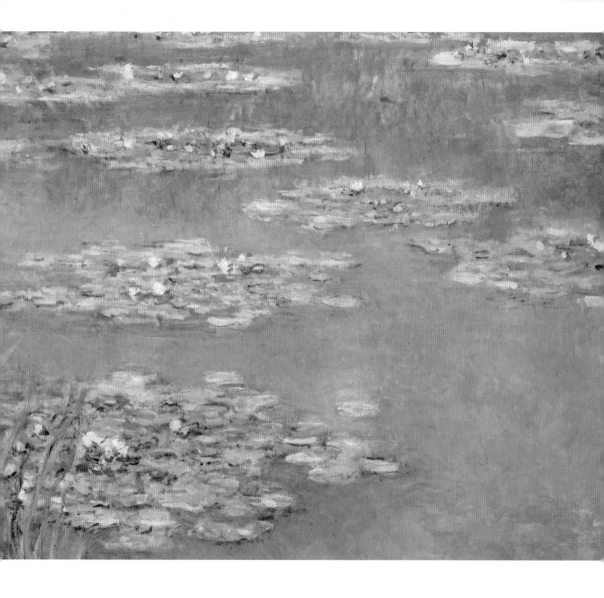

Path in a Wood, 1910

© Musée Renoir, Les Collettes, Cagnes-sur-Mer, France/Giraudon/The Bridgeman Art Library

Following Renoir's death in 1919, Monet wrote, 'Renoir's death has been a great sorrow to me; he has taken with him a part of my life. ... it is hard to carry on alone, though it certainly won't be for long ...'. The two artists had first met in 1862 at Gleyre's studio and enjoyed a friendship and mutual respect throughout the years. Monet and Renoir frequently worked alongside each other, often painting the same motif, rendering it differently but with clear parallels. As Monet increasingly turned to landscape themes, his garden and his family, Renoir embarked on a slightly different course, focusing on family scenes and nudes.

This late work by Renoir, despite his stylistic differences from Monet, shows underlying foundations seen in the work of both. Renoir's absorption with the depiction of light is most apparent; the scene is saturated in a soft, modulated summer light that reflects on trees and figures alike. As in Monet's works, the figures in this painting have been reduced to a small extension of the landscape, losing their identity amidst the organic world.

PAINTED

Cagnes-sur-Mer, France

MEDIUM

Oil on canvas

SERIES/PERIOD/MOVEMENT

Impressionist

SIMILAR WORKS

A Pathway in Monet's Garden, Claude Monet, 1902

Pierre-Auguste Renoir, *Born* 1841, Limoges, Haute-Vienne, France

Died 1919

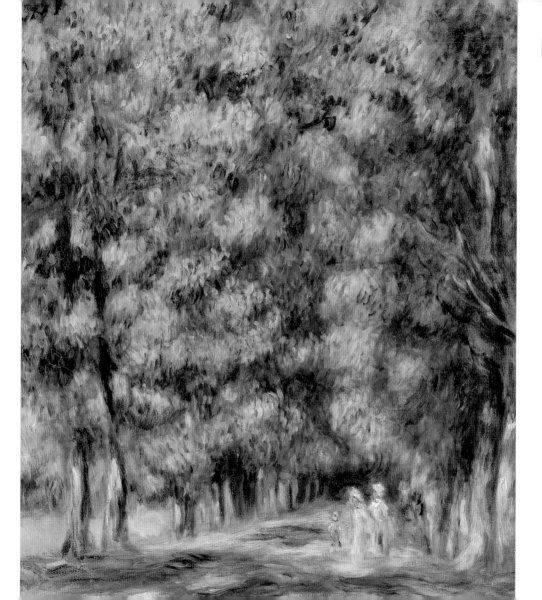

Sunset, Giverny, 1910

In the late nineteenth century there was an influx of young American painters wishing to study art in Paris. In 1873 the artist Carolus Duran (1837–1917), who was good friends with Monet, opened a studio and began taking in large numbers of American students, including Theodore Butler and John Singer Sargent (1856–1925), and introducing them to the work of the Impressionists. By 1876 Monet and Sargent had become close friends; he would be one of only a handful of artists to paint in Monet's garden.

After Monet moved to Giverny in 1883, the village became a Mecca for American artists, including Butler who moved there in 1888. Butler married Monet's stepdaughter Suzanne in 1892 in Giverny and the event was painted by Butler's friend Theodore Robinson (1852–96).

Monet remained a great draw for American artists, who flocked to Giverny, and his influence was significant. Butler worked in a loose impressionistic manner with free, swift brushstrokes and often exaggerated colour. This painting reflects his combination of broad, flat strokes with tiny, delicate modelling, and is almost symbolist in feel.

PAINTED

Giverny, France

MEDIUM

Oil on canvas

SERIES/PERIOD/MOVEMENT

Impressionist

SIMILAR WORKS

Oranges at Corfu, John Singer Sargent, 1909

Miss Motes and her Dog Shep, Theodore Robinson, 1893

Theodore Earl Butler, *Born* 1861, Columbus, Ohio, USA

Died 1937

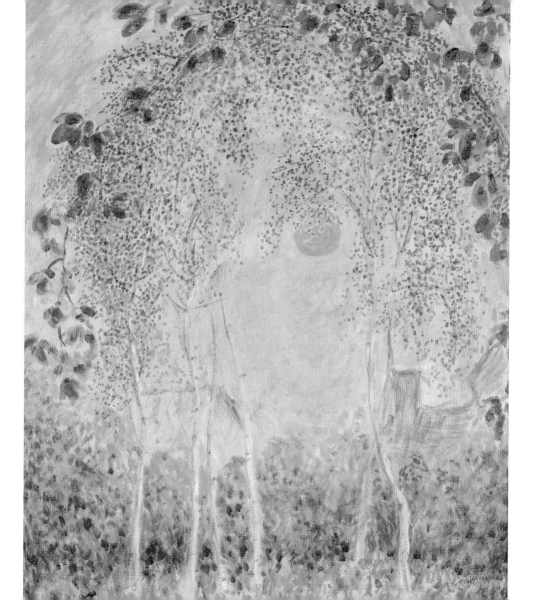

Water Lilies: Morning, 1914–18 (detail)

When Monet came back to his water lily paintings in 1914 following the death of his beloved wife Alice in 1911, he made some radical changes in his approach, namely in the scale of the canvases. They were monumental in scale, most measuring around two metres (six feet) square. He also changed his palette and used brilliant spots of colour to suggest the flowers.

Monet was a painter of impressions to the end, his last 30 years of painting devoted to the depiction of light and reflection on his pond. The depths beneath the surface of the water and the space behind the picture frame were of utmost importance to him and he finally dispensed with frames altogether, so his paintings could become a continuum of the world around him. His avant-garde approach and his extraordinary use of paint and colour began the trail for subsequent art movements: his contemporary Paul Cézanne became affiliated with Post-impressionism; Henri Matisse (1869–1954), who had studied Monet, became of the first of the Expressionist artists; while Whistler was associated with the Symbolists.

PAINTED

Giverny

MEDIUM

Oil on canvas

SERIES/PERIOD/MOVEMENT

Late Water lily series

SERIES/PERIOD/MOVEMENT

Impressionist, water lily series

SIMILAR WORKS

Vase of Flowers, Odilon Redon, 1865

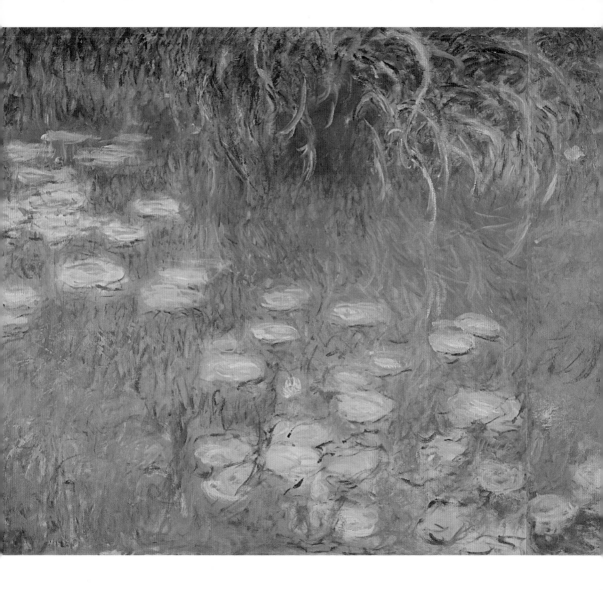

Scent, 1955

By the time of Monet's death in 1926 the art world, both in Paris and in America, was a very different place from the one he had largely struggled against during much of his life. Monet and his circle were the first to truly challenge the conventions of Parisian art in the modern age, and by doing so and progressing their works towards greater understanding of colour and light, they opened the door for successive generations of artists. Monet and his contemporaries broke down barriers and persevered in their artistic quest against great hardship in order to achieve a freedom of expression that is now taken for granted.

Towards the end of his life, Monet's work increasingly reflected a form of abstraction through his simplification of composition and reduction of all unessential elements. By doing this and through his obliquely structured compositions and focus on pure vivid colour, he set a precedent for later artists, particularly those of the Post-impressionist, Expressionist and Abstract-expressionist movements.

PAINTED

USA

MEDIUM

Oil on canvas

SERIES/PERIOD/MOVEMENT

Abstract Expressionist

SIMILAR WORKS

The Artist's House from the Rose Garden, Claude Monet, 1922–24

Jackson Pollock, *Born* 1912, Cody, Wyoming USA

Died 1956

Sea Piece (Wave), 1969

From the beginning of his long career to its end, Monet focused almost exclusively on the depiction of the fleeting moment, a moment changed by light effects, weather and time. His style developed and evolved, but always with the primary objective maintained. He made the greatest steps in this direction through his series of paintings of the same motif under different conditions.

Towards his final years, and suffering from problems with his eyesight, the artist reduced the elements in his compositions, and in so doing created works that were simultaneously monumentally simple and complex. These paintings were often radical compositions, skyless, airless, with no horizon and yet with infinite depths below the surface of water. Alongside these compositions, that at times recalled the work of Japanese prints, he furthered his experiments with colour resulting in sublime works of brilliant tones.

Monet's influence has extended across modern art movements through much of the Western world, from the work of the Post-impressionists, the Expressionists, and abstract artists to contemporary visionary artists such Richter and to the painter of the modern landscape.

PAINTED

Germany

MEDIUM

Oil on canvas

SERIES/PERIOD/MOVEMENT

Seascapes

SIMILAR WORKS

Water Lilies, Claude Monet, *c.* 1920-26

Gerhard Richter *Born* 1932, Dresden, Germany

Styles & Techniques

Sunset at Sea, c. 1862–64

At the very beginning of his career Monet underwent a defining change in style and direction. As a young boy he had exhibited considerable talent as a draftsman, with his earliest known works being wicked caricatures, brilliantly drawn and poking fun at his school teachers. These drawings revealed the artist's inherent artistic ability, his sense of humour, and indicate a subversive side to the man who would later defy artistic conventions and lead a new generation of artists.

Shortly after making the decision to leave school before his final exams to become an artist, Monet changed his direction completely, leaving precise and linear draftsmanship behind him, and began to paint (and draw in charcoal) landscapes. Early landscapes such as this show a lyrical use of colour and the artist's interest in light effects, something that would preoccupy his work for the rest of his life. Here he has painted in the manner of Johan Barthold Jongkind (1819–91) and Eugène Boudin (1824–98), and has used streaks of delicate colour – lilac, pinks, oranges and green – applied smoothly and with strong horizontal accents.

PAINTED

Normandy coast

MEDIUM

Pastel on buff paper

SERIES/PERIOD/MOVEMENT

Early

SIMILAR WORKS

Port Vendres, Johan Barthold Jongkind

Fishing Boats, Eugène Boudin

Terrace at Sainte-Adresse, 1867

Scenes of the fashionable bourgeoisie at leisure were a favoured subject matter for many of the young artists of the day. Although Monet later abandoned these subjects, he painted them with enthusiasm, nearly always choosing scenes involving either water, flowers or landscape.

In this sun-filled painting, Monet has depicted his family at his aunt's house in Sainte-Adresse. His father is seated in the foreground and his aunt and an unknown man appear in the middle ground. The two empty chairs probably represent Monet and Camille. Monet had argued extensively with his father over his relationship with Camille and, at the time of this painting, his father was under the impression that Monet had ended the relationship. In fact she was in Paris waiting for him, soon to give birth to his first child.

Glimpses of Monet's future artistic development can be seen in his treatment of the flowers, wrought in vibrant colours with short, blocky brushstrokes. In contrast, the figures and the garden furniture are tightly painted and sharply delineated with much use of white highlights.

PAINTED

Sainte-Adresse

MEDIUM

Oil on canvas

SERIES/PERIOD/MOVEMENT

Early

SIMILAR WORKS

Family Reunion, Frédéric Bazille, 1867

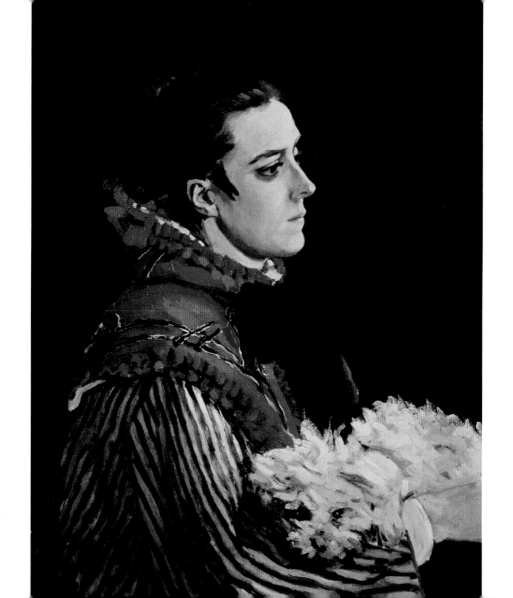

Camille Monet in a Red Cape, 1866

When Monet moved to Paris in 1859 he was exposed to the work of a wealth of different artists, amongst whom Edouard Manet (1832–83) made an initial and lasting impact. There is a clear debt in many of Monet's early paintings to Manet's work, and through him also to the work of Spanish artists such as Diego Velasquez (1599–1660) and Francisco Goya (1746–1828). In 1866 Monet began to experiment with his painting style and adopted that of the aforementioned artists, which is seen to best effect in this painting and another of Camille, *Woman in a Green Dress*.

In both portraits of Camille, the figure is set against a dark background with heavy use of dark tones against which Camille's flesh softly modelled. In the portrait seen here, Monet has accented the dark, tonal quality into which the figure recedes with the use of brilliant, rich red and white, creating a work of stark contrasts: Camille is in a formal and stiff pose yet he has used fluid, smooth brushstrokes; the dog is clearly wriggling about, providing movement against Camille's stillness.

PAINTED

Paris

MEDIUM

Oil on canvas

SERIES/PERIOD/MOVEMENT

Early

SIMILAR WORKS

Michael Harcourt, Diego Velasquez

Madame Manet, Edouard Manet, 1869–70

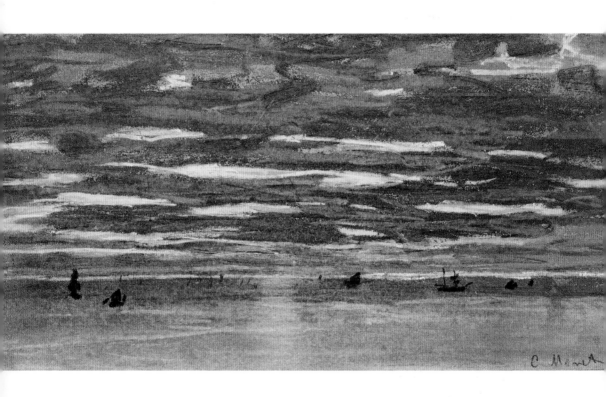

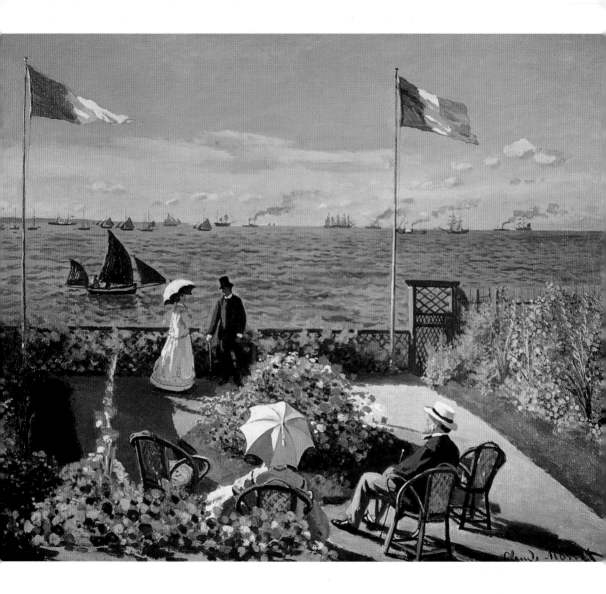

Bathers at La Grenouillère, 1869

Monet and Pierre-Auguste Renoir (1841–1919) painted side by side at the swinging holiday town of La Grenouillère, experimenting with new techniques to depict the effect of light on water. This painting was done *en plein air* and, as such, Monet had to develop a method of rapidly applying paint to canvas, first sketching the composition onto his canvas. He creates a curious spatial dynamic, with the depth through the canvas aided by the perspective of the boats and the curve of the riverbank. The depth of the water is then translated through his use of colour.

This picture demonstrates Monet's early experiments with brushstrokes and colour to capture light. His strokes are swift and short, blunt, with a wide colour range to illustrate the water's surface. He used complementary colours to add luminosity to the painting, a technique that he would use time and again. The pattern of brushstrokes here could be described as 'divisionist', a dense pattern of small strokes of colour, a technique that was taken up and expanded by Paul Signac (1863–1935) and Georges Seurat (1859–91).

PAINTED

La Grenouillère

MEDIUM

Oil on canvas

SERIES/PERIOD/MOVEMENT

Impressionist, La Grenouillère

SIMILAR WORKS

La Grenouillère, Pierre-Auguste Renoir, 1869

The Boat, Pierre-Auguste Renoir, 1867

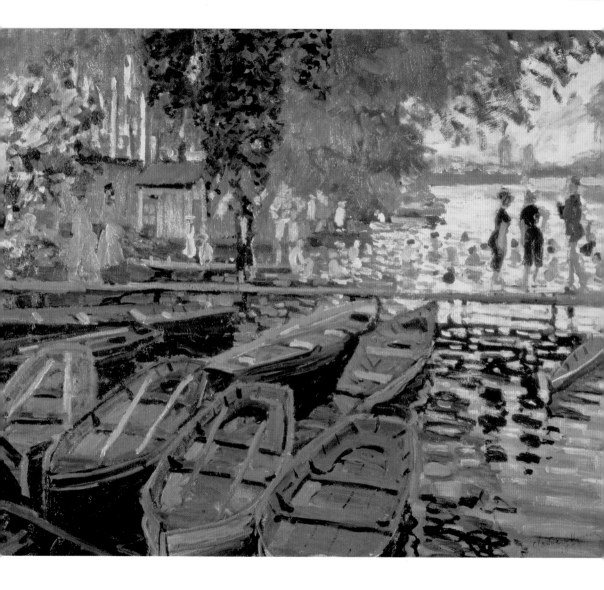

The Magpie, 1869

By the time of this painting Monet was clearly focused on the effects of light, and had already extended his experiments in this regard through the depiction of water, which afforded him an endless motif for exploring reflected colour and light. He soon discovered the joy of painting snow, a subject to which he would repeatedly return.

A heavy blanket of snow transforms the structures beneath, so fence posts lose the integrity of their linear form, which becomes blurred and softened under a mantle of white. Equally this soft covering alters the effect of light, its reflected colours and the colour of the landscape. In this beautifully luminous snowy scene Monet has used blue and mauve tints and a diffuse golden hue to indicate reflected light. The colours are delicate and subtle, turning an essentially white landscape into one of many tones and hues. The structure of the composition is also interesting: he has broken his picture surface down into essential and simple areas of geometric space and, through the use of shadows, has created a structure that moves towards abstraction.

PAINTED

Bougival

MEDIUM

Oil on canvas

SERIES/PERIOD/MOVEMENT

Impressionist

SIMILAR WORKS

Snow at Louveciennes, Alfred Sisley, 1878

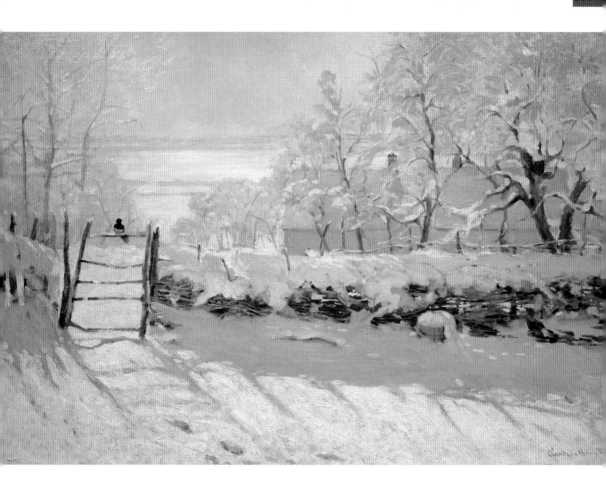

The Reader, or *Springtime c.* 1872

Monet painted this picture of his wife Camille reading, seated on the grass underneath a lilac tree in the garden of their house in Argenteuil. It is an idyllic rendering of his pretty, young wife, one of many paintings he made of her in a similar environment.

The artist has painted his wife looking down at her, resulting in the creation of an enclosed world; there is no skyline or even a path to indicate the world beyond this painted fragment. His technique of creating a private world was one that he increasingly focused on towards the end of his life, seen in his series of paintings of Rouen Cathedral and water lilies.

This painting is a curious mixture of the rounded, flesh of Camille's face and the flattened areas of her full skirts, rendering her almost doll-like. The artist's true intent in the painting is the depiction of light, its reflection seen to particular effect in the white circles falling across Camille's skirt. The light does not fall from above, but appears to spread across the scene, pooling on the figure of Camille.

PAINTED

Argenteuil

MEDIUM

Oil on canvas

SERIES/PERIOD/MOVEMENT

Impressionist

SIMILAR WORKS

Garden at Fontenay, Pierre-Auguste Renoir, 1874

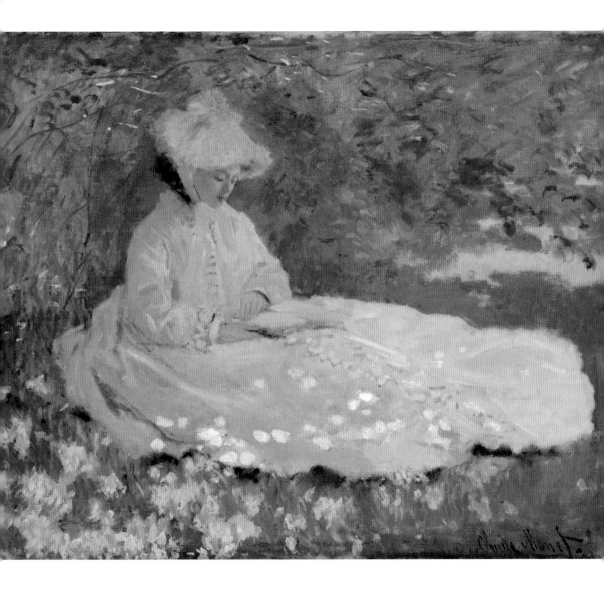

Boulevard des Capucines, 1873–74

Boulevard des Capucines was exhibited by Monet at the first Impressionist Exhibition in 1874, causing a storm of debate. Many were offended by Monet's daubs of colour, his obtuse viewpoint and the hurried, sketchy nature of it, while others revelled in the energy the artist had created. The critic Ernest Chesneau (1833–1890) wrote, 'Never has the prodigious animation of the public street, the swarming of the crowd on the asphalt and of the vehicles on the road ... the instantaneous qualities of movement been seized and fixed in all its prodigious fluidity as it is in this extraordinary, this marvellous sketch.'

Monet worked the canvas up using small strokes of colour with broken brushstrokes and rapid smears, treating the painting as a whole with human figures painted in exactly the same way as the street and trees. The reduction of all components to the same level of importance was in direct conflict with the traditional Academy style. Monet has also dehumanized the scene by removing any identifiable or individual characteristics from the figures, rendering them a seething mass.

PAINTED

Paris

MEDIUM

Oil on canvas

SERIES/PERIOD/MOVEMENT

Impressionist

SIMILAR WORKS

Place du Theatre Francais: Afternoon Sun in Winter, Camille Pissarro, 1898

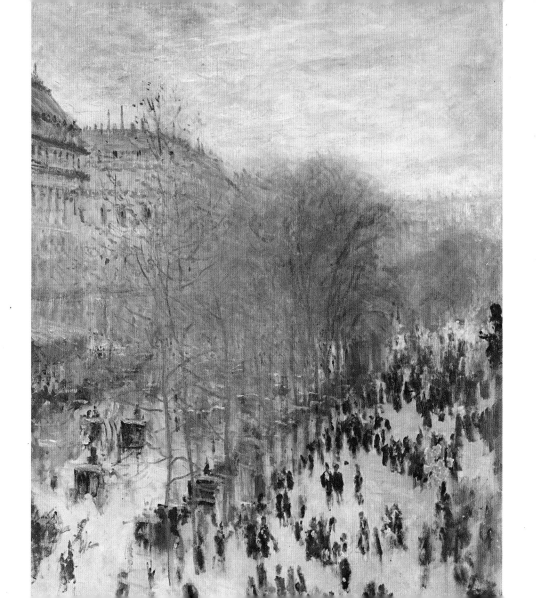

The Railway Bridge at Argenteuil, 1873

During this period Monet was interested in depicting the modern landscape, reflecting the changes that were occurring in late nineteenth-century France. He was particularly inspired by railways and railway bridges, both a relatively new phenomenon, as well as industry that he depicted through smoking chimneys standing along a skyline. His motivation may have been based on a social ideology, but was more obviously due to the structural possibilities that these man-made components lent to his compositions.

He painted this railway bridge at Argenteuil a number of times and often from this oblique, unusual angle that recalled the work of Japanese woodblock artists. Although the bridge dissects the landscape with a monumental force, Monet depicts it as part of the landscape, as something quite in harmony. He has included a train and depicted the puffs of steam trailing across the sky, tinted with purplish and brown hues to distinguish them from the clouds behind. The surface of the canvas has been worked up with thick brushstrokes over which he has used a dry brush to create the delicate leaves, foliage and clouds.

PAINTED

Argenteuil

MEDIUM

Oil on canvas

SERIES/PERIOD/MOVEMENT

Impressionist

SIMILAR WORKS

The Bridge at Maincy, Paul Cezanne, c. 1879

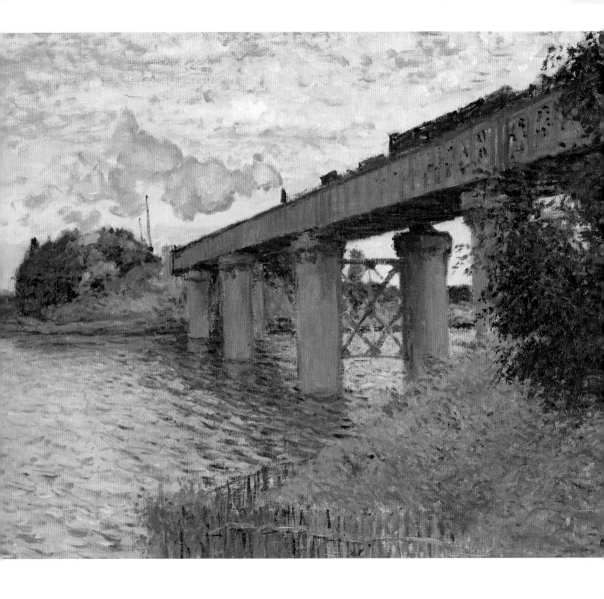

Red Boats, Argenteuil, 1875

Monet painted the town and surrounding area of Argenteuil through the 1870s and in each instant created pictures of beauty and harmony, which were often at odds with the reality of the moment. Although an adherent of *en plein air* painting, Monet carefully chose the elements he wanted to include and often finished his canvases in the studio. There is no hint in his paintings of the pollution in the river at Argenteuil or the disarray of a town throwing everything into its industry. In *Red Boats, Argenteuil* he has constructed the composition through the use of the boats, especially in the verticals of the masts. Here again he uses contrasting colours through his blues and orange and reds and greens. The canvas is alive with colour, while the depth of the water is illustrated through the purples and blues. The brushstrokes are uniform through the water in their choppy style, but the sky is more broadly painted with blurring and merging colours, creating a very distinct contrast between the depth of the water and the translucence of the sky.

PAINTED

Argenteuil

MEDIUM

Oil on canvas

SERIES/PERIOD/MOVEMENT

Impressionist

SIMILAR WORKS

The Seine at Asnières, Pierre-Auguste Renoir, *c.* 1879

Port-en-Bessin, Paul Signac, 1884

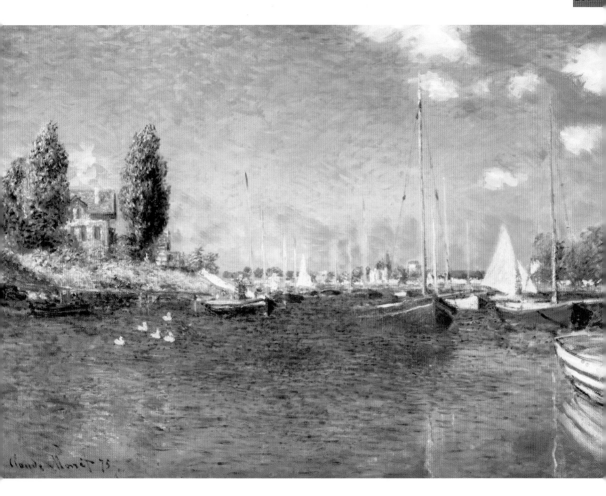

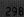

Woman with a Parasol – Madame Monet and Her Son, 1875 (detail)

National Gallery of Art, Washington DC, USA/Photo © AISA/The Bridgeman Art Library

During his years at Argenteuil, Monet produced some of his purest impressionistic paintings, concentrating on the surrounding landscapes, his garden and his family. In this painting of Camille and his son Jean, Monet has adopted an unusual low viewpoint, so the artist is looking up at his subject. This has the effect of increasing Camille's importance as she fills the upper parts of the canvas, giving her an almost iconic feel. The painting demonstrates Monet's great aptitude for painting figures, although figure painting never became a primary subject for the artist. Despite his impressionistic rendering of her – his use of sketchy, broad brushstrokes – he has nevertheless created a totally convincing person. Her skirts appear to whip round with the wind, adding movement to an otherwise static image, and the small figure of Jean is used by Monet to balance the overall composition.

The artist has gone to lengths to give the impression that the figures are not posed, but have been momentarily interrupted on their summer walk, and he would have painted the image quickly and outdoors in front of the motif.

PAINTED

Argenteuil

MEDIUM

Oil on canvas

SERIES/PERIOD/MOVEMENT

Impressionist

SIMILAR WORKS

Madame Renoir and her Son Pierre, Pierre-Auguste Renoir, 1890

Corner of a Flat at Argenteuil, 1875

Monet's ambitions as a gardener culminated in the creation of his garden at Giverny. The importance of the garden to Monet was paramount, and he frequently painted either his own garden or flower-filled landscapes. In many instances his own garden was construed as a private and secure world for the artist, one in which he could retreat from the criticism of the art world and his fluctuating financial worries.

In this painting the garden appears to infiltrate the house with the whole scene framed by leafy plants growing in oriental-style pots. The interior of the house reveals a residence of some substance indicated by the lavish parquet flooring and ornate chandelier. Monet's son Jean stands rather pensively, dressed in expensive and fashionable garb, while the figure of Camille is shadowy and hardly discernible from the recesses of the room. Light floods the foreground and creeps across the interior, reflecting on the polished wooden floor and tabletop. Most striking is Monet's use of colour, particularly the colour in the shadows, which are made up of purples, dark greens, pinks and rustic brown.

PAINTED

Argenteuil

MEDIUM

Oil on canvas

SERIES/PERIOD/MOVEMENT

Impressionist

SIMILAR WORKS

Hide and Seek, James Tissot, 1877

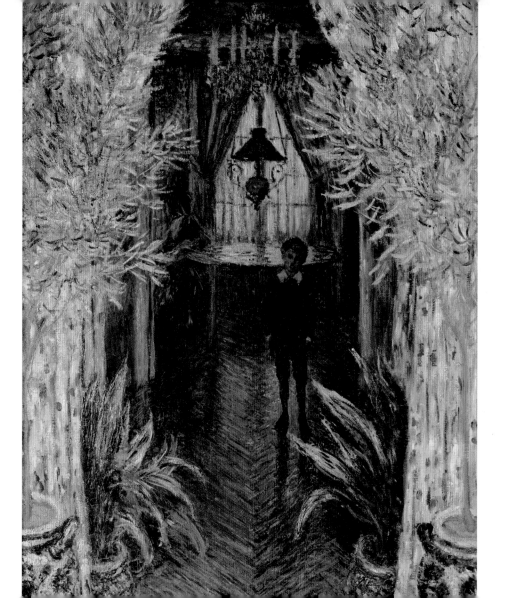

Sketch of the Interior of the Gare Saint-Lazare, c. 1877

Between mid-January and early April 1877 Monet painted 12 views of the Gare Saint-Lazare, with the station depicted with the reverence of a temple to modern progress. He was not interested in the human element, instead he was fascinated by the brute force of the giant trains, their power and the belching steam they emitted, along with their significance in the wider context of progress. Monet was familiar with the station, as it was the station into which the train from Argenteuil ran, and he had travelled many times along the tracks.

He was given permission to work in the station, and on occasion brought the trains and the station to a standstill, causing some inconvenience to staff. Before embarking on his series, he explored various compositions in drawings, making sketches such as this to work out the structure for his painting. In this sketch, bearing in mind that Monet was a natural draftsman, he has included greater detail in the buildings in the background than he would finally include in his impressionistic paintings.

PAINTED

Paris

MEDIUM

Pencil on paper

SERIES/PERIOD/MOVEMENT

Sketch

SIMILAR WORKS

Le Pont de l'Europe, Norbert Goeneutte, late nineteenth century

Cour du Havre (Gare Saint-Lazare), Camille Pissarro, 1893

Seascape, 1881

Monet spent time painting the wild and rugged coastal area of Fécamp in 1881 and produced a number of paintings of the sea and the cliffs. These paintings were almost wholly unoccupied by any human presence and instead reflected the artist's interest in the power of the natural world. He painted several views of the cliffs at Fécamp being pounded, eroded and shaped by the sea.

In this painting Monet has rejected all reference to land completely and focused instead on the sea, placing the spectator directly in the path of the crashing waves. He has created tremendous movement through his use of thick, swirling strokes of paint that move with some rhythm throughout the canvas. The focus of the energy is in the foreground, where he has used a mixture of pale yellows, icy blues and whites to evoke the chilling, powerful breaking waves that form their own small crests and troughs in the middle ground. Dark undertones in the middle ground with overlaid highlights suggest the storminess of the atmosphere and add to the frigid notes of the painting.

PAINTED

Fécamp

MEDIUM

Oil on canvas

SERIES/PERIOD/MOVEMENT

Marine

SIMILAR WORKS

The Wave, Gustave Courbet, 1869

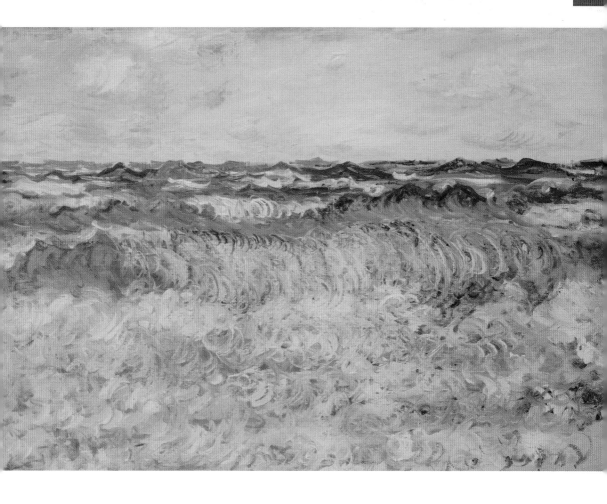

Fruit Tarts, 1882

Although Monet is not known as a still-life painter, he did a number of them throughout his career, primarily because they were popular and sold easily and also because he could paint them in his studio when poor weather prevented him from painting outdoors.

In this still life of fruit tarts Monet's strong use of an oblique composition recalls the Japanese print. Monet was a great collector of Japanese prints and Japanese influence can be seen with some regularity in his work. He has treated this painting with tighter brushwork than he was employing at this time. His use of rich, dark, velvety reds and browns gives the tarts their depth, while overlaid creamy highlights suggest the glazed finish of the tart and its light-reflective surface. The simple composition and his strong use of geometric shapes lend this painting a very modern feel that is a short step away from abstract. A further touch is his use of contrast between the razor-sharp and linear knife and the roundness of the other objects.

PAINTED

Poissy

MEDIUM

Oil on canvas

SERIES/PERIOD/MOVEMENT

Still life

SIMILAR WORKS

Still life with Milk Jug and Fruit, Paul Cezanne, 1886–90

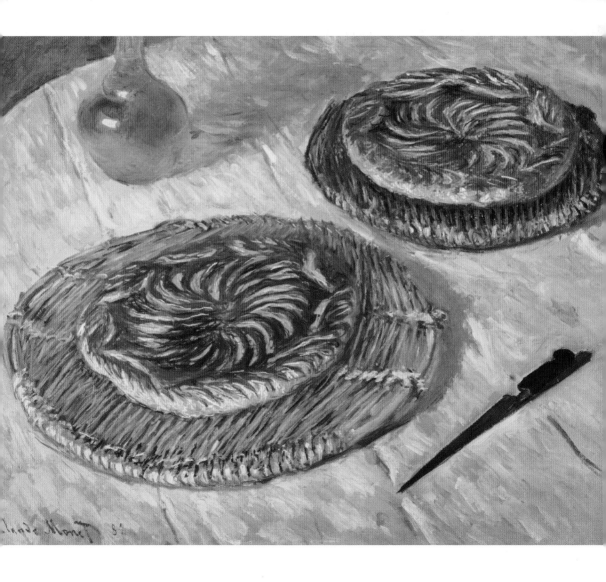
Claude Monet 82

The Basket of Grapes, c. 1883

In 1882 Paul Durand Ruel (1831–1922), Monet's most loyal supporter and art dealer, commissioned the artist to begin a decorative scheme at his Paris apartment on 35 Rue de Rome. The three-year project involved painting 36 panels, decorative rather than avant-garde and featuring fruit and flowers, for six pairs of doors.

In this panel Monet has done away with any background reference. Instead he has painted the fruits against a warm ground of pink and orangey tones that is essentially smoothly painted with the exception of a small area in the foreground that reveals his more characteristic textured brushwork. The fruit and basket has been painted with a much smoother finish than was usual for Monet, who has used delicate shades of green, red and cream. The paint has been applied relatively thinly to allow the background colour to bleed through in places, which has given the fruit great warmth. His divergence from a potentially unexciting still life is his treatment of the grapes, painted in glowing dark-green tones that are a startling and welcoming contrast to the overall uniformity.

PAINTED

Giverny

MEDIUM

Oil on canvas

SERIES/PERIOD/MOVEMENT

Still life

SIMILAR WORKS

Still Life with Pomegranates, Pierre-Auguste Renoir

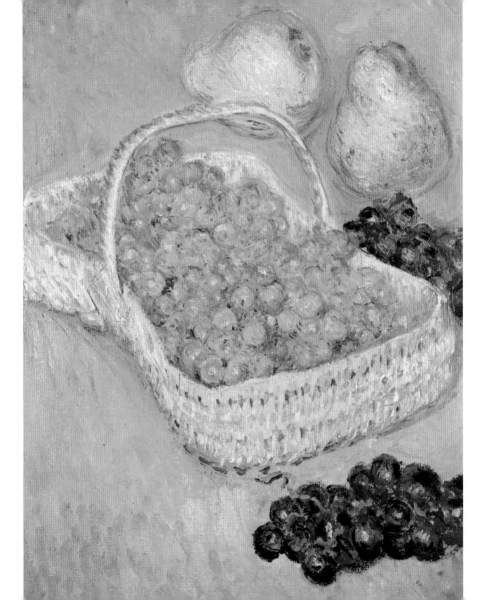

Poppy Field, 1887

Monet signed a long-term lease on a house in Giverny in 1883, and lived there until the end of his life. His house and subsequently his garden that he lovingly planned and created would eventually become his world. At first, however, Monet was greatly inspired by the vast fields of poppies and wheat that stretched across the countryside around the small village. In particular the fields of poppies attracted the artist with their brilliant reds carpeting the landscape in a mass of shifting colour.

He painted these fields many times, and in this highly impressionistic painting has created tremendous movement sweeping across the canvas as the poppy heads appear to sway and ripple in the breeze. He has used dabs and dots of vibrant reds, purples and blues in clear, pure form over a green base and worked across the canvas using fluid, short and textured brushstrokes. From a distance the painting appears a brilliant and real evocation of a poppy field under a bright sun, but close up the canvas dissolves into a blur of opposing colours and brushstrokes.

PAINTED

Giverny

MEDIUM

Oil on canvas

SERIES/PERIOD/MOVEMENT

Poppy fields at Giverny

SIMILAR WORKS

Field of Poppies, Auvers-sur-Oise, Vincent Van Gogh, 1890

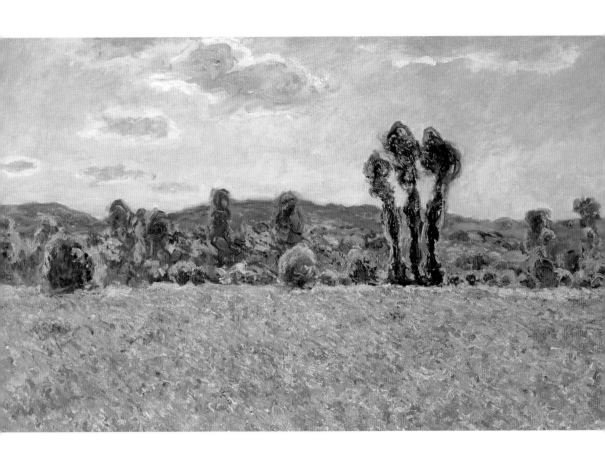

The Boat, c. 1887–90

In 1887 or 1888 Monet embarked on a series of paintings of his stepdaughters floating dreamily in a small boat along the river Epte, near to the artist's house in Giverny. In his youth he had painted fashionable people boating many times, but now, decades later, he approached the subject very differently. These works are amongst the most lyrical of Monet's paintings and in many ways are a precursor to his final water lily paintings.

The oblique and truncated composition of *The Boat* is this painting's most immediately striking aspect. Monet has taken a viewpoint from above, looking down into the boat and the deep waters of the river, but the boundaries between the river and vegetation of the bank are not defined. In this way he has created a surreal, enclosed and almost claustrophobic world. The surface of the water has been painted using fluid, sensuous and fine brushstrokes loaded with light tones, indicating vegetation and reflection, over a smooth dark ground. The effect of the rhythmic wavy brushstrokes is almost hypnotic strongly evocative of the movement of water.

PAINTED

Giverny

MEDIUM

Oil on canvas

SERIES/PERIOD/MOVEMENT

Boating on the Epte

SIMILAR WORKS

The Lake of the Bois de Boulogne, Berthe Morisot, 1888

Blue and Silver, Boat Entering Pourville, James Whistler, 1899

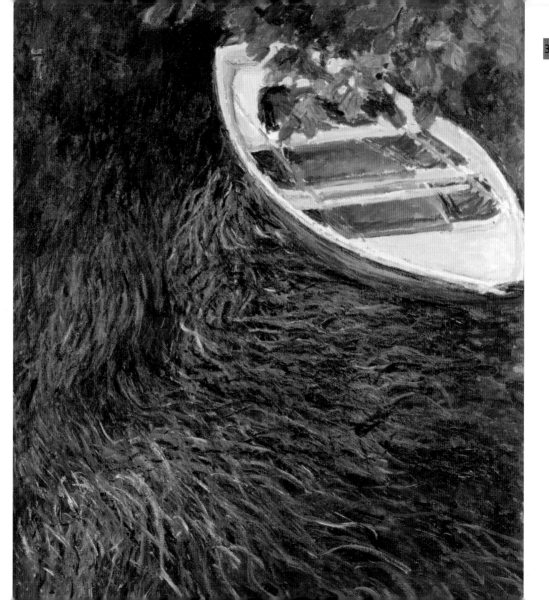

Poplars, 1891

Following the success of his haystack series (1890–91), Monet embarked on a new series in 1891 of a curving row of poplar trees that followed the banks of the river Epte near his home in Giverny. The trees had been planted at equal distances in a regimented row for timber, but when Monet learnt they were to be felled, he paid the timber merchant to delay until he could finish the series. The precise planting of the trees and their structural format were a great draw for the artist, but he might have also had some attachment to the symbolism of the poplar tree, which had been named the 'Tree of Liberty' during the French Revolution.

In this painting the stand of trees creates a smooth curving line across the canvas and demonstrates Monet's use of a restricted but effective geometric composition. He has used flickering brushstrokes loaded with greens, yellows, blues and pinks to create the sun-dappled leaves of the canopies, and used a smooth wash of varying blues to indicate a heaviness of atmosphere moving into the sky from the left.

PAINTED

Giverny

MEDIUM

Oil on canvas

SERIES/PERIOD/MOVEMENT

Poplars series

SIMILAR WORKS

Trees, Pierre-Auguste Renoir, 1915–16

Olive Trees, Vincent Van Gogh, 1889

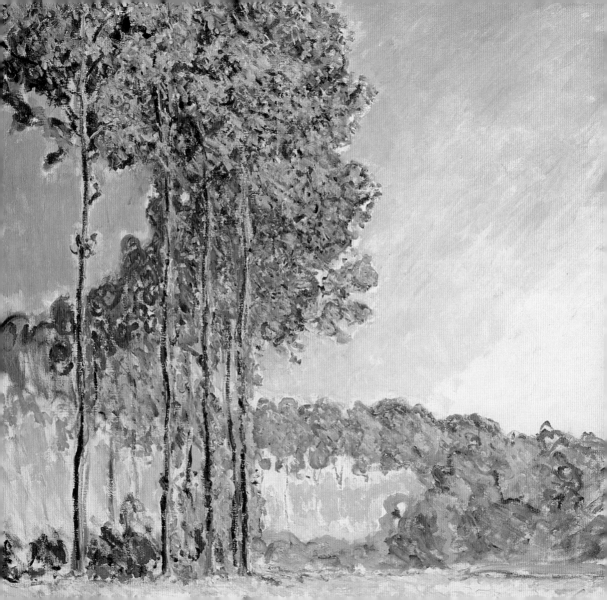

Haystack, Impression Rose and Blue, 1891

Gustave Geffroy (1855–1926), the journalist and biographer of Monet, wrote in 1891 that, 'for a year the voyager gave up his voyages'. He was referring to the period from 1889 to 1890 when Monet produced virtually no paintings. In 1891 Monet started on his haystack series that resulted in 24 canvases. Monet had developed the practice of working on a series of canvases at one time, so as the sun moved across the sky, he could move to the next canvas.

He had painted the subject of haystacks often, but in the paintings of the 1890s the haystacks became the focal point. He used simple compositional arrangements, paring the elements down to the minimal, monumental bulk of the stacks, on which he recorded light changing through time. His use of colour was vibrant to the point that the paintings seem to glow with the radiance of the sun. Here he has applied oranges and reds, set against the blues and purples of the distance. He used a range of different brushstrokes, built up thickly in short dabs and wider sweeps.

PAINTED

Giverny

MEDIUM

Oil on canvas

SERIES/PERIOD/MOVEMENT

Haystacks

SIMILAR WORKS

Haystacks at Moret in October, Alfred Sisley, 1891

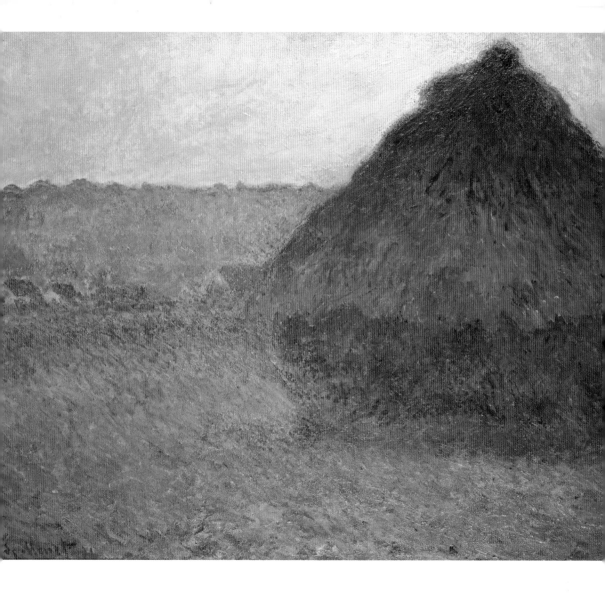

Haystacks, Hazy Sunshine, 1891

Monet's haystack series was apparently begun by chance. Monet would often recount how one day he was painting a haystack in a field behind his house and the light kept changing. He asked Blanche Hoschedé, his stepdaughter, who was assisting him at the time, to keep bringing him a new canvas so creating his first monumental series.

During the winter months the sunlight had a peculiar quality and radiance, quite different from that seen during the summer. Monet embarked on a series of winter effects, the reflection from the white of the snow and frost affording him a whole new set of light nuances to capture.

In this painting, *Haystacks, Hazy Sunshine*, the topographical realism of the haystack within the landscape is all but gone. There is nothing but the haystack itself and the colour of the light. He has used a heavy cross-hatching of short brushstrokes of soft pinks, whites, blues and yellows to build up the overall luminosity of the canvas. The single haystack stands alone surrounded by ethereal light, which lends it an air of magical unearthliness.

PAINTED

Giverny

MEDIUM

Oil on canvas

SERIES/PERIOD/MOVEMENT

Haystacks

SIMILAR WORKS

Haystacks on the Banks of the Loing, Alfred Sisley, 1899

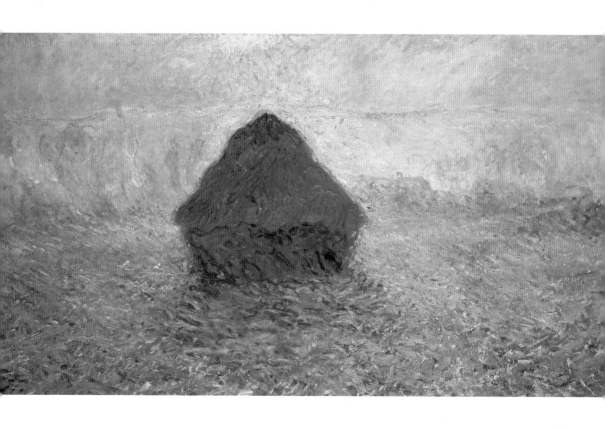

Rouen Cathedral in the Afternoon (The Door in Sunlight), 1892–94

Monet was his own harshest critic and, when viewing the beauty of his paintings, it is hard to imagine the difficulty he went through to achieve them. He finished the Rouen series in his studio before exhibiting the pictures, adding strokes of colour and building up the surfaces of each canvas until they became almost three-dimensional.

His canvases went on exhibition in 1895, at which point Monet explained, during an interview, that he wanted to paint the atmosphere that lay in between him and the object, rather than the object itself.

This depiction of the cathedral is full of the brilliance of strong sunlight, which has bleached out colour completely and is almost the opposite of many of his other Rouen paintings. His palette is nearly all cream and yellow, with a complementary blue sky just showing through above the façade. His painting moves in and out of focus, blurred and soft at the left top and detailed towards the right. This would be how the eye would interpret the image with bright sun falling from the left.

PAINTED

Rouen

MEDIUM

Oil on canvas

SERIES/PERIOD/MOVEMENT

Rouen Cathedral

SIMILAR WORKS

The Church at Moret, Afternoon, Alfred Sisley, 1893

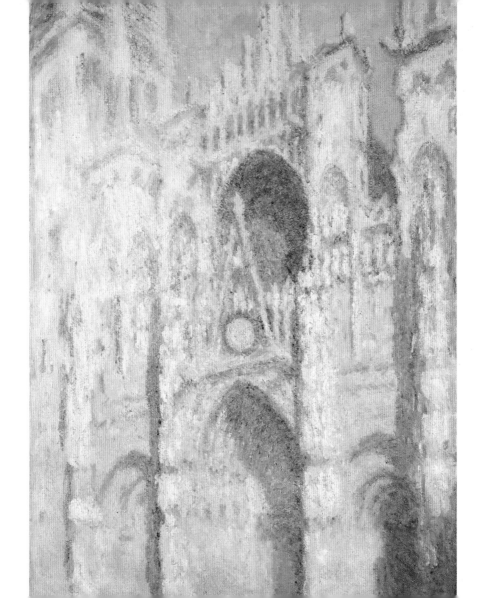

Rouen Cathedral in the Setting Sun, 1892–94

Edgar Degas (1834–1917) famously recounted how one day he saw Monet arrive by carriage at Varengeville to paint. Monet got out, looked at the sky and declared he was half an hour too late and that he would have to come back the next day. Such was Monet's absolute dedication to the exact depiction of the moment of light as he saw it.

Here he has painted the setting sun, which has bathed the cathedral in pinks and hues of blue and purple, a harmonious combination that immediately draws to mind the work of James Abbott McNeill Whistler (1834–1903). Monet has distorted his focus, a technique he often employed in these works, and depicts both sharp and soft focus points. He has used thick applications of paint and a circular formation of brushstrokes to emphasize the cavities of the porch, the dark rose at their centre jumping forward from the surround. He has used thick blue/white areas to highlight the key architectural features and to suggest light bouncing off the pale stones.

PAINTED

Rouen

MEDIUM

Oil on canvas

SERIES/PERIOD/MOVEMENT

Rouen Cathedral

SIMILAR WORKS

The Church at Moret: Evening, Alfred Sisley, 1894

Rouen Cathedral, the West Portal, Bright Sunlight, 1894

Monet's approach to the series of paintings he executed of Rouen Cathedral is fascinating on many levels. It was the first time that he used a man-made and rigidly linear structure on which to experiment with his light effects and it was a long way from his fluid haystacks and natural poplars series. He presented himself with a huge challenge: having been used to an extremely fluid technique of brushstrokes he now had to amalgamate this within the rigidity of a building.

It is interesting to compare Monet's paintings of the West Portal of Rouen Cathedral with the watercolour of *Rouen: The West Front of the Cathedral*, done by Joseph Mallord William Turner (1775–1851) in 1832. While Turner shows the whole of the front of the cathedral, both artists show a similar treatment of light playing off the textured surface of the façade.

Here Monet has used thick strokes of paint, building up the surface of the canvas and introducing white to show the brilliance of the sun reflecting off the mellow stones of the building.

PAINTED

Rouen

MEDIUM

Oil on canvas

SERIES/PERIOD/MOVEMENT

Rouen Cathedral

SIMILAR WORKS

Rouen: The West Front of the Cathedral, J. M. W. Turner, 1832

The Church at Moret: Morning Sun, Alfred Sisley, 1893

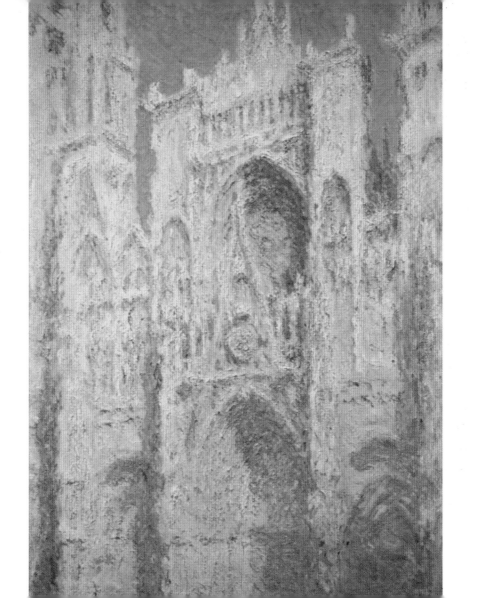

Rouen Cathedral, Foggy Weather, 1894

Monet would typically work on a large number of canvases at one time, a technique that he employed with all of his series paintings. Through correspondence with his wife Alice, we know that he had up to 14 canvases on which he would work each day when he was painting his series of Rouen Cathedral. He struggled to capture the light as it fell on the building and complained of it changing so rapidly that he was not able to paint it: 'the sight of my canvases which seemed to me atrocious, the lighting having changed. In short I can't achieve anything good, it's an obdurate encrustation of colours, and that's all, but it's not painting ...'.

His use of heavy purple, working up through the canvas to the fog, which is built on paler shades, is truly harmonious and calls to mind Whistler's technique in his *Nocturnes*, where he used a minimal tonal base and built through it.

PAINTED

Rouen

MEDIUM

Oil on canvas

SERIES/PERIOD/MOVEMENT

Rouen Cathedral

SIMILAR WORKS

Spring Like Morning, Emile Schuffenecker, *c.* 1896

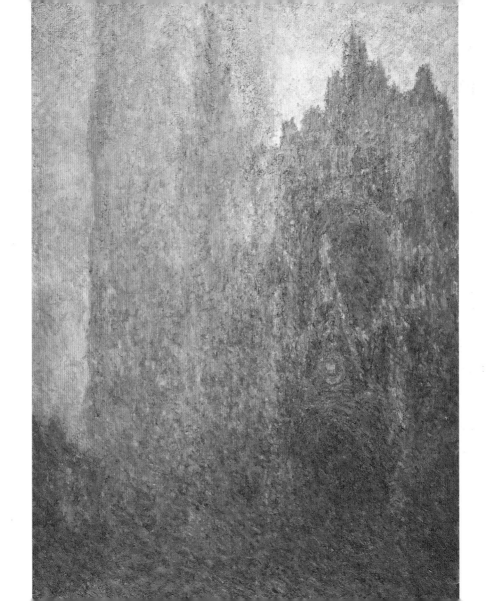

Rouen Cathedral Façade and Tour d'Albane, Morning Effect, 1894

There must have been a certain symbolic significance in Monet's choice of Rouen Cathedral. This was a time in France when there was a spiritual revival in the country and people were again looking to the Church for guidance. However, Monet himself was not religious and in his paintings of the cathedral he has obscured key Christian elements. He has also taken the cathedral as his motif and divested it of any human element in all but one of the pictures, which effectively reduces it back to one of his studies rather than giving the paintings any greater meaning.

Here Monet has used a palette of blue and pinks. He first built up the image of the cathedral façade with thick layers of paint, primarily blue, the exact colour of long morning shadows. He has concentrated the pinks behind the buildings on the left of the canvas to suggest the sun slowly rising up from behind the cathedral. The Albane Tower, bathed in a shimmer of iridescent light, takes on an ethereal magical appearance, not at odds with its religious symbolism.

PAINTED

Rouen

MEDIUM

Oil on canvas

SERIES/PERIOD/MOVEMENT

Rouen Cathedral

SIMILAR WORKS

The Church at Moret, Rainy Weather, Morning, Alfred Sisley, 1893

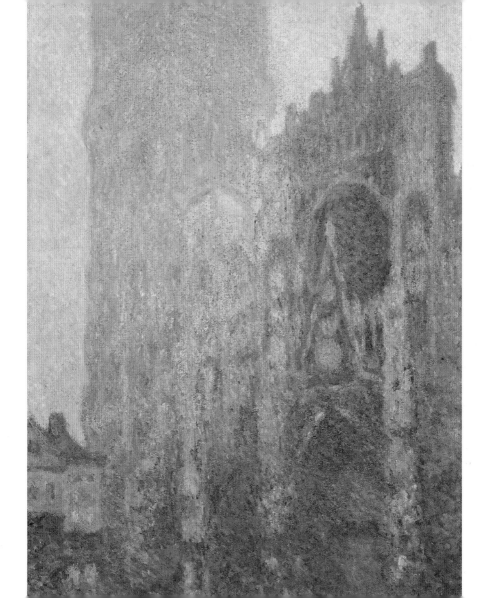

329

Waterloo Bridge, c. 1899

In the autumn of 1899 Monet returned to London to paint 'a series of London fogs' and 'some effects of mist on the Thames'. The trip followed a tragic period in Monet's life: the loss of his friends Stéphane Mallarmé (1842–98) and Alfred Sisley and the unexpected death of his stepdaughter and favourite model Suzanne Hoschedé. Alice was inconsolable and Monet took her with him to London to try to raise her spirits.

They stayed at the Savoy hotel on the fifth floor overlooking the Thames. Monet concentrated solely on depicting Charing Cross and Waterloo bridges, which he painted from his hotel room, and the Houses of Parliament, which he painted from Saint Thomas's Hospital.

It was the London fog and its effect on light and the colour of structures that absorbed Monet, and in this rapidly worked up pastel he has concentrated on creating the sensation of a dense, greenish atmosphere. He has used a base of yellow and overlaid green, blues and purples to capture the opaque air, with barely any differentiation between the sky and the water of the Thames.

PAINTED

London

MEDIUM

Pastel on paper mounted on board

SERIES/PERIOD/MOVEMENT

London, series

SIMILAR WORKS

Thames Nocturne in Blue and Silver, James Whistler, c. 1872

Waterloo Bridge c. 1900

Monet returned to London in February 1901, leaving Alice behind but writing to her daily. The surviving letters reveal the artist's fascination with the Thames and the colours produced through the combination of the sun, water and fog: 'the sun rose with blinding light ...The Thames was nothing but gold'. Equally he was frustrated by the speed with which the sun changed the colours and light, making it almost impossible for him to complete a painting before the effect had vanished. This led him to start a huge number of canvases to which he could return when the right colours and light were revealed again. In this way he started many canvases on location, working on them at length in the studio at Giverny, managing to preserve their immediacy and freshness.

In this painting of the bridge, the light piercing through the gloom of the fog is seen shining off the water, created through broad strokes of creamy green and pink picking up the tonal base of the picture.

PAINTED

London, Giverny

MEDIUM

Oil on canvas

SERIES/PERIOD/MOVEMENT

London series

SIMILAR WORKS

The Bridge at Sèvres, Alfred Sisley, 1877

Moret sur Loing, Armand Guillaumin, 1902

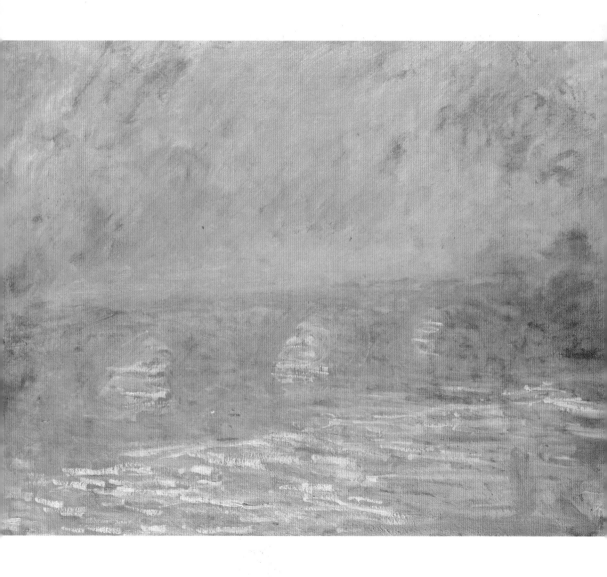

Waterloo Bridge, Soleil Voile, 1903

'In his desire to paint the most complex effects of light, Monet seems to have attained the extreme limits of art.... He wanted to explore the unexplorable, to express the inexpressible, to build, as the popular expression has it, on the fogs of the Thames! And worse still, he succeeded.' So wrote Georges Lecomte for the newspaper *L'Action* following the exhibition of Monet's London paintings in May 1904.

For his London paintings Monet would either start work on a new canvas immediately, or return to one that had the beginnings of what he was witnessing. This practice accounts for the vast number of canvases that he started, many of which were never finished. There was an obvious area of tension between the disparity of being a painter of scenes of impressionistic immediacy and completing canvases in the studio.

The ghostly picture here is at once ethereal and grounded in the realism of the man-made bridge and chimneystacks. He has used a softer brushwork approach and blurred his paint to produce the foggy atmosphere, from which the bridge rises in illuminated grandeur.

PAINTED

London, Giverny

MEDIUM

Oil on canvas

SERIES/PERIOD/MOVEMENT

London series

SIMILAR WORKS

Nocturne: Blue and Gold St Mark's Venice, James Whistler, 1879–80

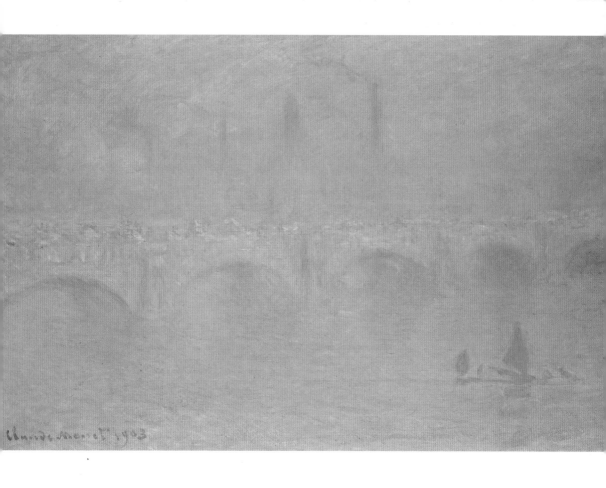

Claude Monet 1903

Water Lilies, 1914–17 (detail)

In the final two decades of his life Monet rarely left the sanctuary of his house and garden in Giverny. He had created his garden over a period of years, and in 1890 he had begun work on the creation of his water garden, which would eventually incorporate a large pond planted with water lilies and spanned by a Japanese bridge. This became Monet's arcadia, where he spent much of his time and virtually the only focus for his late paintings. In these works he employed a technique that he had first used some years earlier. This was the creation of an enclosed space, one without sky or horizon, seen to particular effect in this painting of 1914–17, where the sky is reflected in the still waters of the pond and clouds vie for space with water lilies.

Instead of the real world above, it is the reflected world enclosed by the water, one of oblique reality, that Monet has concentrated on. The relationship of simplified shapes in this painting shows Monet addressing his subject in an almost abstract manner.

PAINTED

Giverny

MEDIUM

Oil on canvas

SERIES/PERIOD/MOVEMENT

Water lily series

SIMILAR WORKS

Water Lilies, Isaak Ilvich Levitan, 1895

Blossoming Chestnut Branches, Vincent Van Gogh, 1890

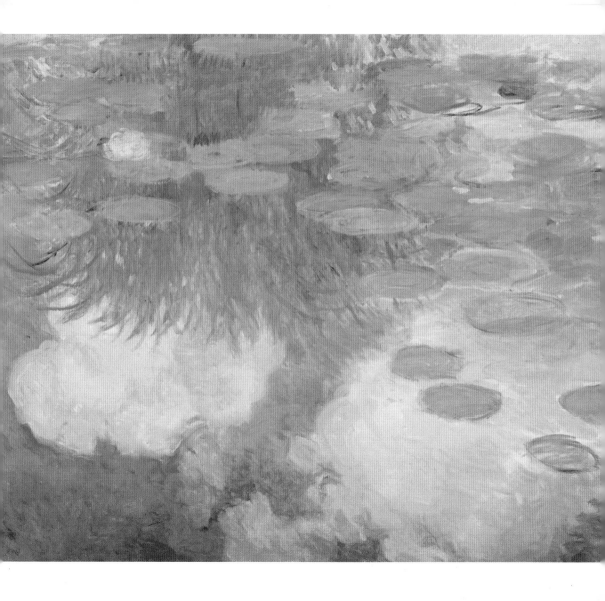

Water Lilies, Harmony in Blue, 1914–17 (detail)

By the time Monet embarked on his last monumental series of water lily paintings, he had gained critical and commercial success. This gave the artist added freedom to explore motifs of his choice and paint to his own schedule. Although he returned again and again to the water lilies, it was a subject that caused him difficulties, and he worried about the paintings, often reworking them.

In 1914 war was declared and Monet shut himself even further away from the horrors around him, focusing on his water lilies. He began to conceive an idea for a grand decorative scheme, and between 1914 and 1920 was hugely productive, painting a number of extremely large canvases – the size of which he had not worked on since his youthful Salon aspirations.

Here Monet has focused on colour: the clash of green trees as their reflection creeps into the violet-blue depths of the pond's water. He has used small accents of complementary reds, pinks and yellows in the buds of the lilies that sit atop curiously colourless lily pads using expressive, but smooth brushwork.

PAINTED

Giverny

MEDIUM

Oil on canvas

SERIES/PERIOD/MOVEMENT

Water lily series

SIMILAR WORKS

Yellow Flowering Branch, Odilon Redon, 1901

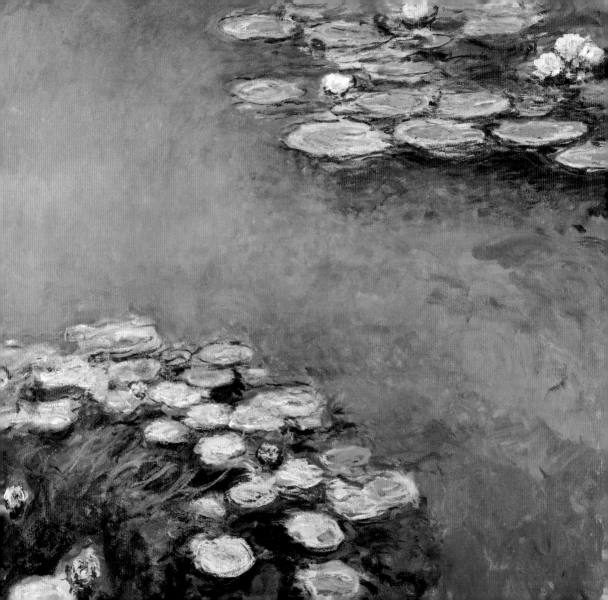

Water Lilies, Green Reflection, 1914–17 (detail)

Monet had a third studio built in his garden in 1915 to allow him to continue painting his vast canvases, which reflect little of the horrors of war going on all around. Monet's son Michel was serving and, by 1917, over one million French had died during the conflicts, yet Monet continued to paint his vast, tranquil canvases.

At some point in 1918 Monet was assured, chiefly through his friend Prime Minister Georges Clemenceau (1841–1929), that his *Grandes Décorations* would be exhibited by the State. He decided that 12 of the giant canvases would form the scheme, even though he had painted far more than this. Part of the State's commitment to the project was to provide a suitable housing for it, and to purchase Monet's *Women in the Garden*, 1866, to offset the costs of the *Grandes Décorations*.

At the time of this painting Monet was suffering from problems with his eyesight. The dark, green tonal ground of this work contrasts with the colours of the lilies, and his swirling brushwork is most evident, adding to the effect of gentle movement.

PAINTED

Giverny

MEDIUM

Oil on canvas

SERIES/PERIOD/MOVEMENT

Water lily series

SIMILAR WORKS

Flowers, David Bomberg, 1943

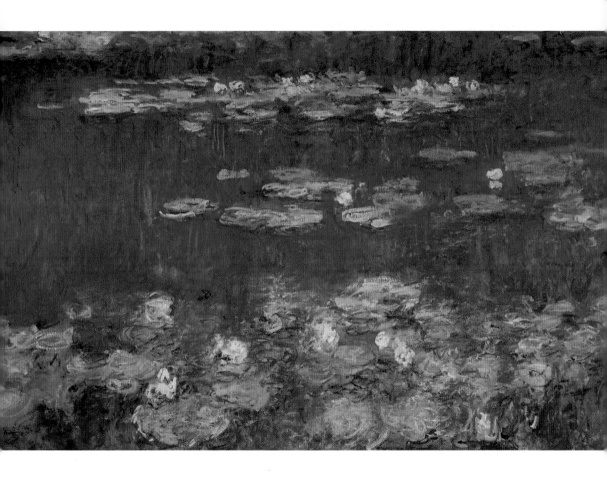

Water Lilies at Sunset, 1915–26

Monet was insistent that his *Grandes Décorations* be situated in the centre of Paris, and the decision was finally made to house them in the Orangerie. The irony of this was not lost, since the Orangerie sat opposite where the old Salon used to be, the Salon that had rejected Monet's *Women in the Garden*, which had now been bought for a huge sum by the State.

Monet deliberated over the arrangement of his huge canvases at great length. This painting that forms part of the *Setting Sun* works hangs opposite that of the *Green Reflections* on the previous page, its vibrancy counterbalancing the more sombre colours of *Green Reflections*. In *Water Lilies at Sunset* Monet moved towards abstraction, seen in both his use of surreal but beautiful colour and the indeterminate world he has depicted, one of either sky or water, or somewhere in between. By the time of this painting his eyesight had deteriorated, necessitating two operations in 1923. The extent to which his eyesight affected the brilliance of his colours or his brushwork is unknown, but is a consideration.

PAINTED

Giverny

MEDIUM

Oil on canvas

SERIES/PERIOD/MOVEMENT

Water lily series

SIMILAR WORKS

Flowers, John Hubbard, 1984

The Artist's House from the Rose Garden, 1922–24

Monet wrote in 1925, 'I am caught up in my work with no thought for anything else, so happy am I to see colours again. It is truly a resurrection.' It is colour that dominates his final works and none more so than his paintings of his house and garden. In this painting, structure has given way almost entirely to an explosion of light and colour, rendering the effect of a spectator viewing a scene through a sudden burst of sunlight. The shutters of his house are barely discernible in the background as they melt into the vibrant clash of pinks and reds, oranges, purples, blues, greens and yellows. He has used the same brushwork throughout the canvas, applying short and loaded strokes fluidly and with a rhythm that evokes a sense of the organic.

These were the last paintings on the artist's easel. Monet died on 5 December 1926 leaving behind Blanche Hoschedé-Monet, his stepdaughter and daughter-in-law who cared for him in his final years. His *Grandes Décorations* were hung at the Orangerie and opened to the public in May 1927.

PAINTED

Giverny

MEDIUM

Oil on canvas

SERIES/PERIOD/MOVEMENT

Final works

SIMILAR WORKS

Flower Garden (Roses, Orange Lilies, Larkspur), Emil Nolde, 1917

Number 22, Jackson Pollock, 1949

Author Biographies

Tamsin Pickeral (author)

Tamsin Pickeral has studied Art and History of Art since she was child, and lived for some time in Italy furthering her appreciation of the subject. She has travelled extensively through her life, and has recently returned to the UK after nine years spent living an unusual life on a cattle ranch in the US. 'Life was never dull,' the author said, 'between writing books, studying art, chasing cows, training horses and keeping tabs on my husband.' She now resides in Norfolk, with her cowboy, where she continues to write about art and horses, two of her favourite topics.

Stephanie Cotela Tanner (foreword)

Stephanie Cotela Tanner holds a masters degree in the History of Art from Birkbeck College, University of London. She is a freelance art historian and writer. She also lectures on a wide range of subjects, including Northern and Italian Renaissance art, British modernism and post-World War II Italian painting and cinema. She publishes the blog, VisualBites, visualbites.blogspot.com, which features daily commentary, issues and debates on international art news. She has extensive experience in the art world in both America and Britain having held positions at museums, galleries and auction houses in San Diego, New York and London.

Picture Credits: Prelims and Introductory Matter

Further Reading

Andrews, M., *Landscape and Western Art*, Oxford Paperbacks, 1999

Bataille, G., *Manet*, Skira, 1994

Bichler, L. and Trede, M., *Hiroshige: One Hundred Famous Views of Edo*, Taschen, 2010

Blunden, M and G, *Impressionists and Impressionism*, Rizzoli International Books, 1980

Butlin, M. and Joll, E., et al, *Paintings of J. M. W. Turner*, Yale University Press, 1987

Cogeval, G., Patin, S., et al., *Claude Monet 1840–1926*, RMN, 2010

Cowell, S., *Claude & Camille: A Novel of Monet*, Crown Publishing Group, 2010

Dorment, R. and Macdonald, M. F., *James McNeill Whistler*, Tate Publishing, 1994

Dunstan, B., *Painting Methods of the Impressionists*, Watson-Guptill Publications, 1992

Fell, D., *The Magic of Monet's Garden: His Planting Schemes and Colour Harmonies*, Frances Lincoln, 2007

Hayes Tucker, P., Shackelford, G. T. M., et al, *Monet in the 20th Century*, Royal Academy, 1998

Herbert, R.L., *Impressionism: Art, Leisure and Parisian Society*, Yale University Press, 1991

Hillier, J., *Hokusai*, Phaidon Press, 1978

Holmes, C., *Monet at Giverny*, Weidenfeld Nicholson Illustrated, 2001

House, J., *Monet*, Phaidon Press, 1981

Katz, R. and Dars, C., *The Impressionists in Context*, Crescent Books, 1991

Levy, M., *A Concise History of Painting: From Giotto to Cézanne*, W. W. Norton & Co. Ltd, 1977

McConkey, K., *British Impressionism*, Phaidon Press, 1989

Moffett, C. S., Rathbone, E. E., et al, *Impressionists in Winter*, Philip Wilson Publishers, 2001

Meslay, O., *J.M.W. Turner: The Man Who Set Painting on Fire*, Thames & Hudson, 2005

Neret, G., *Renoir, Painter of Happiness*, Taschen, 2009

Rewald, J., *Cezanne: A Biography*, Harry N. Abrams, Inc, 1996

Rodner, W. S., *J. M. W. Turner: Romantic Painter of the Industrial Revolution*, University of California Press, 1998

Roe, S., *The Private Lives of the Impressionists*, Vintage, 2007

Sagner-Duchting, K., *Monet*, Taschen, 2006

Shone, R., *Sisley*, Phaidon Press, 1994

Spate, V., *Claude Monet: The Colour of Time*, Thames & Hudson, 2001

Swinglehurst, E., *The Life and Works of Monet*, Parragon Publishing, 2000

Taillandier, Y., *Monet*, Bonfini Press, 1995

Thomson, B., *Impressionism: Origins, Practice, Reception*, Thames & Hudson, 2000

Wildenstein, D., *Monet's Years at Giverny: Beyond Impressionism*, Metropolitan Museum of Art New York, 1978

Wilson-Bareau, J., *Manet by Himself*, Little, Brown, 2004

Wilton, A., *Turner in his Time*, Thames & Hudson, 2006

Index by Work

General Index